Oil Painting

Tips & Tricks

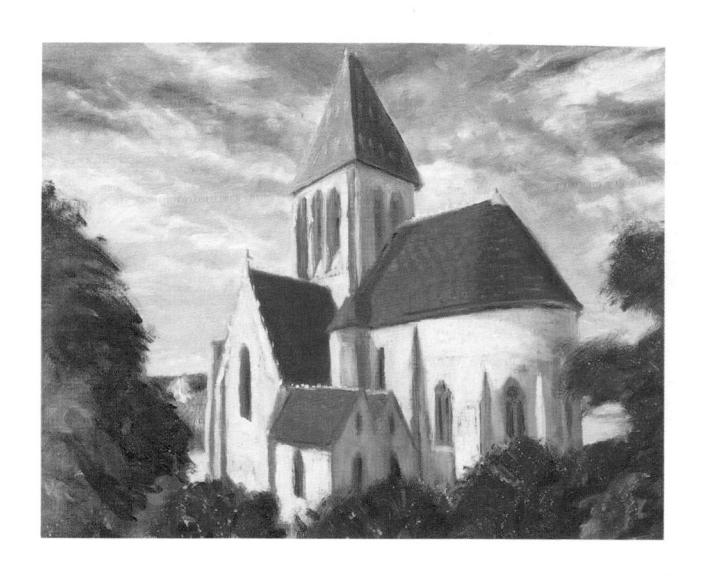

ROSALIND CUTHBERT

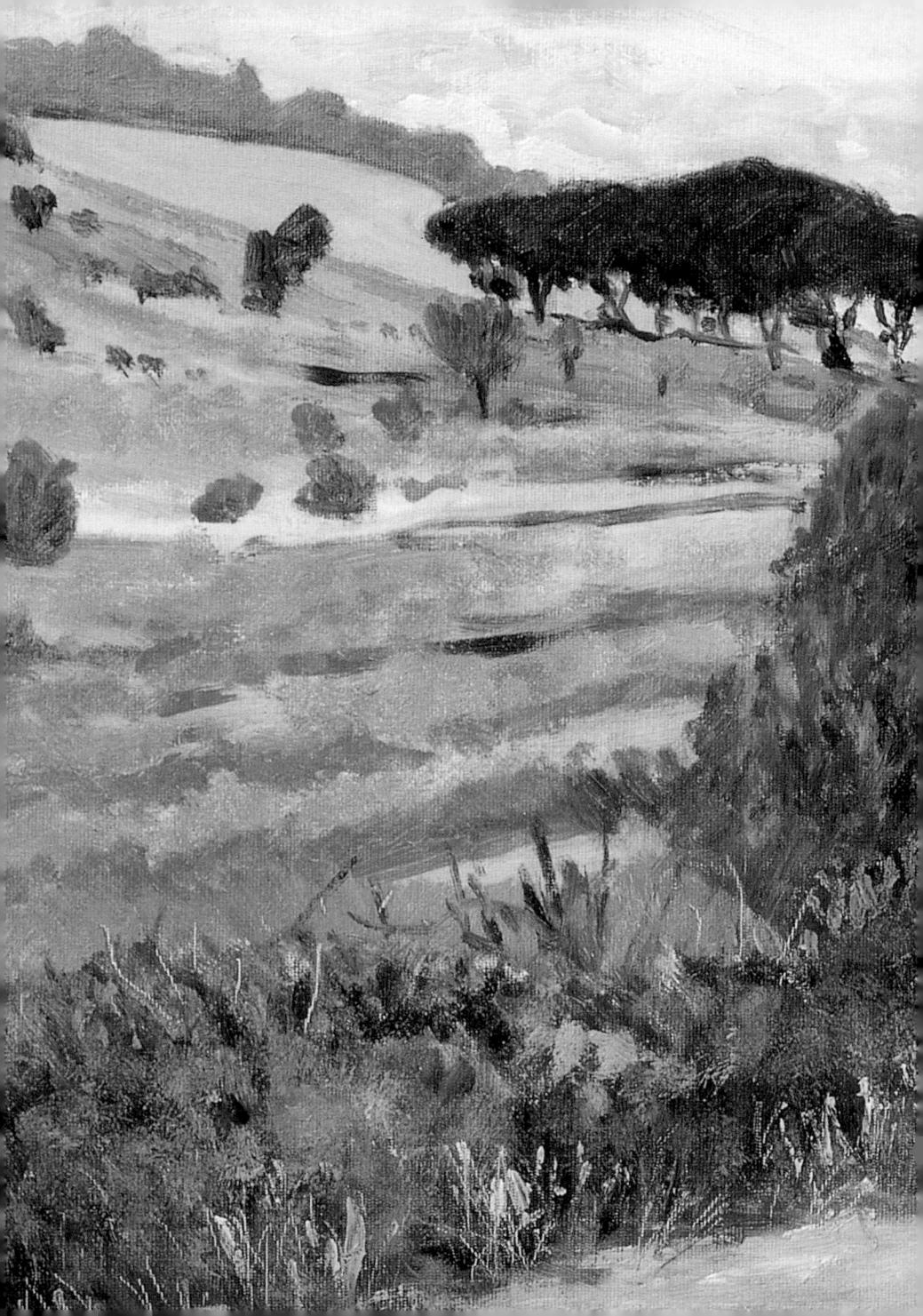

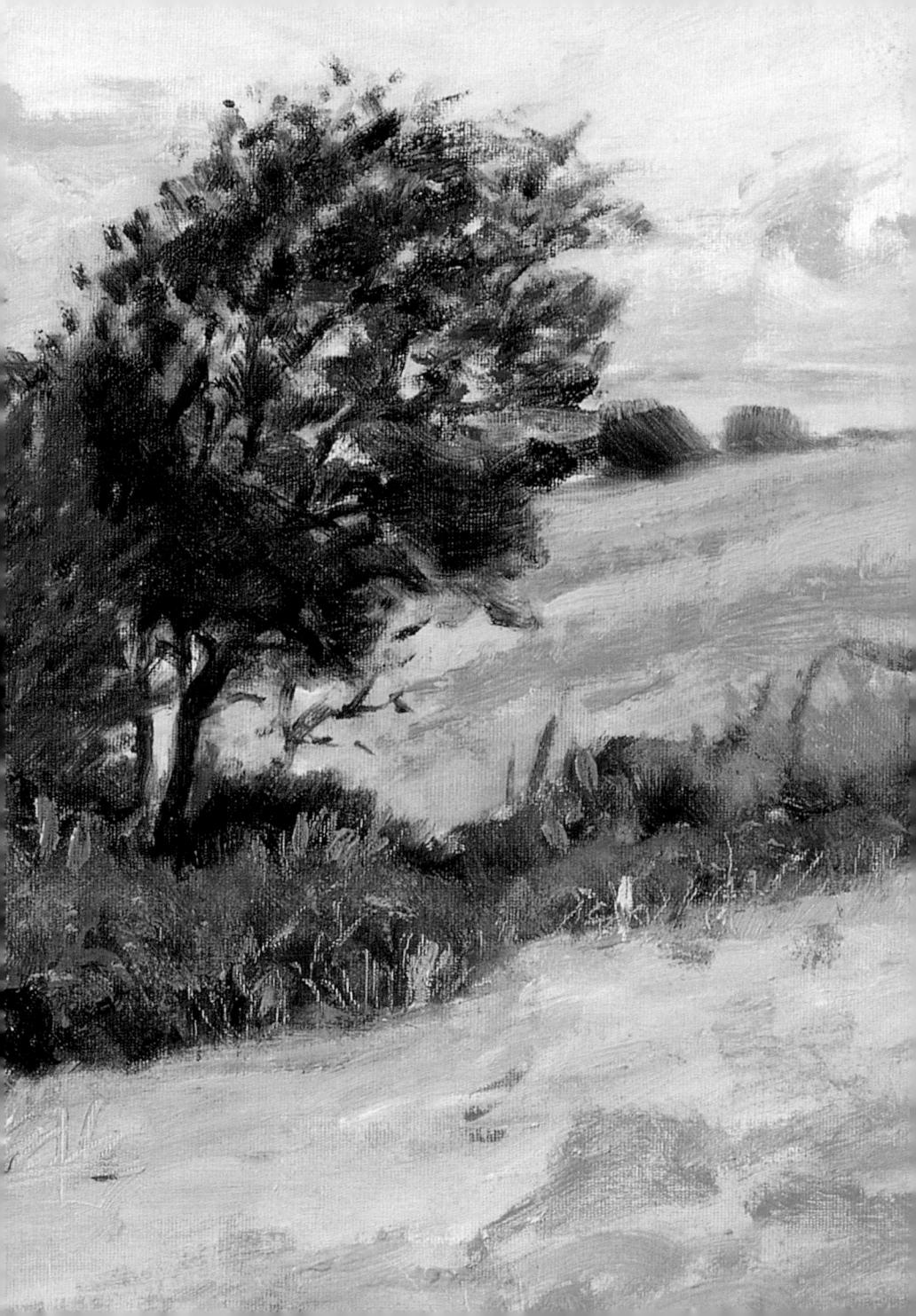

This edition published in 2009 by Chartwell Books, Inc., a division of Book Sales Inc.

114 Northfield Avenue
Edison, New Jersey 08837

USA

ISBN-10: 0-7858-2440-5 ISBN-13: 978-0-7858-2440-4 OTT.TTO

A Quintet Book.

Copyright © 2009 Quintet Publishing Limited.

All rights reserved. No part of this publication may be reproduced, stored in a retrieval system, or transmitted in any form or by any means, electronic, mechanical, photocopying, recording, or otherwise, without the prior written permission of the copyright holder.

This book was conceived, designed, and produced by Quintet Publishing Limited, 6 Blundell Street, London N7 9BH, UK

Project Editor: Robert Davies
Designer: Jason Anscomb
Art Editor: Michael Charles
Managing Editor: Donna Gregory

Publisher: James Tavendale

The material in this publication previously appeared in *Artists' Questions Answered: Oil Painting.*

Printed in China by Midas Printing International Limited

987654321

Contents

Introduction	n	6
Painting equipment		8
Key terms		10
Chapter 1	Basic techniques	14
Chapter 2	Understanding and mixing color	42
Chapter 3	Composing and painting still life	78
Chapter 4	Developing landscapes and townscapes	120
Chapter 5	Depicting water	156
Chapter 6	Painting figures	192
Index		222

Introduction

People have made paintings as far back as we can peer into our history, from whatever materials were at hand. The first pigments were ground rocks, carbon, and vegetable and animal dyes. Then, these substances were used dry, smeared with fingers, or bound with water or animal glues. We use many of the same pigments today, although they have been added to—and also sometimes replaced by—new discoveries. More recently, new colors have been invented in laboratories, such as phthalocyanine and indanthrene colors.

Oil paint is said to have been invented by Jan van Eyck in the Netherlands in the fifteenth century. His famous painting *The Arnolfini Marriage* (1434) demonstrates his mastery on many levels. The fact that the picture has lasted so well and still glows with brilliant freshness today proves the durable qualities of oil paint in the hands of one who knows how to use it. These qualities of richness, durability, and versatility, are the reasons for its popularity.

Artists as diverse as Titian, Monet, and Picasso have used oil paint. Abstract painters and pop artists, Expressionists, and photorealists have all used it, each movement renewing the possibilities of this wonderful medium. Contemporary artists such as Lucian Freud, Wayne Thiebaud, and Frank Auerbach also all use oil, each in a dramatically different way. The possibilities for expression seem endless.

The story of oil painting is long and grand, but this book is not intended to be a history of the medium. Rather, its purpose is to illuminate some basic principles and procedures so that you can develop a technically sound use of the medium, to give advice about equipment, and to make suggestions about picture making. Oil paint has a reputation for being a difficult medium to master; this book hopes to show you that there is no need to feel daunted. It will help you to paint with the confident enjoyment that comes with getting to know your medium and experiencing a growing awareness of the visual world.

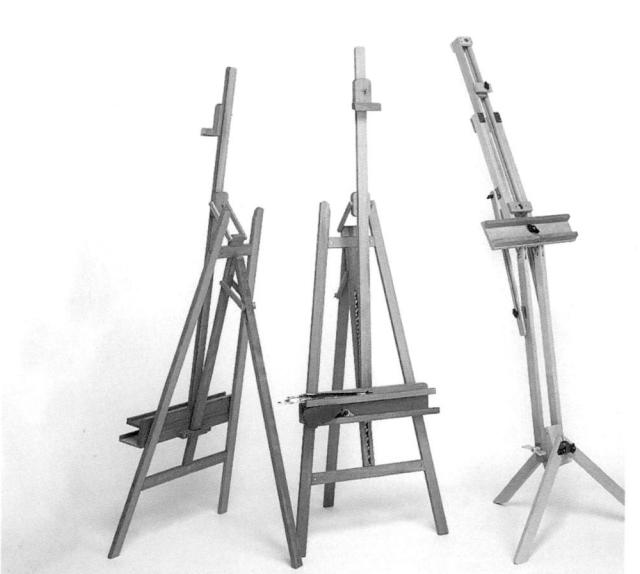

Easels
Easels range from heavy
radial easels, which are
used indoors, to light
portable easels, which are
ideal for those who enjoy
painting outside.

Painting equipment

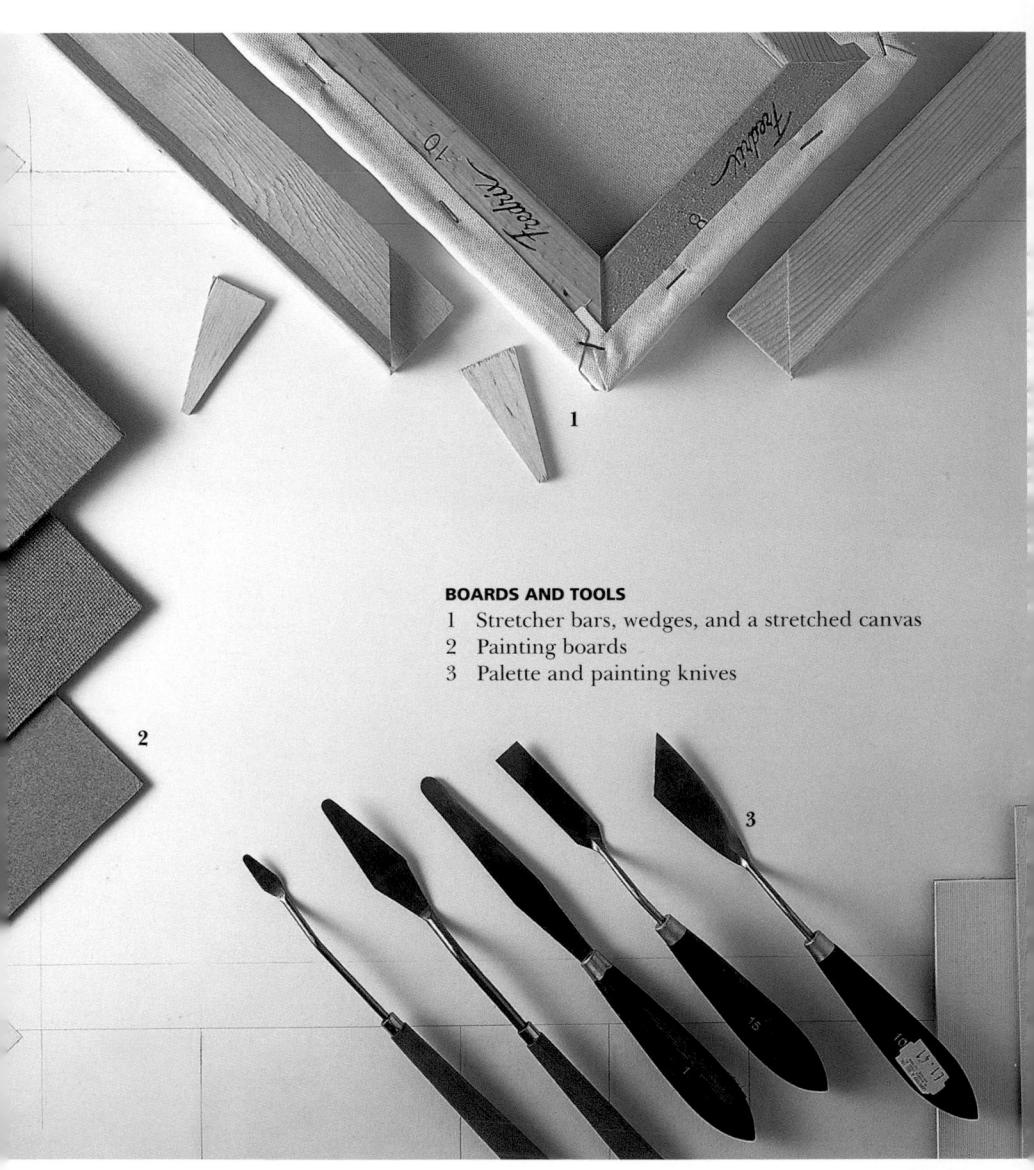

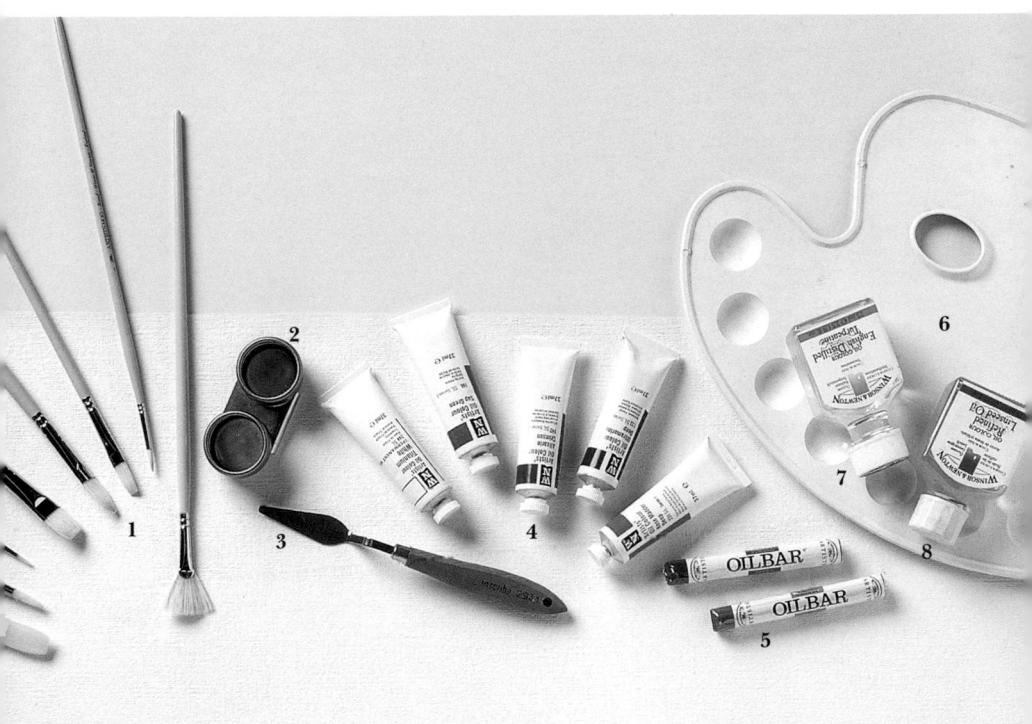

PAINTING EQUIPMENT

- 1 Brushes
- 2 Palette cups
- 3 Palette knife
- 4 Tubes of oil paint
- 5 Oil sticks
- 6 Palette
- 7 Distilled turpentine
- 8 Refined linseed oil

Key terms

and reducing contrasts.

Atmospheric (or aerial)
perspective—How the atmosphere
affects the perception of distance,
making distant colors cooler (bluer)

Alla prima—Italian, meaning "first time": when a painting is completed with only one layer of paint applied.

Complementary colors—Colors that lie opposite one another on the color wheel. Each secondary color is made of two primaries— the third primary is the complementary.

Composition—The arrangement of the subject matter in a way that is harmonious and pleasing to the eye.

Fat paint—Possessing a high proportion of oil to pigment.

Filbert—A hazelnut-shaped brush that tapers like a flattened cone.

Fixative—Made from synthetic resin; can be used to seal pastel or charcoal drawing. Fixative can be toxic and should be used outdoors.

Foreshortening—A perspective term used to describe an object appearing to diminish in size as it recedes from the viewer.

Form—The appearance of the subject matter—its line, contour, and three-dimensionality.

Glaze—A transparent film of paint over an area of colored paint that has already dried.

Gradation—A gradual, smooth change from dark to light or from one color to another.

Ground—An initial layer of color, sometimes textured, used as a base on top of which the rest of the colors are applied.

Highlight—The area on any surface that reflects the most light.

Horizon line—An imaginary line at the same level as your eyes. If you are on a flat plain, the horizon will be the same as the skyline. If you are looking at hills the horizon will be lower than the skyline. **Hue**—The pure color, as distinct from its lightness or darkness.

Impasto—Paint applied thickly, so that the brush or palette knife marks are visible.

Lean—Paint containing little oil in relation to pigment.

Linear perspective—A technique of drawing or painting used to create a sense of depth and three dimensionality. Most simply, the parallel lines of buildings and other objects in a picture converge to a point, making them appear to extend back Into space.

Luminosity—The effect of light appearing to come from a surface.

Mahl stick—A stick with a padded or ball-shaped end, used as a rest for your arm to keep your hand steady when painting.

Medium—The material or technique used by an artist to produce a work.

Negative space—The space around an object, which can be used as an entity in composition.

One-point perspective—A form of linear perspective in which all lines appear to meet at a single point on the horizon.

Opaque—Something that cannot be seen through—the opposite of transparent.

Palette—A flat surface on which to mix paints.

Perspective—The graphical representation of distance or of three dimensions.

Picture plane—The plane occupied by the surface of the picture. When there is any illusion of depth in the picture, the picture plane is similar to a plate of glass behind which pictorial elements are arranged.

Primary colors—The colors that cannot be mixed from any other colors; yellow, red, and blue.

Proportion—A principle of design referring to the size relationships of elements to the whole and to each other.

Resists—Materials that protect a surface from paint in order to maintain paint-free areas of paper. Paper, masking tape, and masking fluid are all resists.

Sable—A bristle brush made of soft hairs that come from a variety of animals; particularly suited to soft applications of color.

Scumbling—Dragging dry, opaque paint across a layer of underpainting to give a broken color effect.

Secondary colors—Colors made from mixing two primary colors, for example, orange (red and yellow), green (blue and yellow), and purple (red and blue).

Sgraffito—Lines produced by scratching through one surface of paint to reveal the color underneath.

Shading—The application of light and dark values that gives a two-dimensional drawing or painting its three-dimensional appearance.

Sketch—A quick freehand drawing or painting.

Spattering—A method of spraying droplets of paint over a painting using either a toothbrush or a flat brush.

Sponging—Applying paint with a sponge to produce a textured surface.

Stippling—A method of shading that uses dots instead of lines.

Stretcher bars—A wooden frame on which canvas is stretched.

Support—The paper, board, or canvas on which the drawing or painting is made.

Tertiary colors—Colors that contain all three primary colors. Brown, khaki, and slate are all tertiary colors mixed from varying combinations of the three primaries.

Texture—An element of art that refers to the surface quality or "feel" of an object—its smoothness, roughness, softness, etc.

Tint—A color to which white or water has been added to dilute the hue. For example, white added to blue makes a lighter blue tint.

Tone—Without reference to color value, the degree of lightness or darkness in an area or object.

Tonking—A technique in which paper is pressed onto a painting to remove excess paint and reveal the underdrawing.

Underdrawing—A sketch of the composition with pencil, charcoal, or paint that suggests tonal differences.

Vanishing point—The point on the imaginary horizontal line representing eye level where extended lines from linear perspective meet.

Viewfinder—L-shaped pieces of cardboard that are placed together to form a rectangular shape, used by artists to frame a composition.

Warping (buckling)—The wrinkling that occurs to lightweight papers after wetting. The heavier the paper, the less warping occurs.

Wet-into-wet—A technique in which wet paint is worked into a still-wet layer of paint.

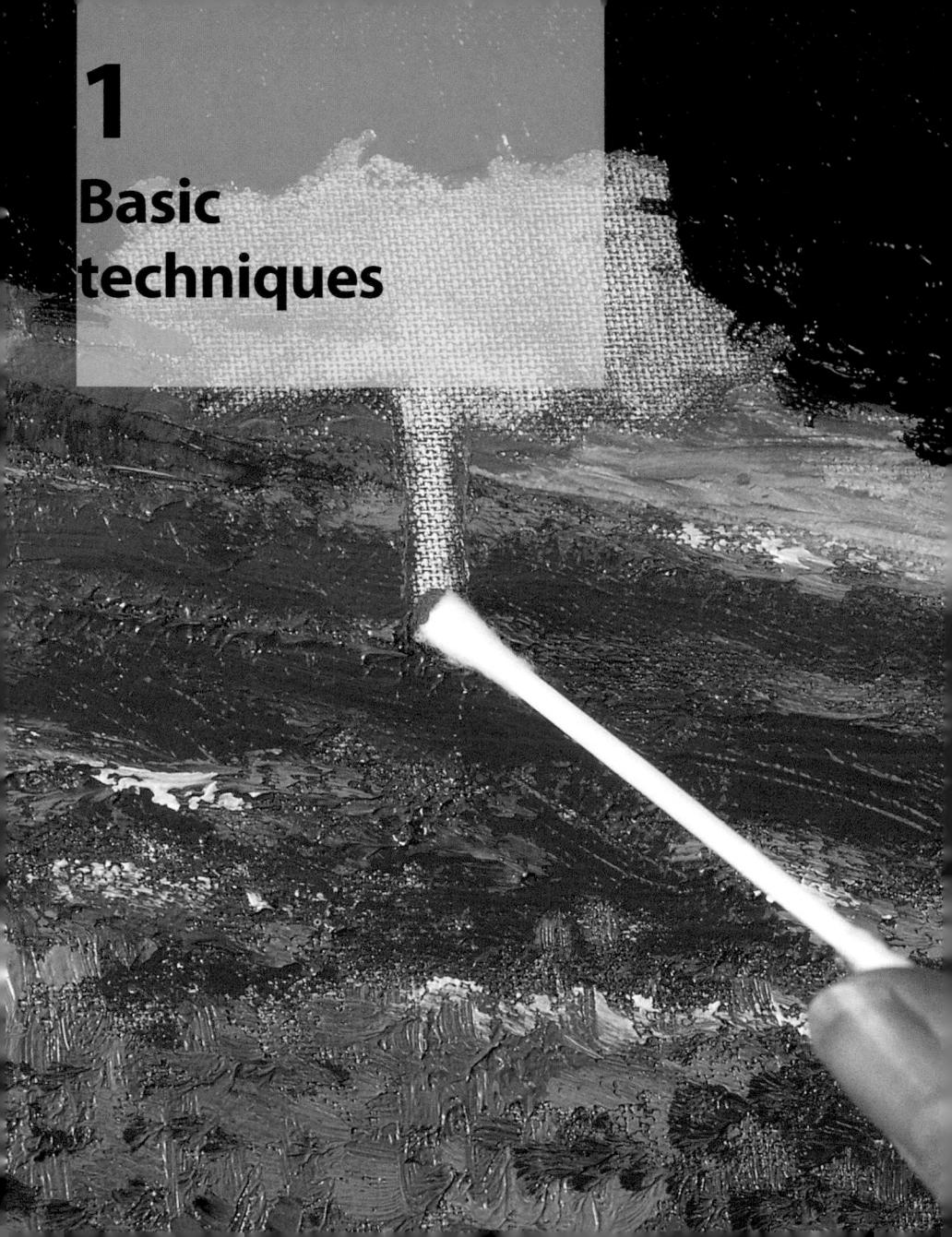

rt supply stores offer a huge A choice of equipment for oil painting, from paints and brushes to a host of other specialty tools. You really don't need to buy every available piece of equipment. An easel is useful, but you can just as easily sit at a table with your work supported on a slanted board. A few tubes of paint, a basic palette, three or four brushes, and a bottle of turpentine, along with something to paint on, are all you need to get started. You can paint in oil on a canvas-covered painting board from the art store, an oil painting sketchbook with primed pages, or even a piece of cardboard primed with house paint, so there is no need to buy expensive canvases at the outset.

It is important to give as much importance to drawing as to painting. Keep a sketchbook, and use it often. You will be more capable with a brush in

your hand if you have some experience in setting down your observations with a pencil first.

Do not rush into oil painting expecting to create masterpieces.

Take time to get used to the paint and brushes. Be open-minded, and try different ways of doing things. Explore different effects and marks. And don't just limit yourself to brushes. You can create interesting textures with a sponge, toothbrush, and your fingers.

The main thing to remember when you start painting with oil is not to panic if you make a mistake. This doesn't mean that you have to start your painting all over again. There are many ways to correct a mistake, including scraping and wiping off unwanted paint, overpainting, and tonking. Keep your early paintings for reference. Even mistakes can make useful reminders of what can go wrong and how to remedy or avoid it.

Types of brush

There are a bewildering number of different types, shapes, and sizes of brush in art supply stores. The main materials used for the brush hairs are hog (or bristle), sable, and nylon. Hog bristle brushes are stiff and designed to leave brush marks in the paint, whereas nylon or sable brushes are generally used for finer, more delicate work. As a simple guide, wider brushes hold more paint and make thicker, bolder marks; narrow brushes hold less paint and make delicate marks.

A round hog is a great all-purpose brush. Hog brushes in general are good for looser styles of painting, but the tip can also make relatively fine marks for painting details. The more pressure you apply, the wider the mark. Use a large hog brush for blocking in large areas of color.

Filbert brushes are flat with a rounded end. They are named for their outline, which is similar to that of a hazelnut. Hold the brush flat to produce wide strokes and on its side for narrow ones. Filberts are also available with short bristles—these hold less paint and are better for short, accurate brushwork.

Flat-ended brushes are available with long or short bristles and produce a characteristic squared-off mark, very different from the round and filbert brushes. These brushes work well if you need to block in areas of color. They are also good for creating texture, especially for things like wood and brickwork. Use the end or side of the brush for parrow lines or marks

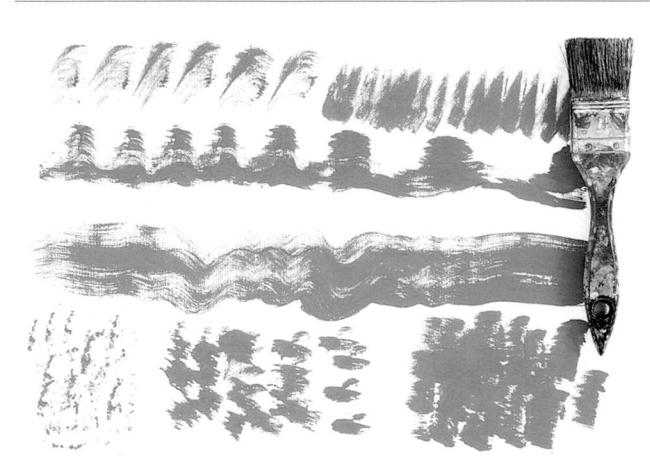

Decorator's brushes are very useful for priming, laying down large areas of color very quickly, and creating a wide range of brush marks in a painting. Don't buy cheap brushes; they may shed and leave bristles in the paint. Nylon brushes make softer marks than their hog counterparts do, and they are ideal for use with thinned paint because they leave few brush marks in the paint. They are good for glazing and blending, and for fine detail work.

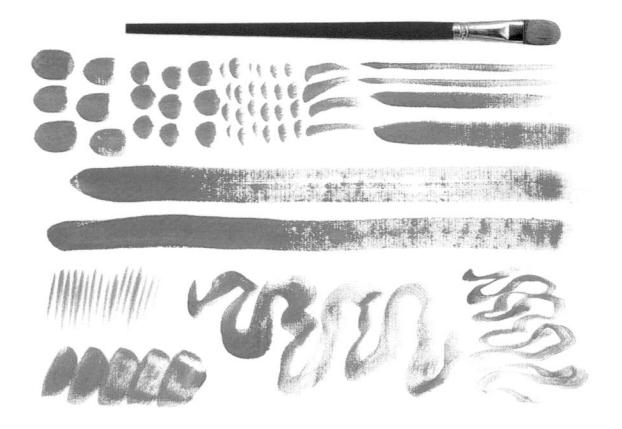

A fan brush is not a basic requirement, but it can be fun to use. It is ideal for blending and for creating textures, such as those of hair and fur.

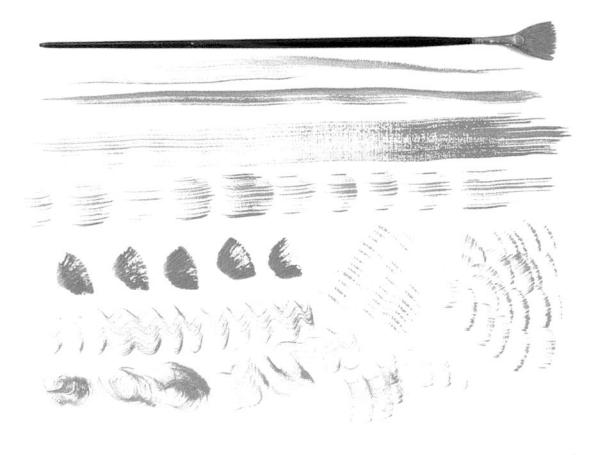

Always clean your brushes after use. Wash them in mineral spirits, then rub them gently on a bar of soap and work up a lather in the palm of your hand. Rinse them thoroughly and allow them to dry naturally. It is also important to clean your brush between each new color. Have a jar of mineral spirits nearby while you paint. As you finish with a color, rinse your brush in the spirits and wipe it clean on a soft rag before applying the new color. This will ensure your colors do not become muddied.

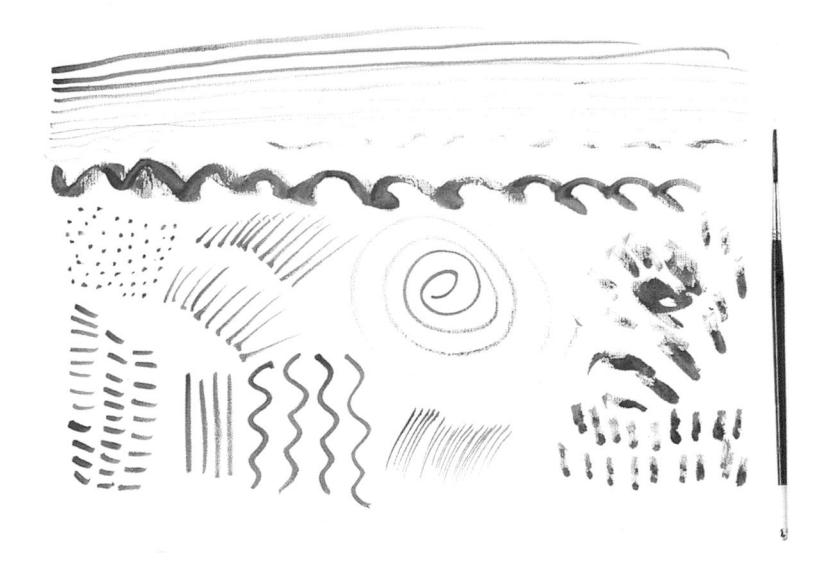

Like the fan, the rigger brush is not a basic requirement. It was designed to paint the rigging on paintings of sailing ships, hence its name. Its hairs are very long so it can hold plenty of paint, and its tip is flat, so the lines it makes are consistently the same width. These brushes are great for painting long, thin, continuous lines.

Stretching canvas

Stretching your own canvas needs some investment and practice, but it offers more freedom over your size of painting, and financial savings in the long term. To stretch

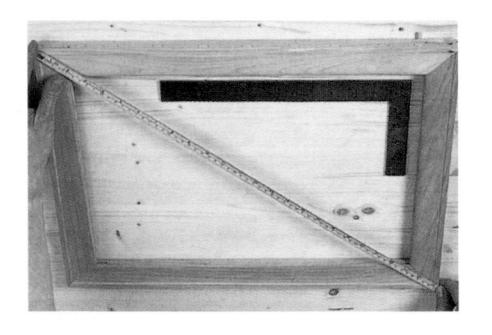

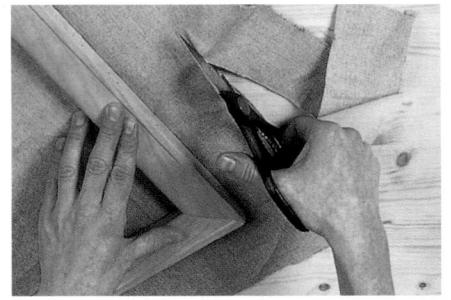

Tap the stretcher bars together to make a frame, and check its squareness with a large L-square or by comparing the diagonals with a tape measure.

Lay the stretcher frame down on the canvas, allowing an overlap of about 3 inches (7.5 cm) all around.

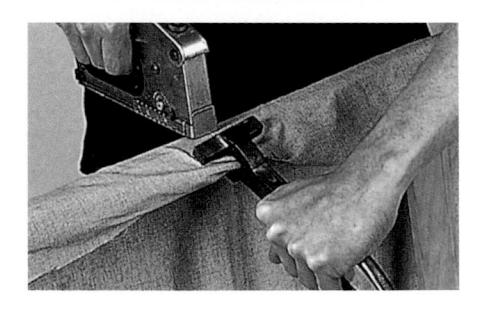

Make sure that the warp and weave threads of the canvas are parallel with the edges of the frame. Pull the canvas taut and staple it to the center of one of the long stretcher bars; then repeat the process on the other side.

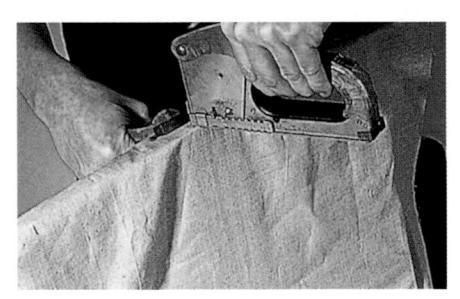

Do the same with the shorter sides, taking care to pull the canvas taut with the second pair of opposing staples. This prevents the canvas from being stretched unevenly.

a canvas you will need two pairs of stretcher bars for the frame and a pair of pliers to help you create enough tension on the material.

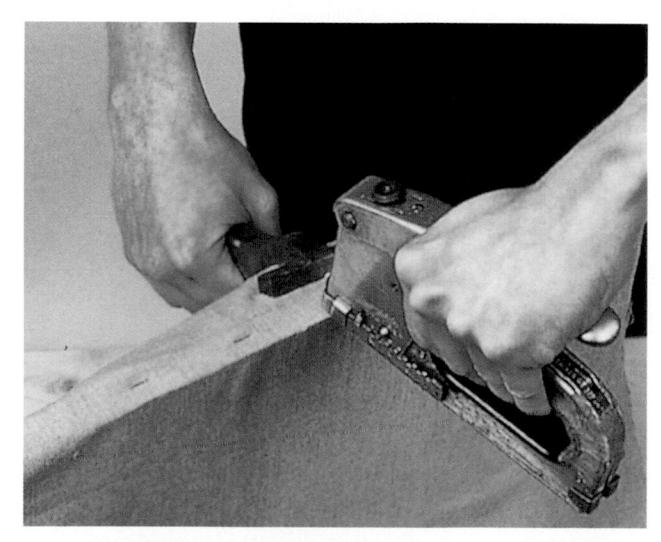

Return to the first long side and place a staple 1½–2 inches (4–5 cm) to the right and left of the first staple. Do the same to the remaining sides. Continue working outward from the center toward the corners, pulling the canvas taut as you go.

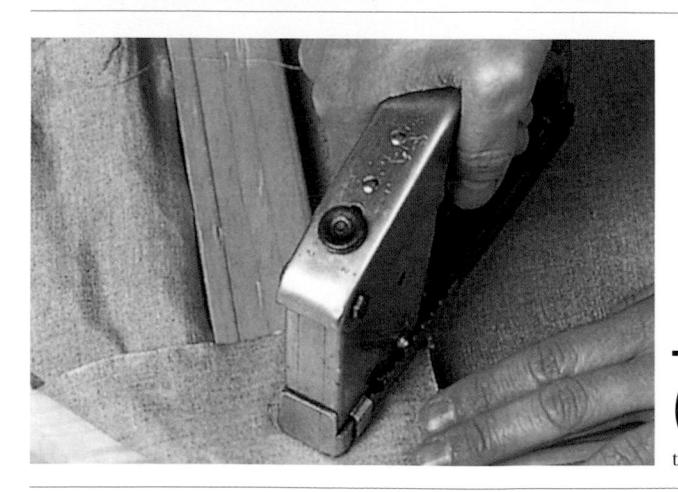

Fold the canvas around the corners and staple it to

Thinning oil paints

Always observe the golden rule of oil painting—work from "lean to fat." As oil paint dries, it is very absorbent and will draw oil away from any layers painted on top, making your painting look dull and lifeless. If you dilute the paint, it dries more quickly and prevents this from happening. As you progress to each paint layer, it should contain less dilutent, so that the thickness of the paint increases. Only when you get to the very final layers can you start to use paint straight from the tube.

The simplest way to dilute oil paint is with turpentine. For small amounts of paint, squeeze a little paint onto

Permanent mauve is a transparent pigment, used here straight from the tube. Transparent pigments can look very dark unless they are thinned down.

your palette, and mix in the turpentine with a brush until you have the desired consistency. Add a little turpentine at a time—it is much easier to thin paint than to thicken it again. Also make sure that you have a smooth consistency so that the paint goes on evenly. Turpentine dries the paint out, so in time it may crack or flake. To compensate for this, add a very little linseed oil to the mix to produce a durable, elastic paint surface with a rich, glossy appearance.

Thinned with alkyd (synthetic) painting medium, permanent mauve retains its color while appearing more transparent.

Thinned with pure turpentine, the paint consistency is much more liquid and the effect even more transparent.

Alternatives to brushes

You can create many exciting and unexpected effects in paint with a variety of tools, adding to the range of marks you make with brushes. These techniques include scratching, spattering, sponging, and finger painting.

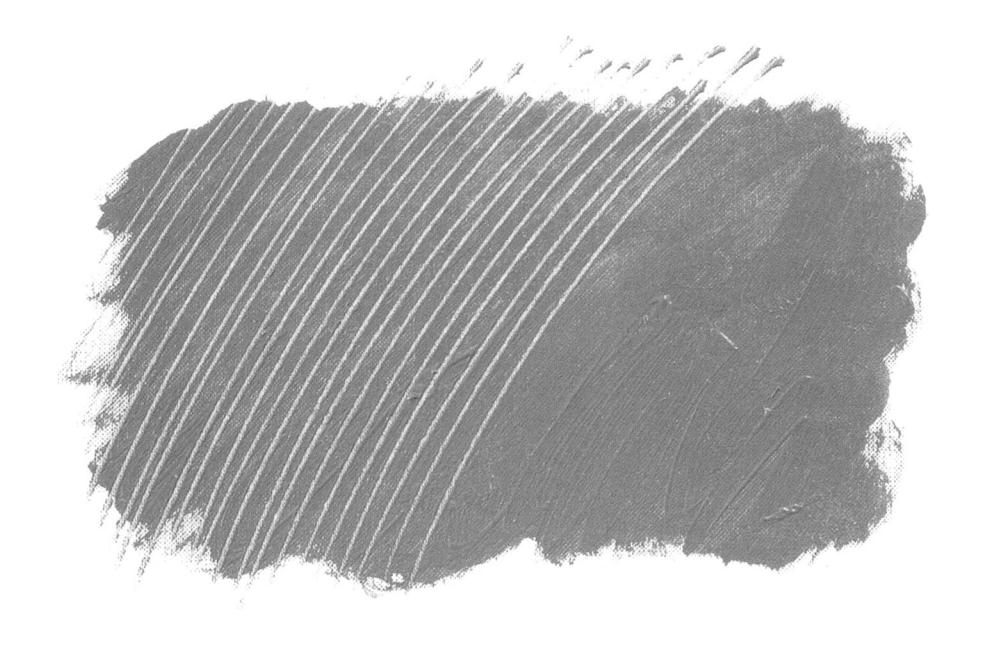

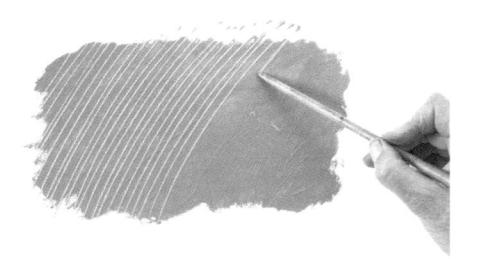

Apply a layer of paint over an already-dry ground. Then scratch into the wet paint surface with the handle of your paintbrush, a painting knife, or any other pointed implement to create uniform, sharp lines that reveal the colored ground beneath. This technique is known as *sgraffito* and is a great technique for painting grasses.

ALTERNATIVES TO BRUSHES

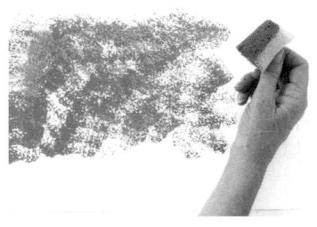

Create a broken paint texture with a piece of sponge. Thin the paint with turpentine and apply the sponge to your paper. This kind of texture has many uses, such as adding interest to an expanse of foliage, to the walls of a building, or even to a cloudy sky.

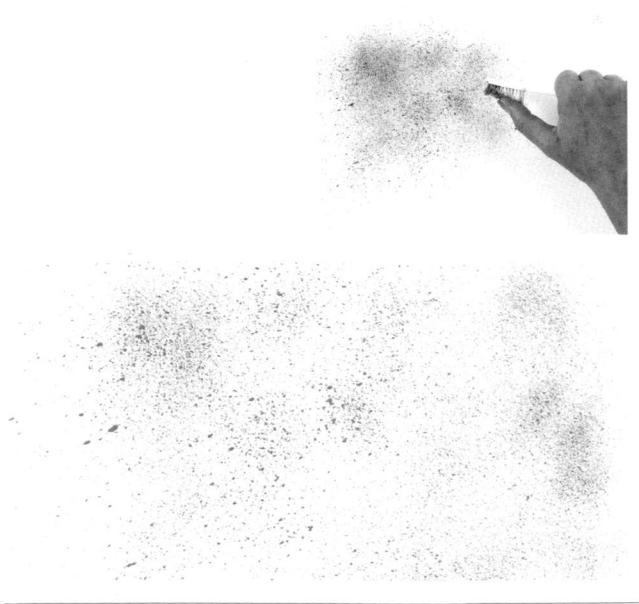

A toothbrush is great for spattering a fine spray of paint onto the picture. Thin the paint with turpentine to a very runny consistency. Add a little linseed oil or painting medium, dip your toothbrush into the mixture, and flick the paint onto your paint surface. Make sure your painting is flat on the table so that the paint does not run. Spattered paint gives a dramatic impact to moving subjects such as sea spray and storm clouds, or added subtlety to misty scenes.

For smooth, sculptural effects, apply the paint with your fingers. Use your fingers to blend colors and soften sharp edges. Swirl or drag the paint depending on the effect you want to create. Sometimes it is good to be drastic with your picture surface, for example, when it looks too tidy, predictable, or over-controlled.

Painting alla prima

Alla prima describes a painting completed in one sitting. It is a simple and direct approach to oil painting, and it is very popular with amateur artists. Alla prima encourages a straightforward and even energetic painting style. It can result in lively color and brushwork, and it is commonly used by artists when working out of doors. Many well-loved artists used this approach, including Van Gogh, Monet, and Pissarro. You can paint alla prima on a white primed surface or on a drawing or underpainting that has been allowed to dry. Although colors can be mixed on the palette, they can also be mixed and blended together on the canvas itself. Apply the colors to the canvas side by side and blend them wet-into-wet.

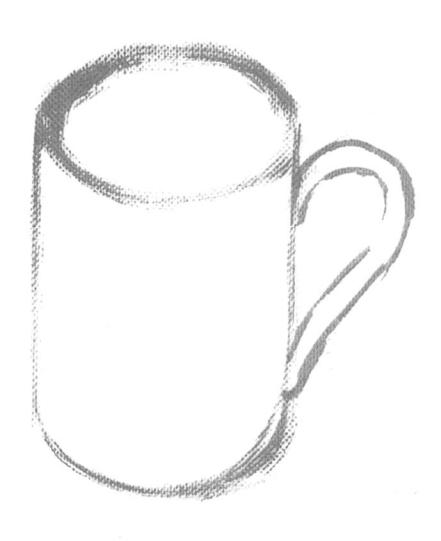

Paint the contours of the mug with a lightcolored paint thinned with turpentine. When you draw with a brush rather than pencil or charcoal, it is easier to move from the "drawing" stage to the "painting" stage, as you do not have to change media.

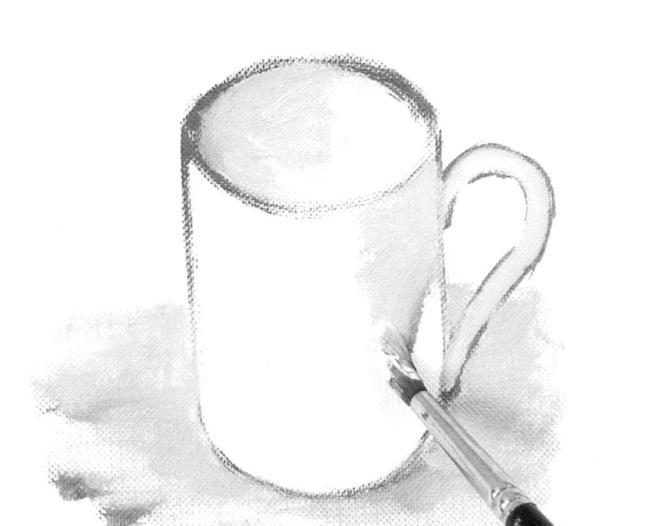

Observe where the light falls on the mug, and block in the paler areas with a mix of your sketching color and titanium white.

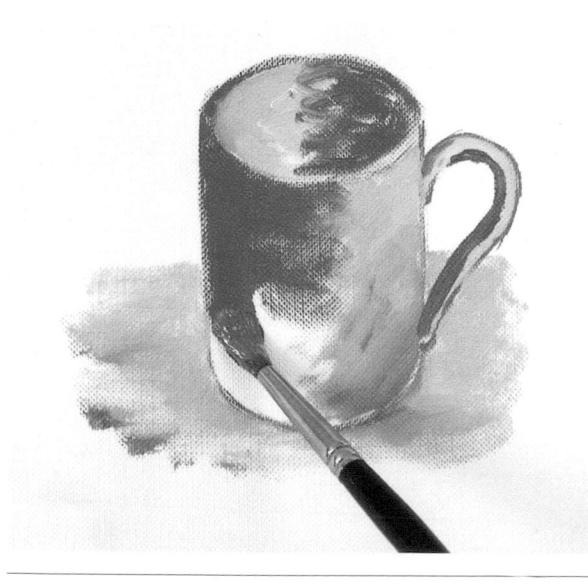

Continue to block in color using a brighter mixture of colors.

Roughly blend the color into the lighter mix applied earlier. Vary the tone so that it gets lighter as you move toward the light side of the mug; you do not want sharp contrasts.

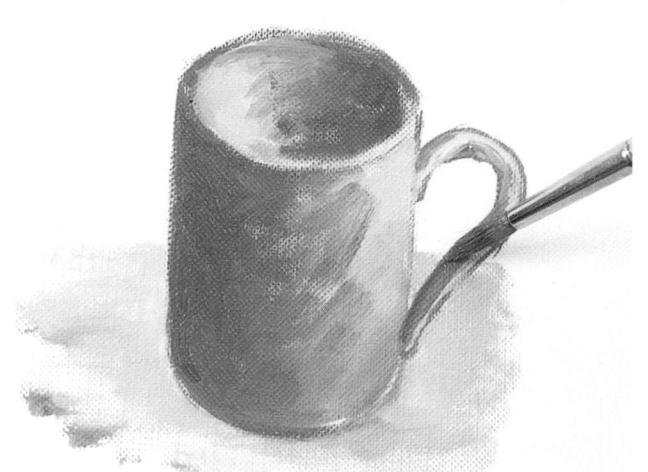

Add some ultramarine to the mix, and develop the shadows. Apply the color roughly to give the mug some texture, but blend it gently into the colors applied earlier to create a gradual tonal change.

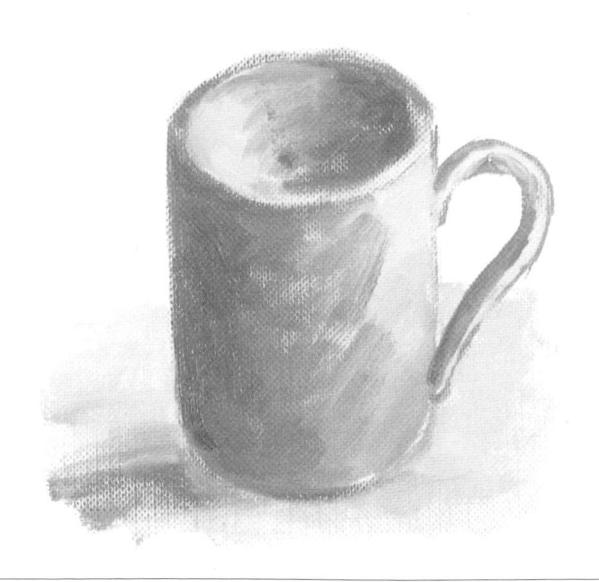

The contour drawing disappears under the layers of paint. Working the paint wet-into-wet, and painting alla prima, have given the mug a convincing three-dimensional form in a short amount of time.

Drawing preliminary sketches

Your sketch is the map or plan of your painting. Concentrate on the major shapes, forms, and the relationship among objects, and draw in the main outlines of your composition. At first, you will probably want to use something that you can erase if you make a mistake, so draw your outlines using a soft pencil or a stick of charcoal. If you draw in pencil, avoid the tendency to get carried away with too much detail. Do not worry if you make a mistake; you will cover it later with the paint. As you become more confident, sketch your subject with a brush to loosen your sketches and to develop a smooth transition from drawing to painting.

For a pencil sketch be sure to use a soft pencil—a hard pencil will indent the picture surface and be difficult to erase. Draw in the outline only; do not fill in any areas of shade or tone but concentrate instead on the shapes. Too much graphite will dirty your colors, so, when you are happy with the drawing, gently erase the whole drawing so that you can just see a faint outline.

DRAWING PRELIMINARY SKETCHES

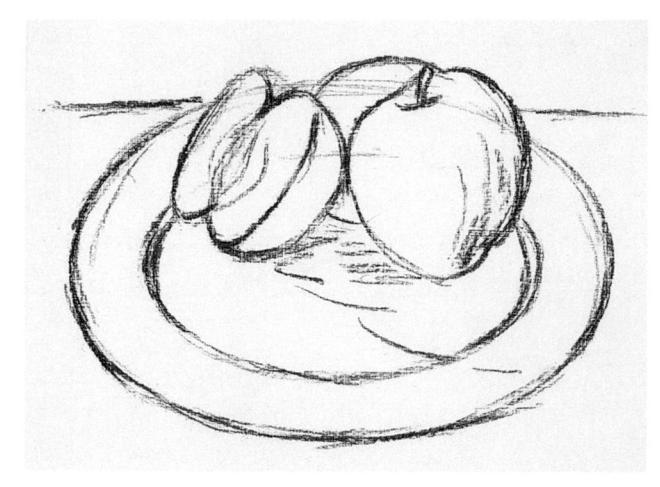

Charcoal is a much broader medium than pencil and will encourage you to draw simply and freely. Sketch the outlines roughly and then spray it with a fixative, so the charcoal won't smudge into your paint later. Alternatively, you can dust your sketch with a piece of cotton wool so that only a ghostly impression is left behind.

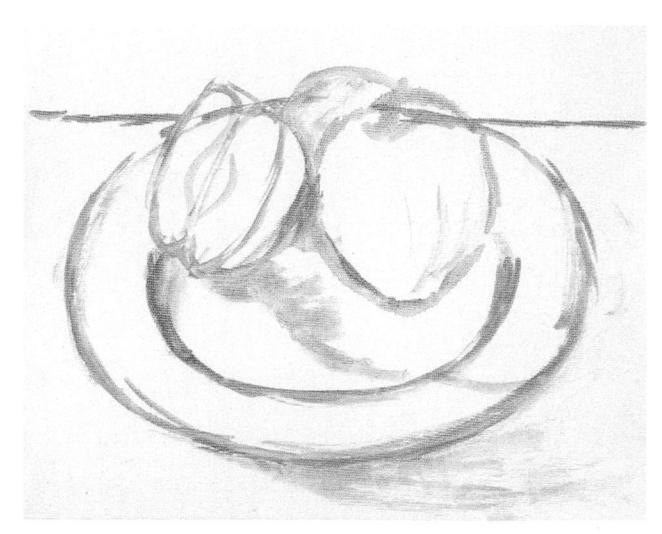

Sketching with paint can seem daunting, but it actually makes it easier to apply paint later on. Dilute your paint with turpentine to speed up the drying time. If you make a mistake, just wipe off the drawing with a rag dipped in turpentine.

Using impasto

Impasto is the term for using paint that has the consistency of paste and is applied generously, either with a bristle brush or with a knife. The paint stands off the canvas in thick brush marks, ridges, or slabs, and can be worked to create a densely textured surface. You will use a great deal of paint, so mix your colors first with

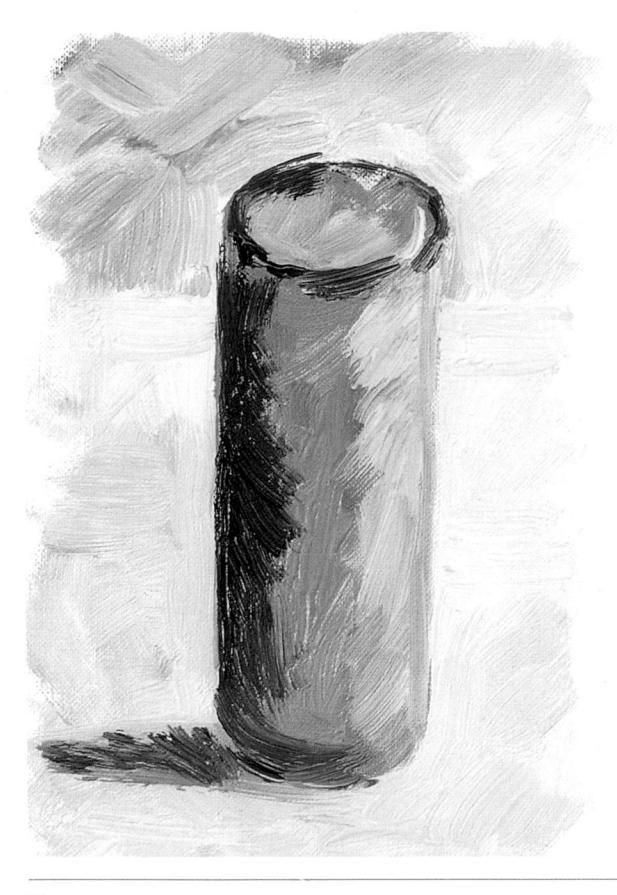

In this example, the paint was applied with a hog bristle brush. The brush marks are clearly visible in the rich, textured surface. impasto medium—a substance available at art supply stores—designed to extend the paint without reducing the color intensity. Then apply the color in thick layers. Such thick paint can take at least a year to dry, so impasto work needs to be done quickly in one sitting and should not be overpainted.

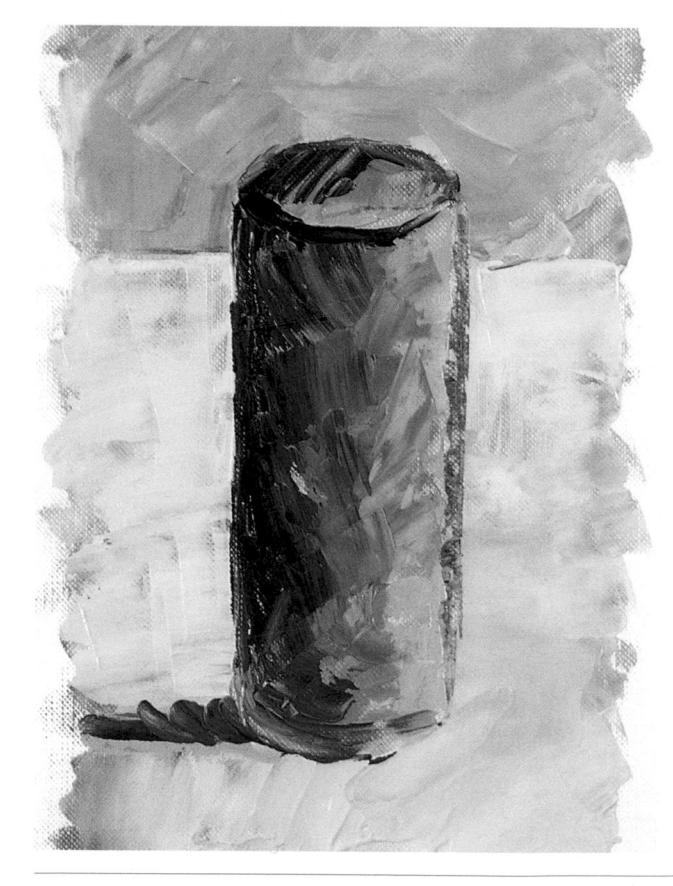

Here, the same mix of paint and medium was applied with a painting knife. The knife imparts a lively, uneven texture to the paint, ideal for painting rough textures.

Tonking

Professor Tonks at the Slade School of Art in London developed a technique for removing large areas of excess or "wrong" paint from a painting, a technique now known as "tonking." Press a sheet of newsprint onto the painting, then lift it off. The excess paint will come up with it and reveal the underdrawing. This also works if you apply the wrong color to a large area of your painting.

Once the paper has been placed over the area you want to tonk, you should rub it gently to ensure that the excess paint soaks into the paper. You can also use this technique to soften any hard edges.

To practice tonking, paint the outline sketch or underdrawing as you would for any painting.

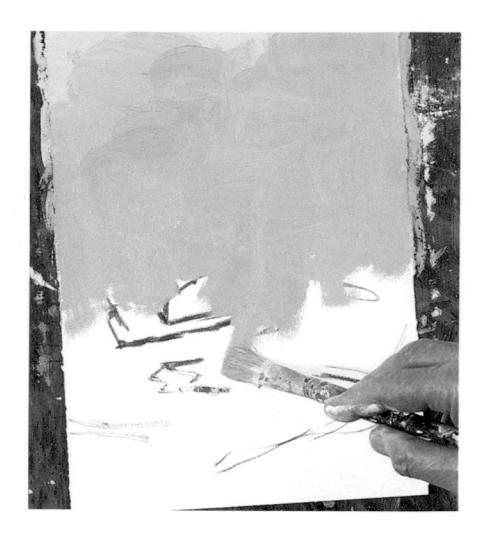

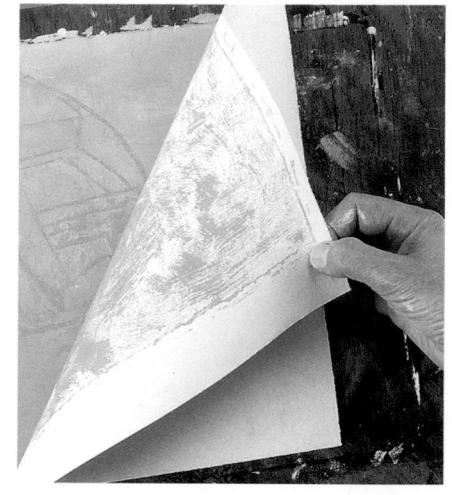

Add a thick opaque layer of paint over the drawing so that it is entirely covered.

A Lay a sheet of newsprint over the drawing and press it firmly. Rub the back of the paper gently, then peel it back; much of the paint layer will lift with it.

The drawing is visible once more.
This is a great way of removing paint where the drawing has been lost under too much color.

Making corrections

Corrections can be made very easily with oil, so don't panic if you make a mistake. If you apply a small amount of the wrong color, it can be removed with a cotton swab or a small, clean brush. Larger mistakes can be scraped back with a painting knife, then wiped clean with a little turpentine on a rag. Large or small areas of a picture can also be glazed over, once they a e dry, to adjust a color or improve the color balance.

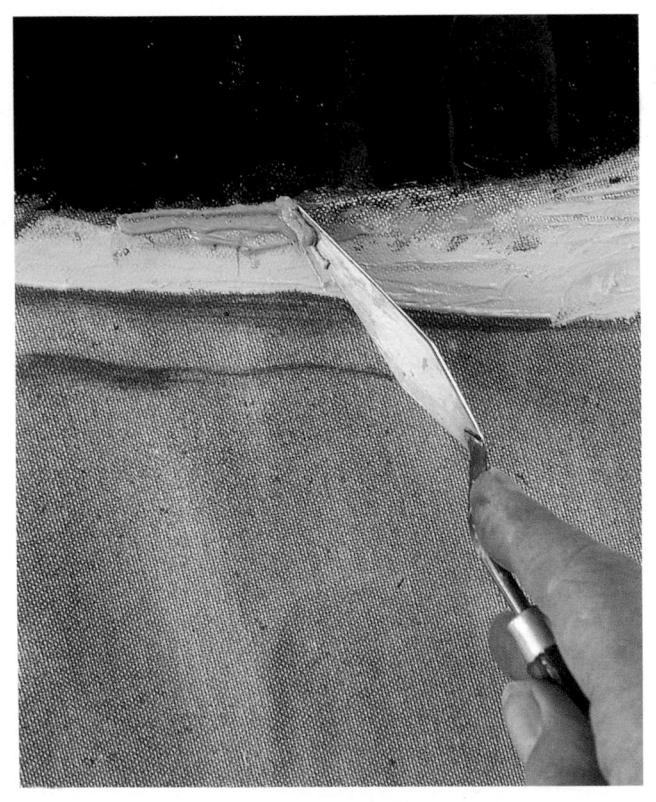

If you have applied the wrong color to your painting, simply scrape off the offending color with a knife. In this case, the yellow ocher is far too bright.
artist's note

An artist using a painting knife will constantly scrape off and re-apply paint until the desired effect is achieved. It's an exciting technique, but it's wise to restrict the number of colors you use until you have the feel of it, as the paint will quickly lose its freshness if overworked.

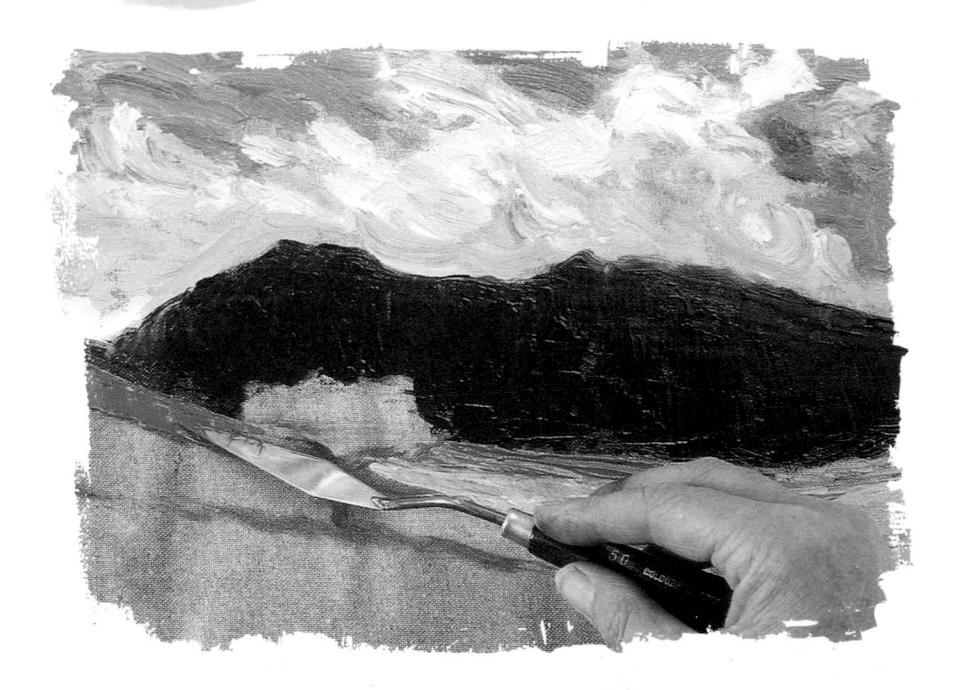

Remix the correct color and re-apply with a palette knife or a brush. Here the color is made a shade darker using raw sienna.

BASIC TECHNIQUES

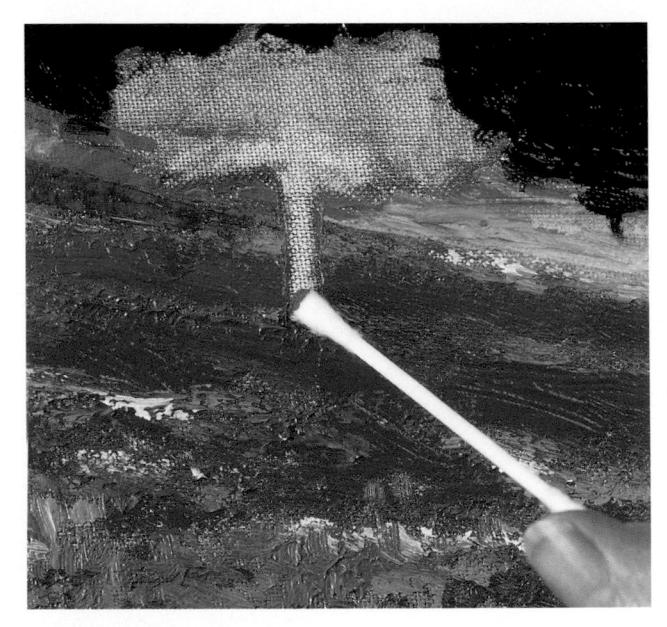

To remove small areas of paint, such as this tree, scrape away the unwanted color with a palette knife. Then clean the area with a cotton swab and turpentine and paint the correct color.

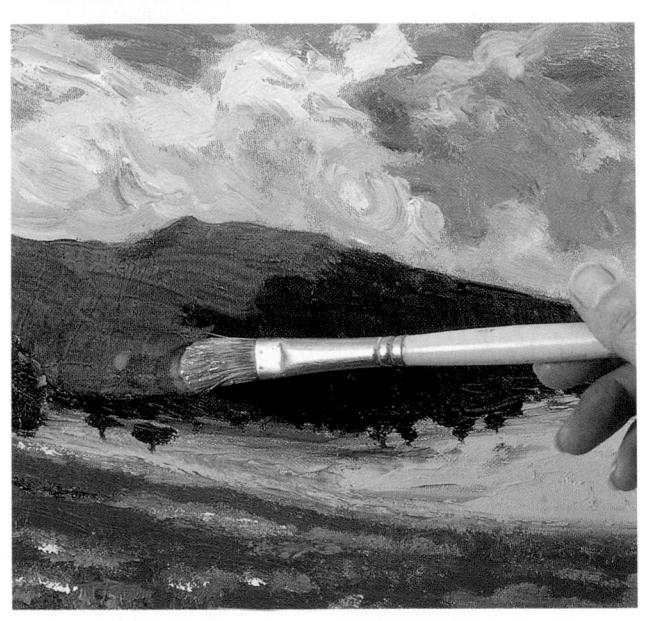

If you make an area of your painting too dark, like the hill in this landscape, let the paint dry and apply a lighter glaze of colors. In this case, a semiopaque blue was applied to cool the whole area.

MAKING CORRECTIONS

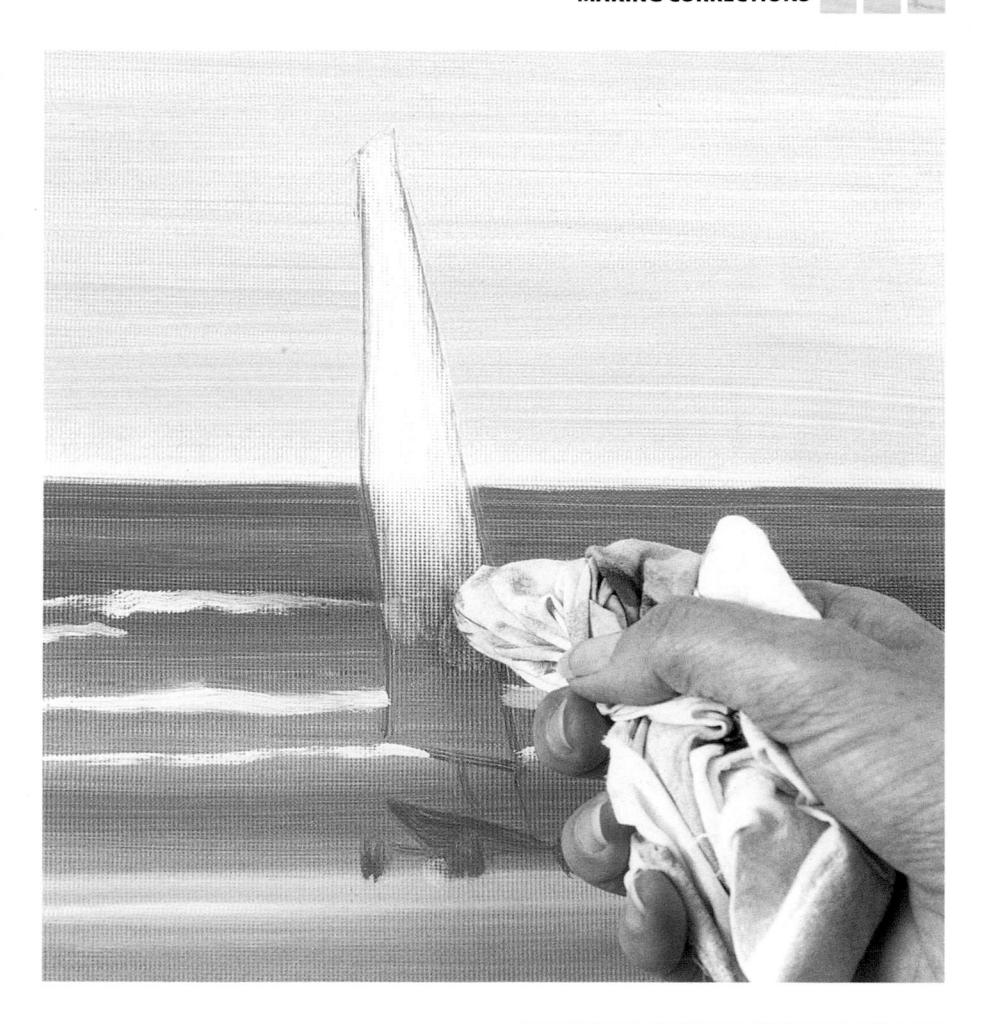

An alternative to scraping off paint with a knife is to dip a clean rag into some turpentine and gently rub away the unwanted color, taking care not to touch any other areas. Here, to achieve the continuation of the lines of the sky and sea, the paint was initially applied over the sail. Once the paint is removed, the sail is ready for its own color.

Rules of perspective

When you paint on a flat, two-dimensional surface, the challenge is to create an illusion of three-dimensional depth. The basics of linear perspective will help you make objects appear to recede convincingly. Imagine a cube. Unless you are looking straight on to one face, the edge of a face farthest away from you appears to be shorter than the edge nearest to you, and the horizontal lines appear to be converging as they recede from you. In all basic perspective diagrams, there is a theoretical spot on the horizon line called the "vanishing point" to which all horizontal lines eventually extend. There can be an infinite number of vanishing points, but the basic rules of perspective involve one, two, and three points.

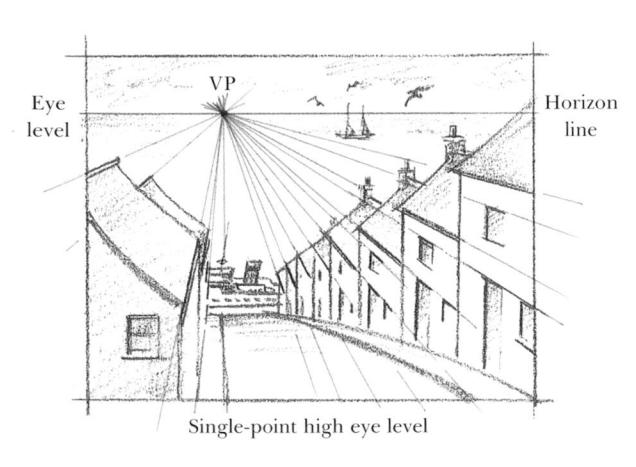

One-point perspective, high eye level

The position of your eye level will greatly affect your view of a scene. Eye level directly corresponds to the horizon, and the vanishing point is where all lines parallel to your line of vision will converge. In this example of one-point perspective, the high eye level allows you to see the bottom of the street, the sea, and the boat.

RULES OF PERSPECTIVE

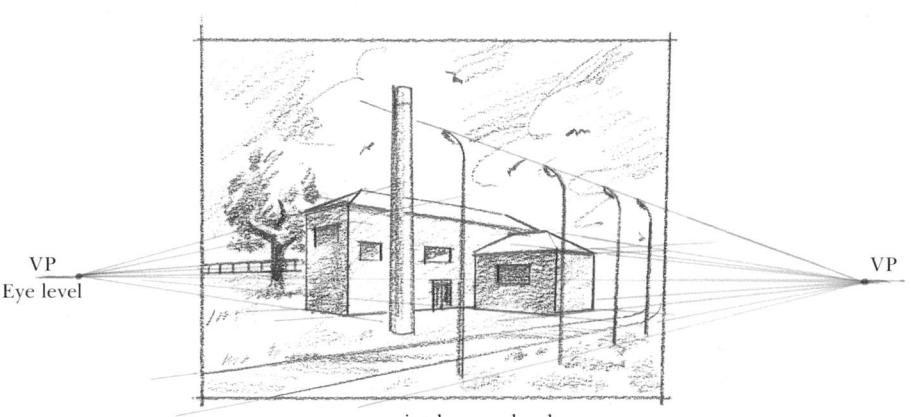

two-point low eye level

Two-point perspective

Here there are now two vanishing points because the building appears to be receding in two directions.

Three-point perspective

Tall things recede vertically as well as horizontally. In this diagram, the building is far higher than your eye level, so a new axis has been added—a vertical axis. Somewhere along this axis, the sides of the building have been projected with dotted lines to meet at a new vanishing point. Because the building is mostly above your eye level, its top edges recede downward toward the vanishing points on the horizontal axis.

Inderstanding color theory is fundamental to painting. You should have a firm understanding of primary, secondary, complementary, and tertiary colors, especially with regard to mixing.

Your starter palette should be basic and should contain a warm and cool hue for each primary, for example, lemon yellow, cadmium yellow, cadmium red, alizarin crimson, cerulean blue, ultramarine blue, and titanium white. A wide range of colors can be created from this simple selection as long as they are combined correctly. For example, many beginners make the mistake of adding black to make a color darker. In fact, this makes it appear dull and lifeless.

The term hue indicates the color value as distinct from its lightness or darkness. Tone is the quality of light and dark. For example, when a colored picture is reduced to shades of gray on a photocopier, we can see the tonal values clearly. Knowing the effects of tones and hues in oil is important, especially for layering colors and

creating light and shade. A sense of light is created by the juxtaposition of colors, and shade is also a mix of hues. You will very rarely find that the shadow cast by an object is pure black.

Oil paints come in both transparent and opaque pigments. Transparent colors can look almost black when applied straight from the tube and often need diluting with turpentine or a painting medium to reveal their brightness. To make a transparent paint opaque, simply add white. Transparent pigments make excellent glazes and can cool a painting down or add life to a painting that has become too dull. Learning how to apply glazes is essential when it comes to making the most of your oil paintings.

Colors can also be defined in terms of saturation. A fully saturated color is one used at full strength to obtain maximum intensity. Desaturation, on the other hand, describes diluting a paint to reduce its intensity. This chapter shows you when and how to dilute oil to achieve colors that are both delicate and powerful.

Primary and secondary colors

The three primary colors are red, yellow, and blue. They are called "primary" because they cannot be mixed from any other colors. Mixing red and yellow makes orange, yellow and blue make green, and red and blue make violet; these are the secondary colors. The color wheel is a convenient way of demonstrating this.

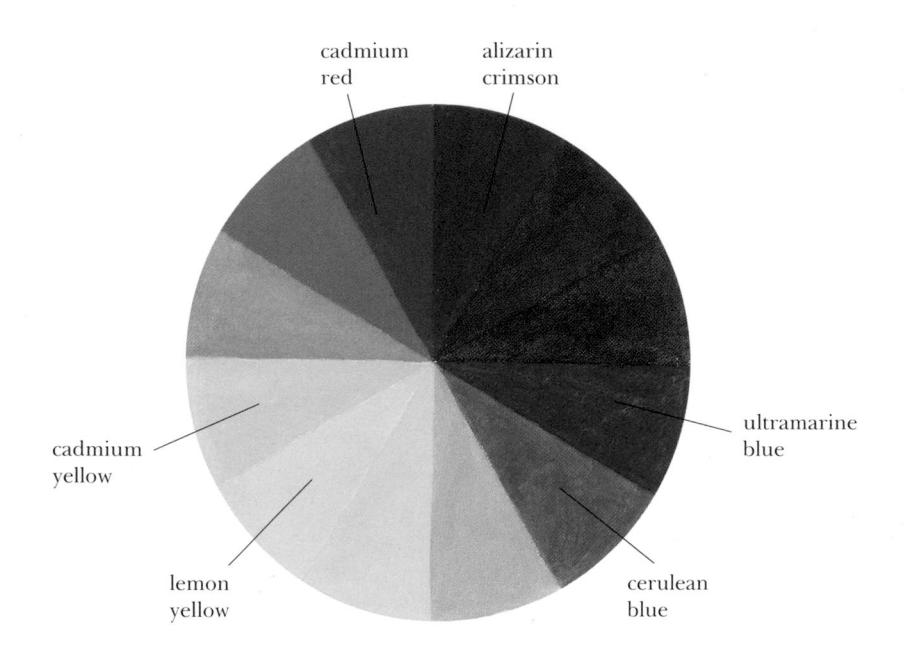

Unlike colored light, (the spectrum), the various red, yellow, and blue pigments are never pure, but always "tend toward" one another. For instance, cadmium yellow is a warm yellow that

tends toward red, while lemon yellow is cool and tends toward blue. In this color wheel two different pigments for each primary color have been used—a warm and a cool (see page 46). Two possible secondary color mixes of adjacent pigments have been shown, for instance between lemon yellow and cerulean blue there is a yellowish green and a bluish green.

Tertiary colors

Tertiary colors are browns, grays, and neutral colors, created by mixing two complementaries—in effect, by mixing the three primaries. For example, if you mix together cadmium yellow, cadmium red, and ultramarine blue, you will make brown. The exact hue of brown will depend on the proportions of the colors used—if there is more red in the mix, a reddish brown will result.

You can also create grays by mixing together any pair of complementary opposites and titanium white. If the gray appears too brown, add a little blue, green, or violet to cool it down. If it is still too warm, add blue. If it is too dark, add white to lighten it. A true neutral gray is quite tricky to mix because the colors have to be balanced so that no single color is dominant. To bring a gray back to neutrality, add the complementary opposite in small quantities until you have it right.

Blend together cadmium orange and ultramarine blue to create a brown. Each pair of complementary colors produces a range of different browns, depending on the proportion of each color in the mix.

artist's note

Colors can be categorized as "warm" or "cool." Warm colors are those on the red, orange, and yellow side of the color wheel. Blues, greens, violets, and blue-purples are broadly categorized as cool colors. Warm colors advance, while cool colors tend to recede. This allows you to create an illusion of depth and space, which is particularly useful when painting landscapes.

Mix together cadmium red and Hooker's green deep to create a rich, reddish brown. Other pairs of reds and greens will create different browns. Pair different reds with different greens to see which browns you can create.

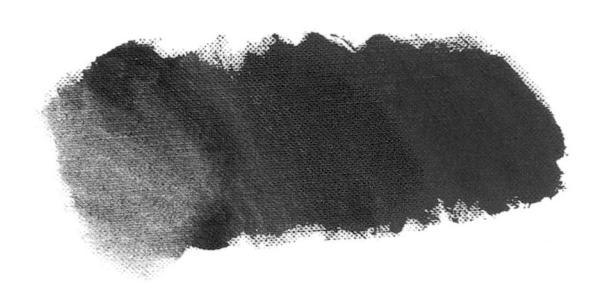

Blend cadmium yellow and permanent mauve to create a light brown. A surprising range of browns-similar to yellow ocher and raw sienna-can be mixed from these two colors.

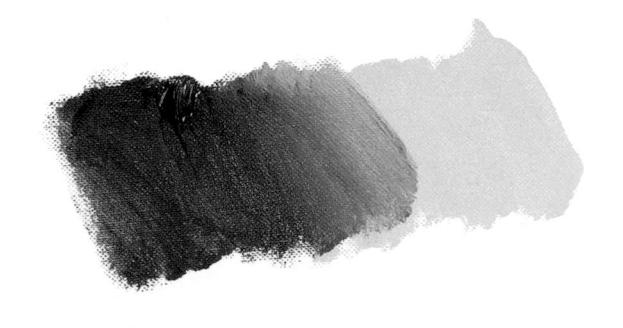

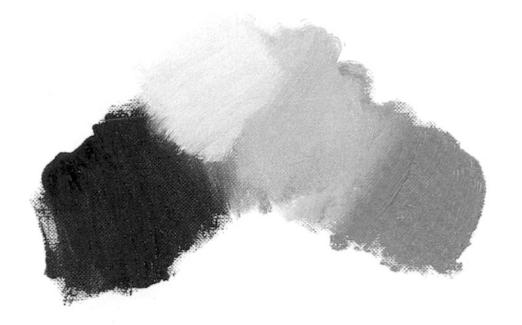

Mix ultramarine blue and cadmium orange together with titanium white to create gray. Add a small amount of white to obtain a medium or dark gray; add more titanium white to make a light gray.

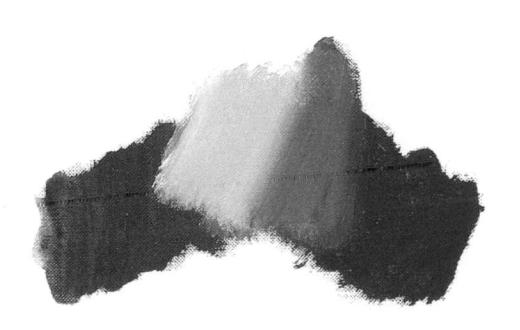

Blend cadmium red and Hooker's green deep together with titanium white. A wide range of grays, both light and dark, as well as warm and cool, can be achieved with these colors.

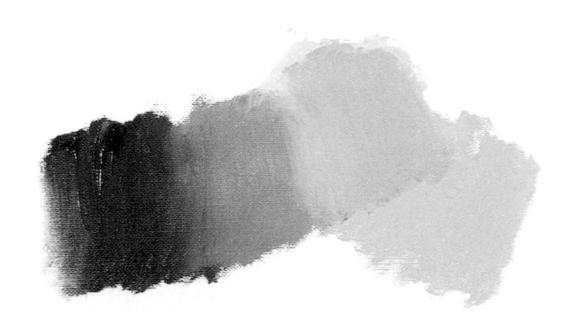

Mix cadmium yellow, permanent mauve, and titanium white. These colors make subtle, beautiful, neutral tints.

Complementary colors

There are three pairs of complementary colors, each composed of one primary and one secondary color. This means that each pair contains a balance of all three primary colors, but in different combinations. These three pairs are red and green, orange and blue, and yellow and violet, and they are easy to spot on the color wheel (see page 44) because they are opposite one another. The colors in your tubes of paint are never pure primaries or secondaries, so you need to think carefully before deciding, for instance, which green is a true complementary color to which red. Crimson is a bluish red; therefore its complementary color is going to be a green that leans toward yellow, rather than blue. A pair of complementary colors is often used to enhance a painting. Equal use of each color in a picture can result in a kind of stasis, whereas a small amount of one can energize a large area of the other.

COMPLEMENTARY COLORS

Cadmium red is an opaque pigment, so it does not need to be thinned to obtain its greatest luminosity. On the other hand, Hooker's green deep is transparent, and a thin layer will appear much brighter than a thick layer.

Ultramarine blue is transparent, whereas cadmium orange is opaque. You will find that it is not possible to mix a shade of orange from red and yellow pigments that will be quite as bright as cadmium orange.

Permanent mauve is a transparent color, and it needs to be painted thinly enough to reveal its luminosity. This pair of complementary colors has the greatest difference in tone. In a painting of a sunny beach, it's a good idea to offset hot yellows and whites with cool blues and mauves.

Blending colors directly on the canvas

When two areas of color meet on a canvas, there are all sorts of ways they can be blended together, depending on the type of brush used, the direction of the marks, and the amount of time spent smoothing out the paint.

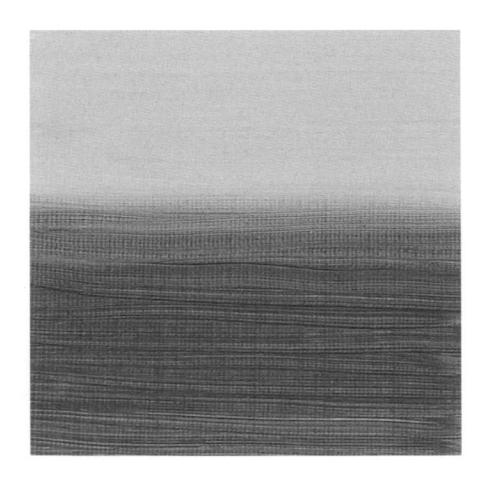

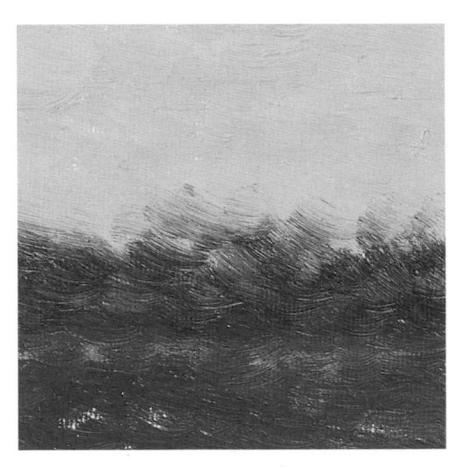

Apply both colors using horizontal brush strokes to create a smooth blend. Above, lemon yellow and cerulean blue were blended to create a green. The horizontal strokes produced a soft, unfocused effect, ideal for merging the colors of a sunset or for creating the hazy appearance of mist. This is also a useful technique for blending two shades of the same color, such as where a shadow gradually darkens an object.

Apply two colors with loose, irregular brush strokes to create a rough blend. Above, cerulean blue and lemon yellow are roughly blended together to produce this lively impression. This technique would be useful for creating the effect of spray from waves or wisps of cloud in the sky. This is also a useful technique for lightly blending two shades of the same color, such as where there are many shades of green in foliage.

BLENDING COLORS DIRECTLY ON THE CANVAS

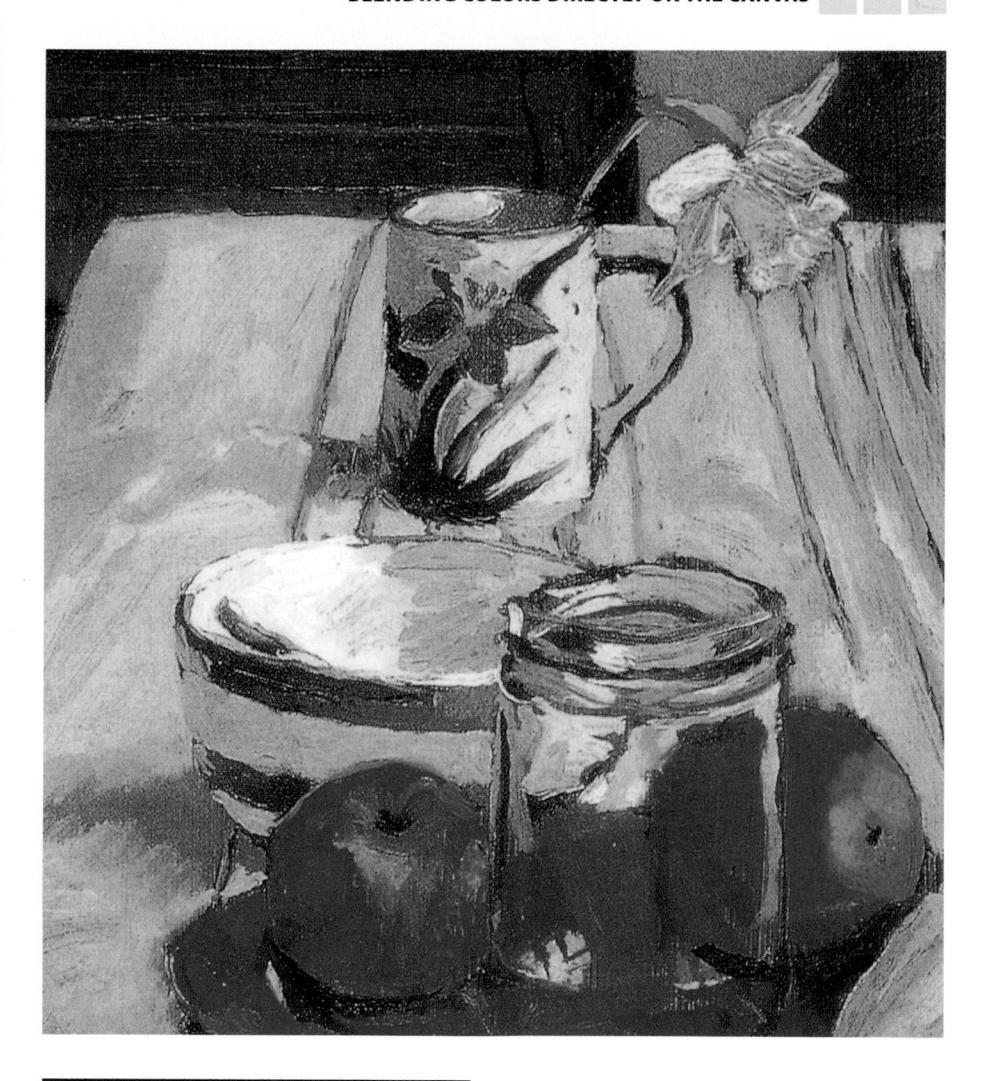

In this still life, notice that the careful blending of the green and red on the apples gives them shine and makes them appear rounded. Similarly, the blending of whites and grays creates a subtle shade change and denotes the curve inside the bowl.

Choosing a background color

The visual impact of a color is dramatically affected by the colors around it. White backgrounds tend to mute pale hues and overstate darker ones. Select a colored background that works with your subject, contrasting positively with it. Contrasts can be tonal (light and shade), chromatic (color value), or both, but they should neither overpower the subject of the painting nor make it too stark.

On a white ground, the dark brown petals stand out sharply, but the yellow gets lost because it is both tonally and chromatically close to white. The green petals are neither too sharp nor too soft in contrast.

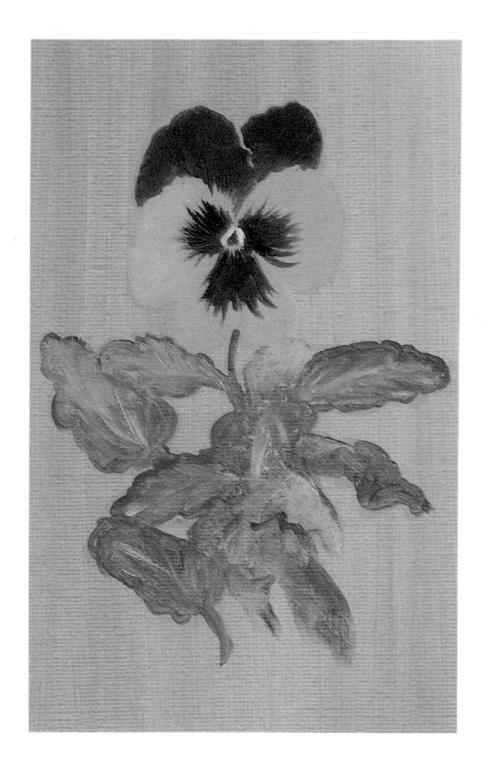

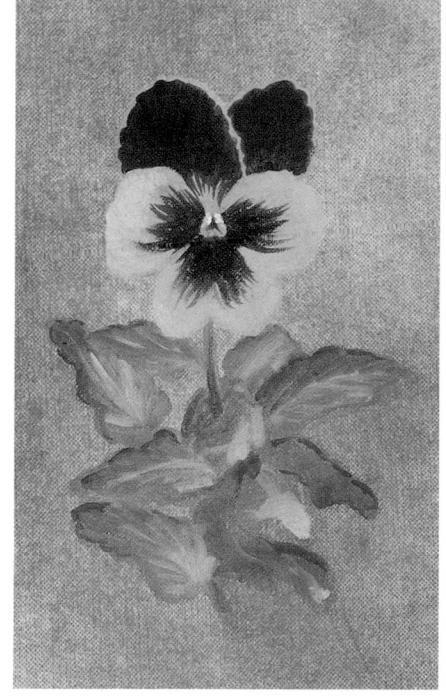

On a yellow ocher background, the cadmium yellow flower almost disappears; only the dark brown is visible.

A pale permanent mauve background contrasts chromatically with the yellow petals. This has a more dramatic effect than the white or yellow background.

UNDERSTANDING AND MIXING COLOR

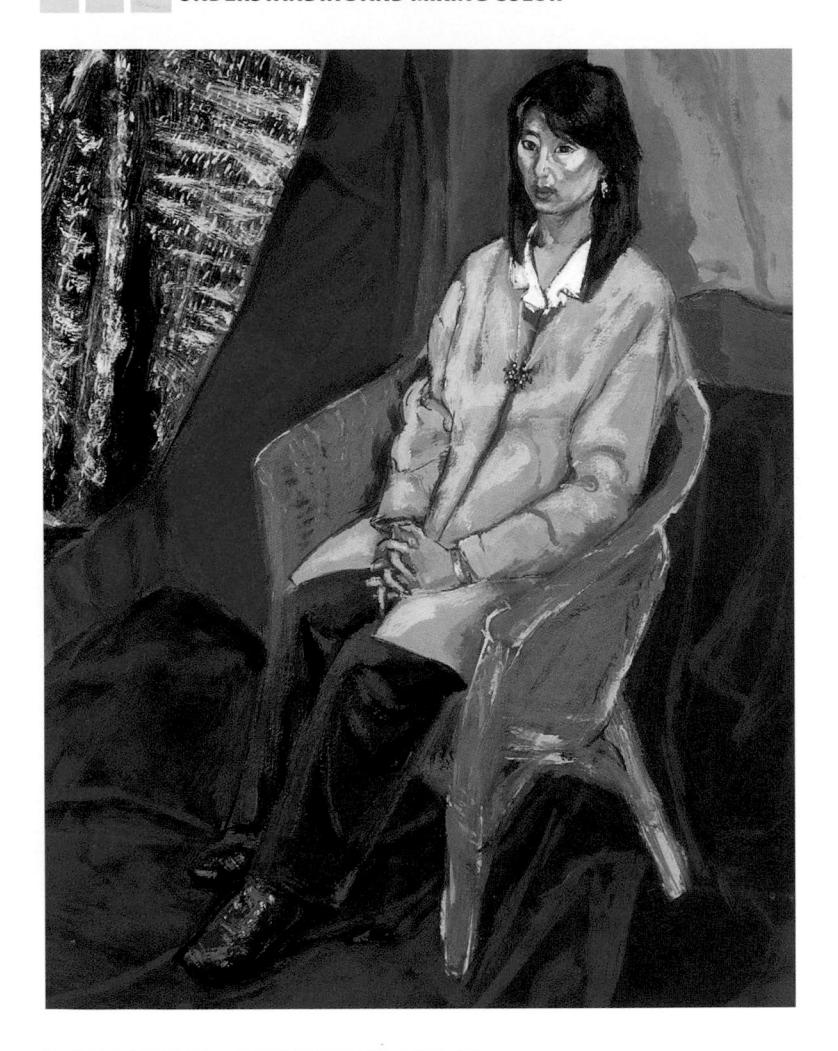

The palette for this colored background consists of strongly contrasting colors and shades, integrating the model with her surroundings. Warm/cool and light/dark contrasts are beautifully balanced. A bright ultramarine underpainting shows through here and there between the warm colors of the portrait, further enriching the colors.

Using a glaze

A glaze is a layer of thin, usually transparent paint, brushed over another, dry, layer to alter its color. Glazes can be used to enrich or tone down the color beneath. Build up layers of glazes to create bright or deep glowing colors and make the painting shine. Mix the paint with a glazing medium—fast-drying alkyd medium is available in art supply stores—or mix a homemade glaze with equal parts of linseed oil, turpentine, and dammar varnish. This mixture can be further diluted with more turpentine, up to about four parts turpentine. Use a soft brush rather than a stiff bristle, so that the brush marks do not show. As with paint, the golden rule is to work from "lean to fat." This means first layers should contain less linseed oil than subsequent ones.

Dust your charcoal sketch with a piece of cotton wool to keep any loose particles of charcoal from dirtying the glazes. Leave only a ghostly impression that will disappear into the paint layers as the picture develops.

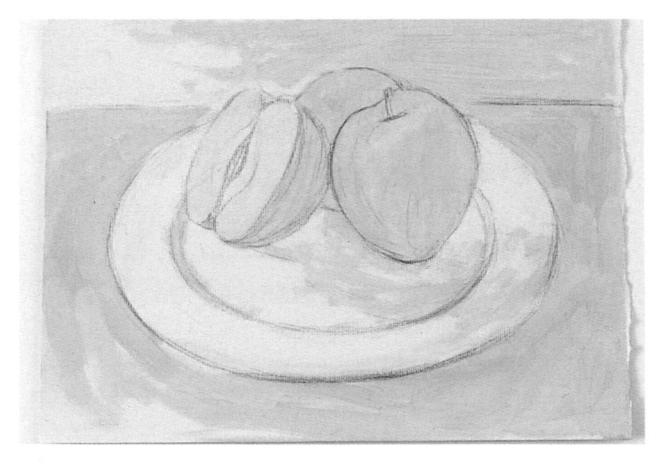

Start with a lemon yellow glaze diluted with glazing medium and a little turpentine. Paint the background, apples, plate, and table which will become brown and green after further glazes are applied.

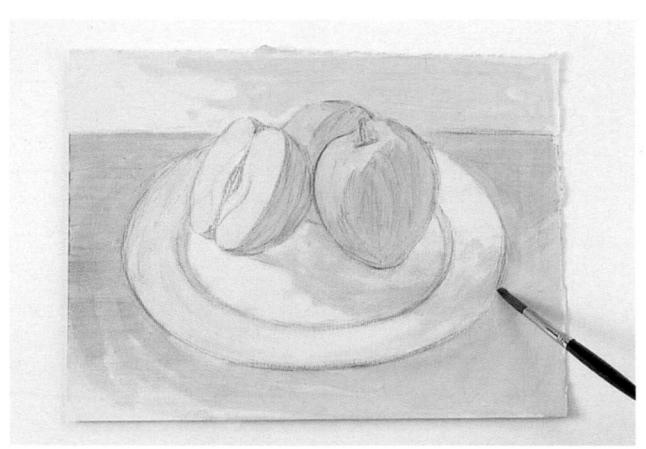

Once the first glaze has dried, apply a second glaze to the shaded side of the apples and plate using a mix of cerulean blue and glazing medium. This will react with the yellow glaze to create a green.

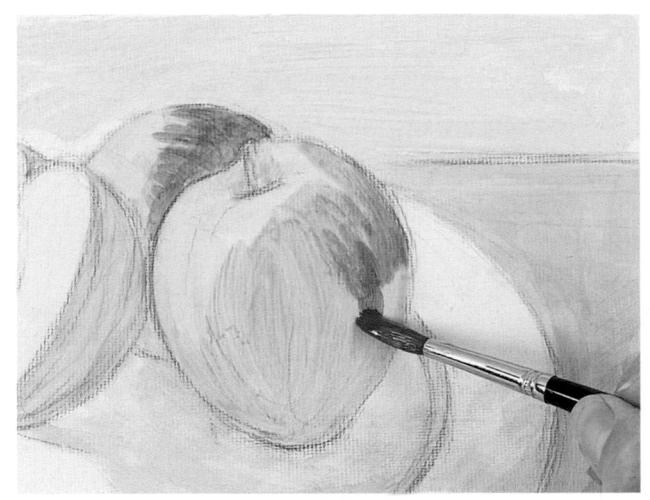

Tint the apples with cadmium red thinned with glazing medium. To produce the illusion of volume, brush the glaze in a different direction from the blue glaze applied previously.

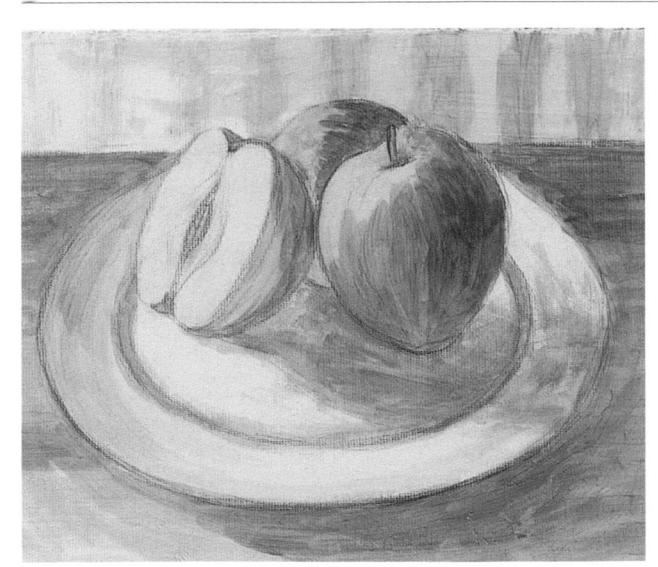

Although the painting at this stage has received three glazes, it still looks too pale. You need to add further glazes to make the colors richer.

UNDERSTANDING AND MIXING COLOR

Add a second, stronger, glaze of cadmium red deep to develop stripes on the apples and to darken the table top. Apply glazes thinly to avoid a "sticky" looking surface. If the result is too pale, add more paint to the mix. But always add glazing medium to each paint layer and allow it to dry before applying the next.

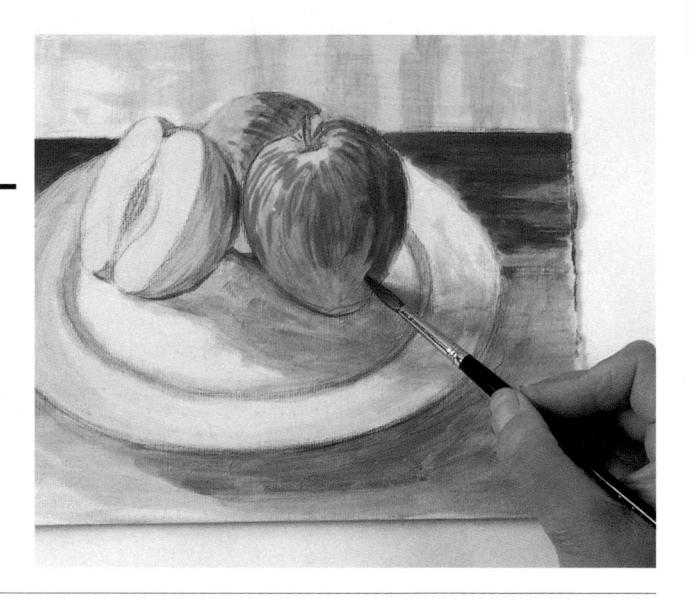

Apply a final glaze of ultramarine to deepen the shadows. This will help create a sense of depth and three-dimensionality.

artist's note

Some common transparent pigments are aureolin yellow, lemon yellow, Indian yellow, scarlet lake, alizarin crimson, permanent rose, carmine, crimson lake, magenta, permanent violet, Prussian blue, indanthrene blue, French ultramarine, indigo, monestial turquoise, alizarin green, sap green, Hooker's green, viridian, transparent gold ocher, raw sienna, burnt sienna, brown madder, and burnt umber.

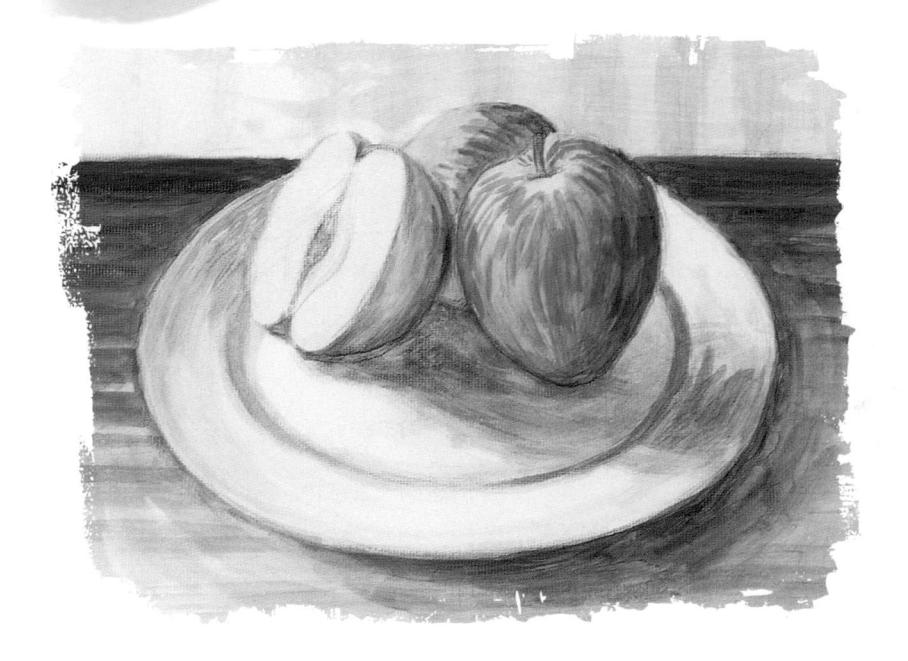

In the finished painting, notice that the charcoal drawing has disappeared underneath the glazes. However, the glazes glow through one another, adding depth and life to your painting.

Glazing over a textured surface

Glazes are a little like colored glass in that they are transparent, allowing light to penetrate. Oil glazes can be used over textured paint surfaces—created either with acrylic texture paste or with thick oil paint that has been allowed plenty of time to dry—to alter the depth of hue in the pigments and add to the visual impact of the textured surface.

Use a tough brush, such as a hog bristle, to apply a glaze over a rough texture. A more delicate hair brush will get damaged. In this example, cadmium orange mixed with glazing medium is brushed over an acrylic textured surface, using a round hog brush. Because the paint is already heavily textured, you can apply these glazes quite roughly.

artist's note

A good mix for a glazing medium would be 1 part linseed oil, 1 part dammar varnish, and 1 part pure turpentine. Combine these ingredients in a screw-top jar. Pour some of the mixture into a small painting cup, and dilute the mix further with more turpentine for the first layer of glaze, less on the next, and so on. If you are applying a glaze over a thick layer of dry paint, the glaze should contain a little more oil than the layer before it.

The glaze transforms the color of the texture paste from a dull beige to a glowing burnt orange, giving it a rich, glossy finish.

Selecting your glaze

Some glazes enrich colors, others tone them down. A glaze can make a sky more intensely blue or a sea more deeply green. A translucent or semi-opaque glaze (one made with an opaque pigment, such as cadmium red or titanium white) can produce a milky or veiled effect. The choice of pigment for a glaze is important because some are already transparent by nature, whereas others are inherently opaque.

artist's note

A translucent glaze of titanium white and alkyd medium brushed over the crimson vein of a leaf produces a pale, bluish violet. As well as lightening a color, a pale translucent glaze over a darker color will appear to cool it.

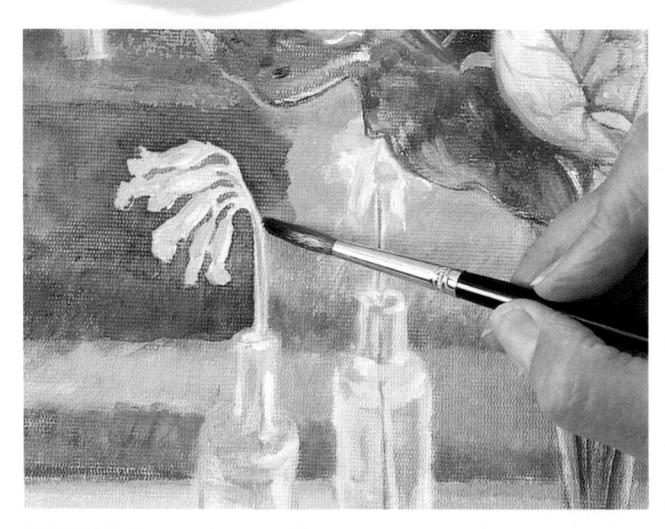

Tone down the middle ground with a glaze of permanent violet. Stroke the glaze thinly across the surface with a round sable brush.

SELECTING YOUR GLAZE

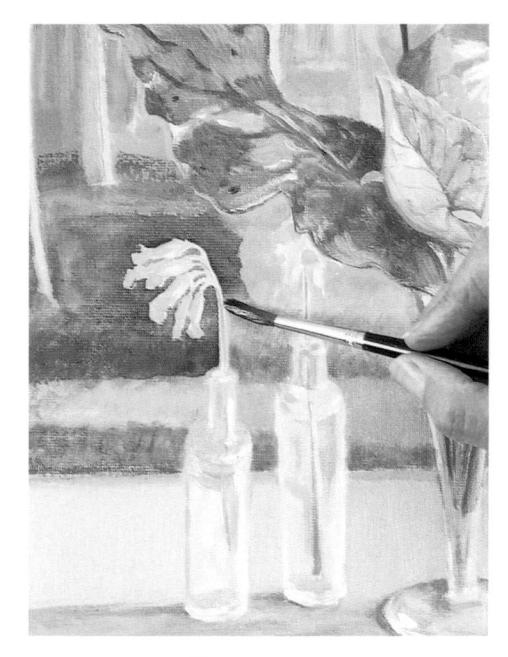

The half-completed glaze shows the dramatic change of emphasis it can achieve.

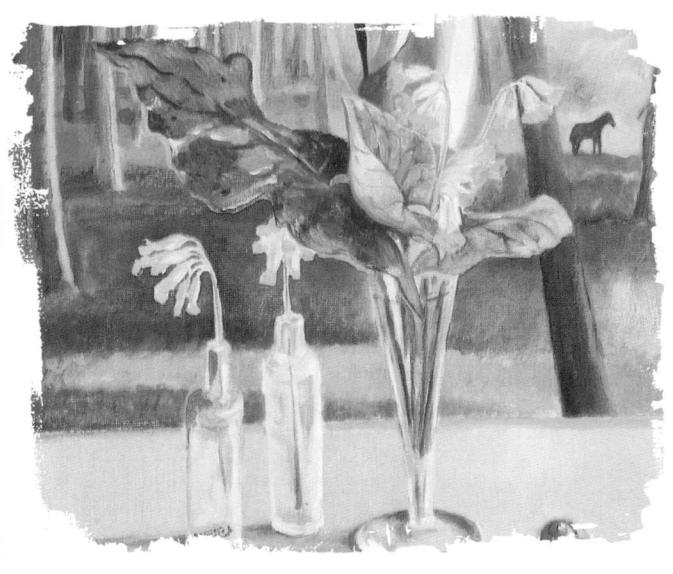

The completed picture shows the yellow cowslips glowing against the darker middle distance, painted with their complementary color, violet.

Demonstration: Poppy landscape

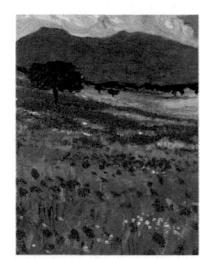

Many painters adore using a rich, colorful landscape as a subject in oil. The range of colors and tones in nature allows for vibrant hues and interesting brushwork. In this example, *impasto* painting with a brush and a knife creates the varied textures of the

landscape, while glazes are used to cool some areas of the painting without reducing the overall impact of the vibrant color of the poppy field.

Lay down a blue ground of ultramarine thinned with painting medium, and use the same color to draw the outlines of the elements.

DEMONSTRATION: POPPY LANDSCAPE

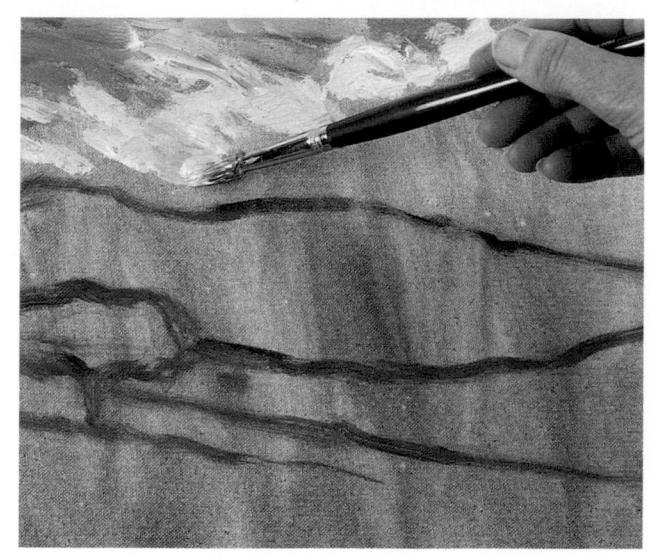

Mix *impasto* medium (see page 33) with all the colors to make them really thick. Paint the sky with a mix of ultramarine, raw sienna, and titanium white. Apply the paint generously with a filbert hog and loose brush strokes. Then add more white for the clouds.

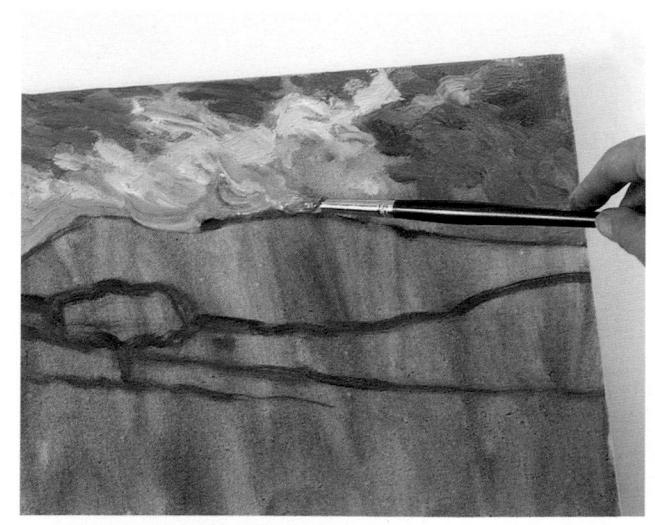

Add a little permanent mauve to the previous mix, and swirl this into the color already applied to imitate the movement of the clouds.

UNDERSTANDING AND MIXING COLOR

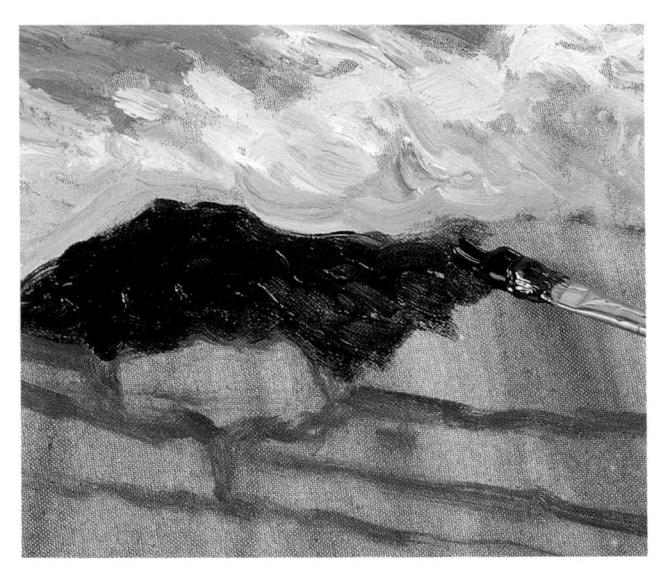

Paint the hill with a mix of alizarin green, Hooker's green, and *impasto* medium. Use rough brush strokes to keep texture in this dark expanse of color.

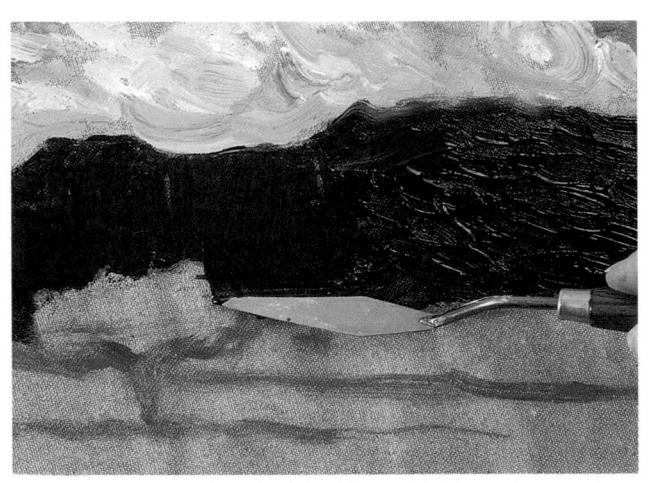

Smooth out the paint on the hill with a palette knife to remove the obvious brush strokes. This area should be smoother than the trees below, to differentiate it from the rest of the landscape, but it should not be a sheer flat area of color.

DEMONSTRATION: POPPY LANDSCAPE

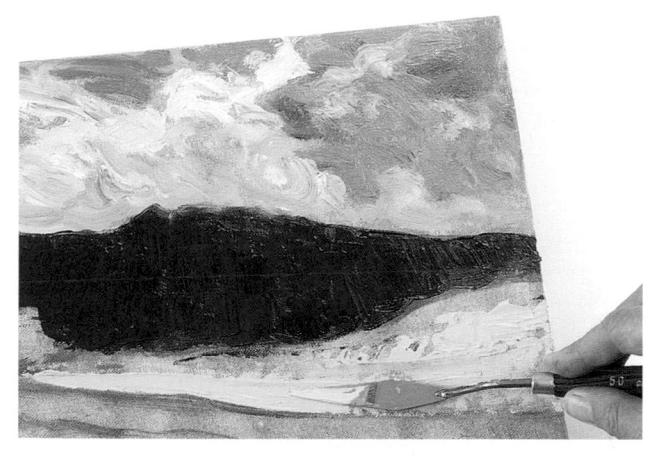

Clean the knife with a cotton rag; then mix lemon yellow with a little Hooker's green and white for the distant field. Drag the color across the canvas with the flat of your knife.

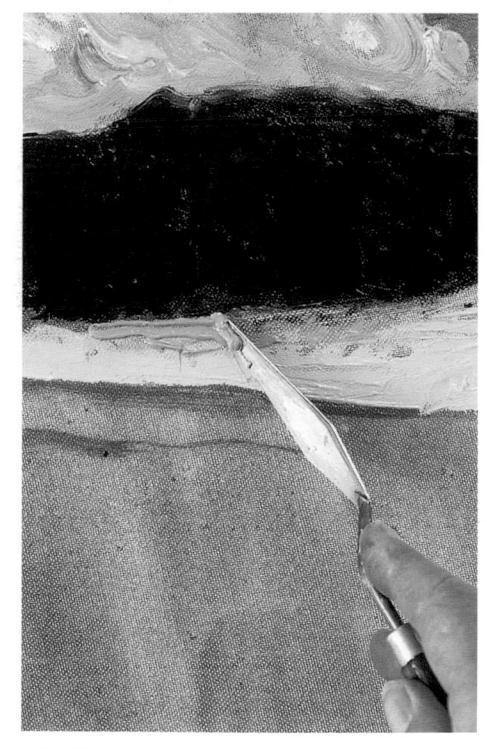

If you make any mistakes, scrape off the paint with your palette knife.

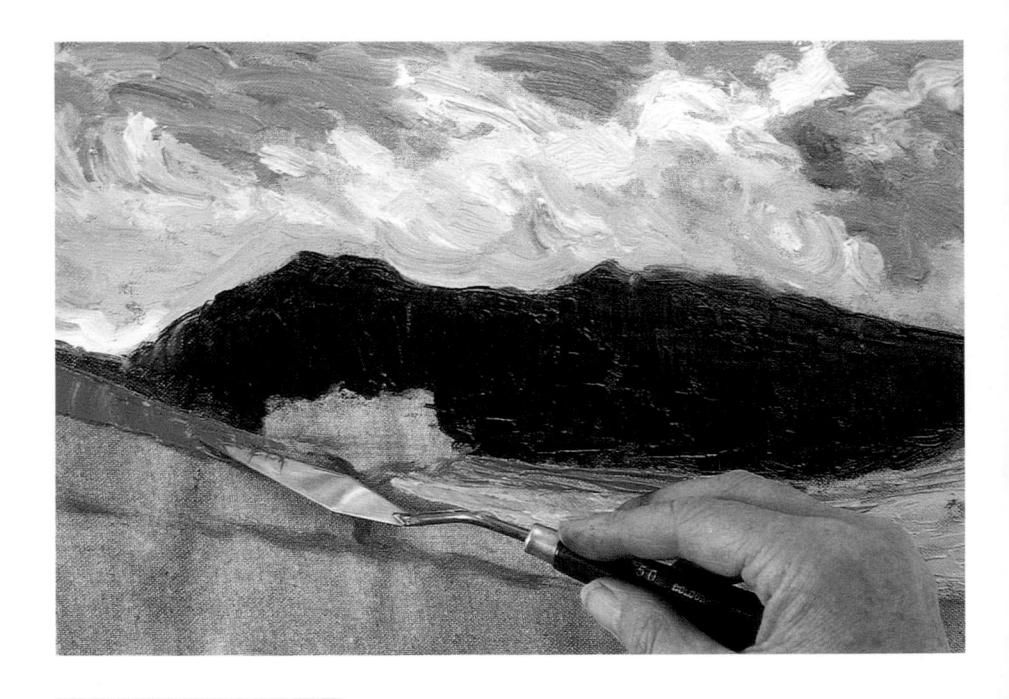

Mix a darker shade of yellow using raw sienna with a little cadmium red deep and Hooker's green. Apply the color over the existing bright yellow.

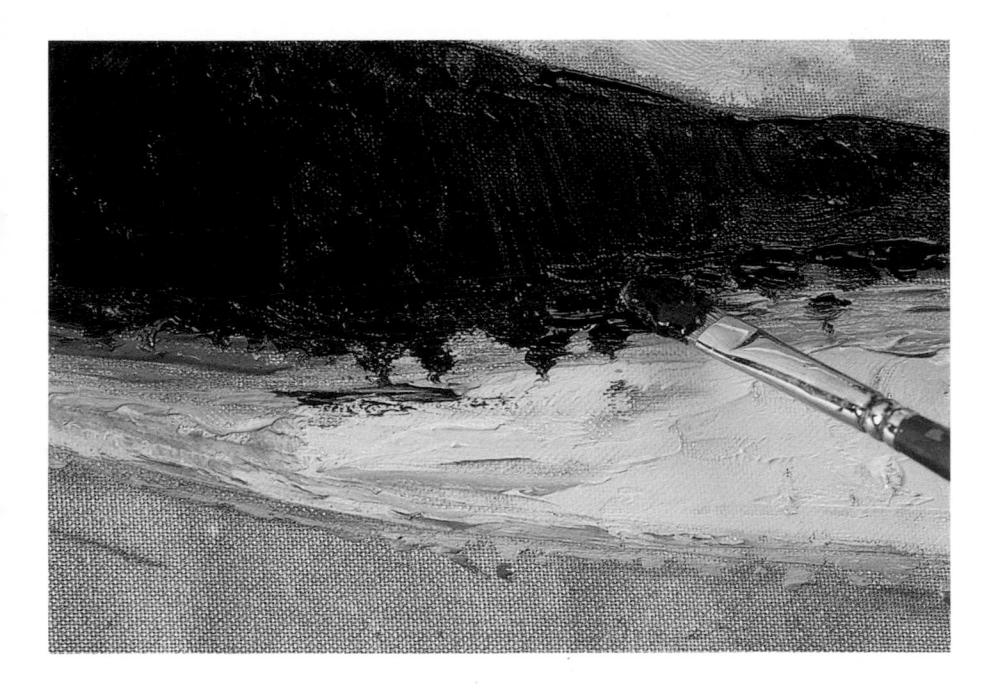

Mix a dark green from Hooker's green deep and alizarin green for the distant trees. Then add a little cadmium red to warm and darken the greens.

UNDERSTANDING AND MIXING COLOR

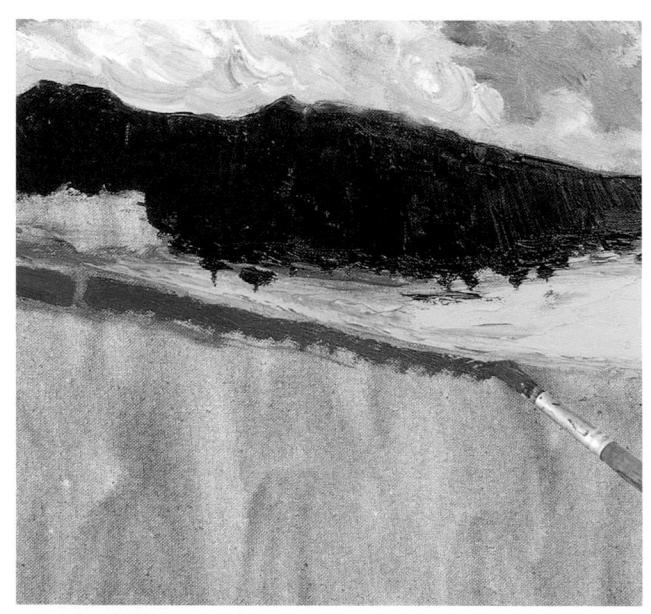

Paint the distant poppies with a mix of yellow ocher and cadmium red using a round hog brush. Apply the paint in horizontal strokes, and loosen the brushwork as you work toward the foreground.

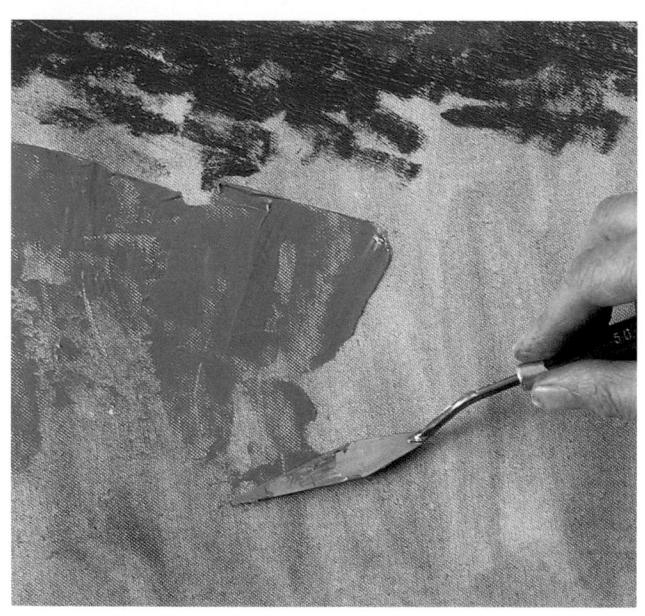

Apply broad vertical strokes of lemon yellow, Hooker's green, and a bit of white with the knife. You need to cover the foreground with a generous layer of paint as a base for other colors you'll add later.

DEMONSTRATION: POPPY LANDSCAPE

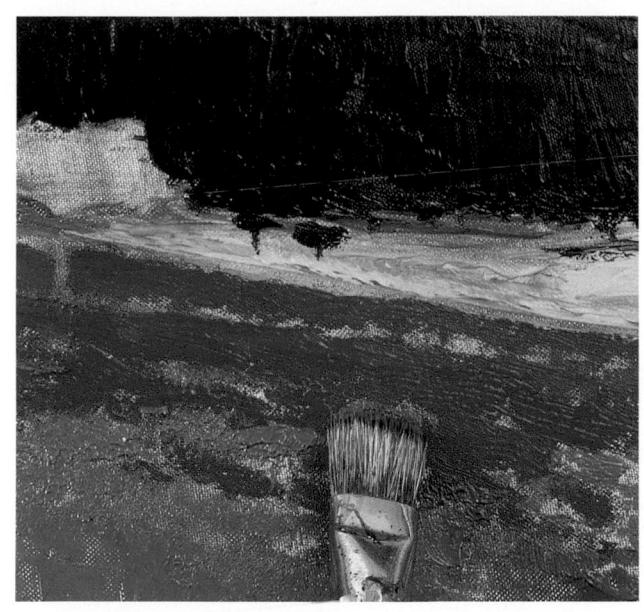

Stipple some of the foreground color into the poppy red in the middle distance. Use an old flat hog brush to get an uneven covering so the red will show through in places.

13 Drag the same green mix over the earlier knife work to create a rough texture suggesting grass.

UNDERSTANDING AND MIXING COLOR

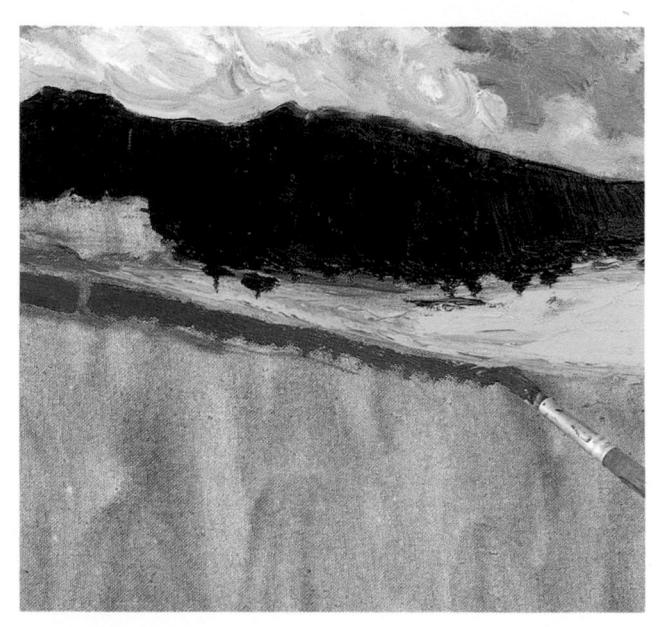

Mix a paler tint of green with lemon yellow, Hooker's green, and titanium white. With the edge of the filbert brush, paint short vertical strokes to create the grasses in the foreground.

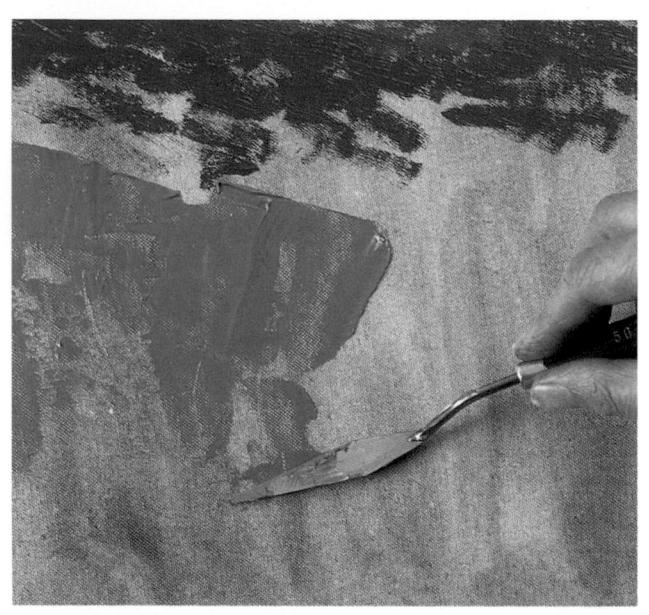

At this stage, the painting has a sense of depth, with the dark greens in the distance drawing the eye deep into the picture.
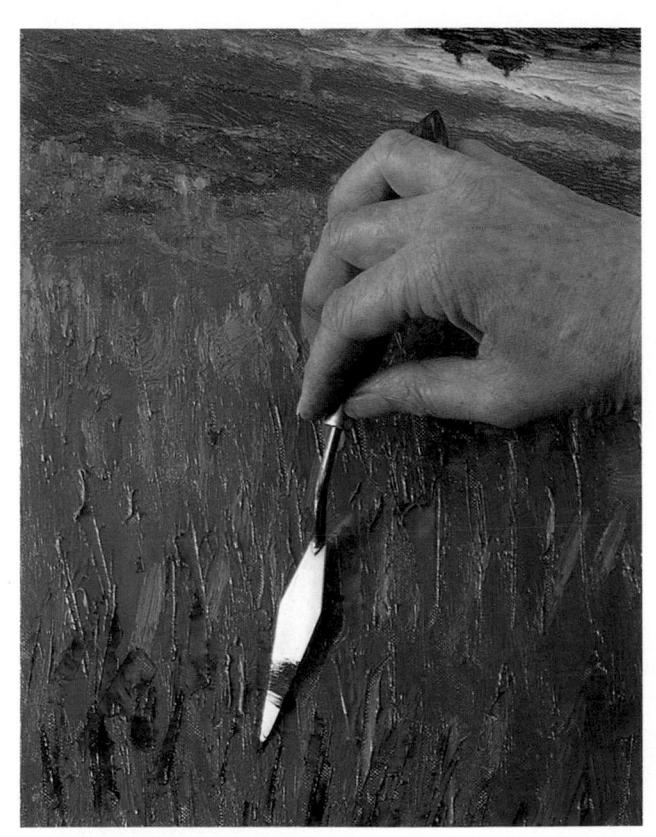

Mix a darker green using Hooker's green deep and a touch of cadmium red. Use the edge of your palette knife to make small vertical strokes to indicate areas of shadow between the clumps of grass.

UNDERSTANDING AND MIXING COLOR

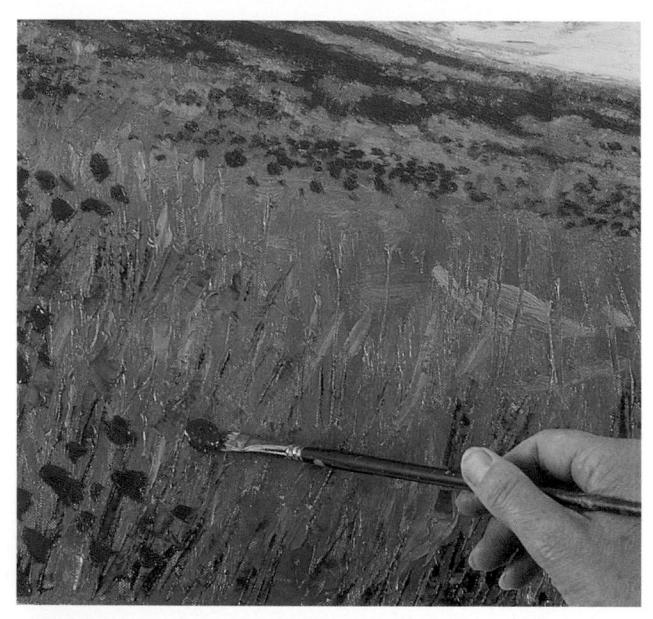

Paint the poppies with cadmium red using a small filbert. Vary the size and shape of the strokes as you paint deeper into the picture space. Carefully adjust the size of the most distant strokes so they merge with the bands of red painted earlier.

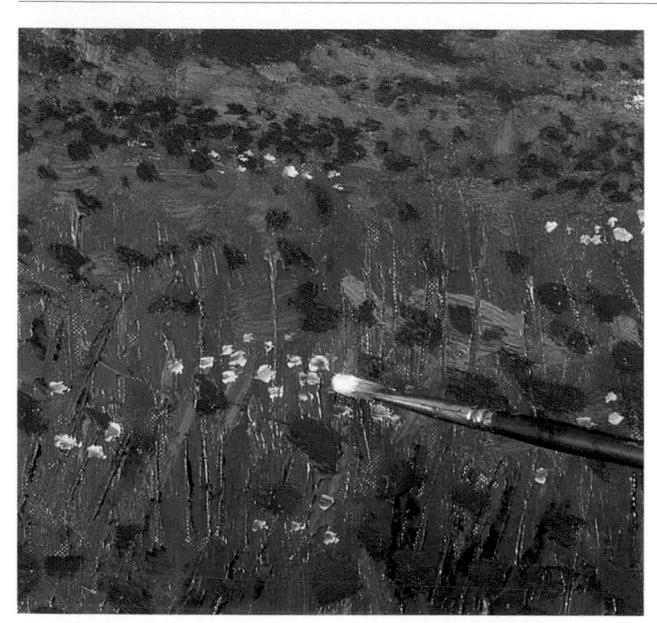

Use the edge of a filbert brush to paint white daisies with a mix of titanium white and *impasto* medium. Make the marks smaller and less clearly defined the farther away they are.

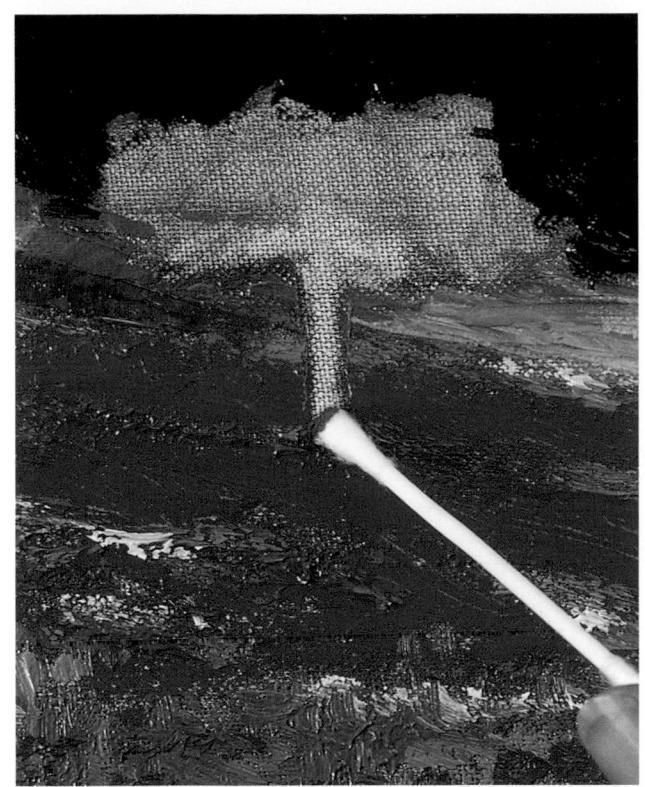

Clean the paint away from the trunk of the large tree with a cotton swab dipped in turpentine. This will give you a clean area so the next color won't get muddy.

Paint the tree with a mix of Hooker's green deep and a little lemon yellow and cadmium red. The tree needs to be dark, although you don't want it to unbalance the whole painting. Rather than darken the tree, adjust the hue of the hill.

Wait until the hill is dry, and then apply a semi-opaque glaze of ultramarine, permanent mauve, and titanium white to push it back in the picture space and separate it from the tree. Apply it roughly so that the brush strokes give it texture.

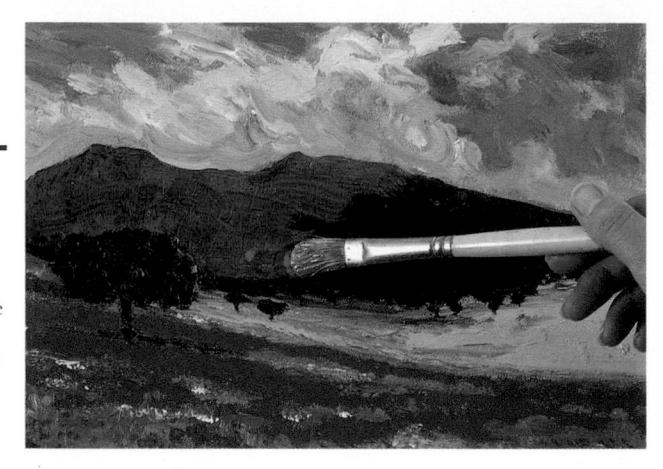

At the moment, the yellow of the field is too sharp. Balance this area with a thin layer of cobalt blue glaze over the left-hand side of the field. This will make the field recede in the picture.

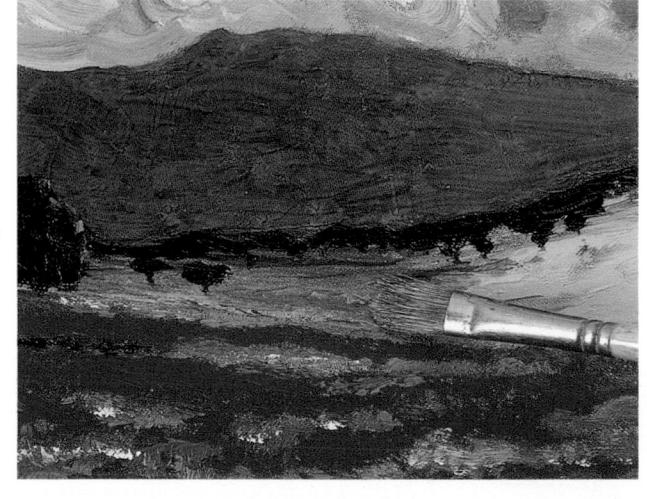

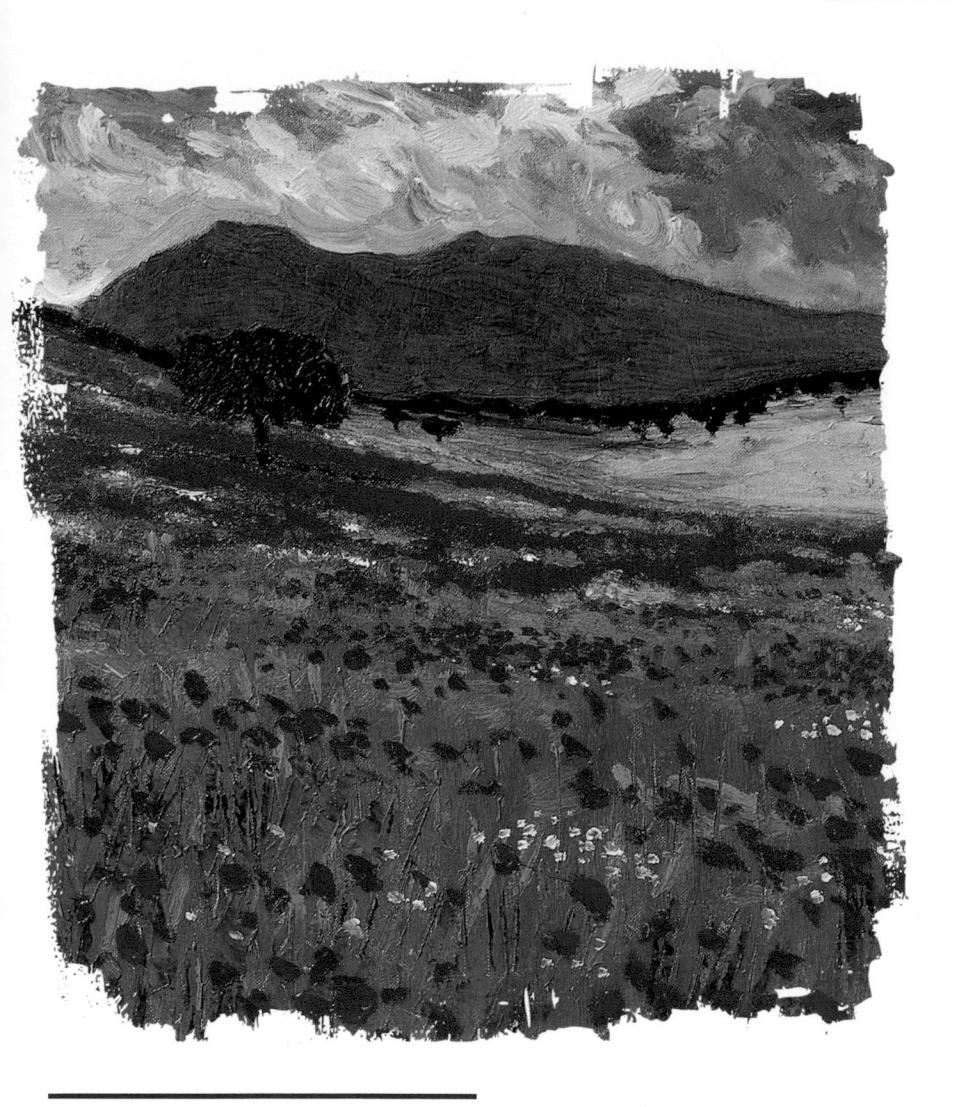

The hill is now paler and more blue, distinct from the row of trees at the far side of the yellow field. The blue glaze has pushed it back a long way, introducing a sense of depth using atmospheric perspective (see Chapter 4).

A still life is one of the most popular and rewarding subjects for oil painting. Unlike landscapes and portraits, where the subject matter moves or is prone to changes in light, a still life offers an artist complete control over composition, lighting, subject, and time—a bowl of fruit does not get tired or have to change positions. However, a still life requires just as much careful composition and attention to detail as any other subject.

The objects in a still life usually occupy a small space, making these paintings essentially intimate. As soon as one object is joined by another, a relationship is created between their colors, forms, light and shade, texture, scale, and proximity. The relationship can be close or distant, depending on

the nature of the objects and where they are positioned in the picture.

Objects displace space; so setting up a still life is a contemplation of the interaction between space and form. Begin simply, with perhaps just a couple of pieces of fruit on a plate. Look at the relation of the objects to one another, the spaces created between them, and the spaces created by the edges of your picture-space. Try to construct a still life with echoing shapes and related objects, so that the viewer's eye is led around the canvas from one focal point to another without visual jarring.

As you master the genre you will find that there is an opportunity for endless variety in your compositions.

Selecting the best format for a still life

The format is often dictated by the objects in your still-life arrangement. Set up your still life, and then make a simple viewfinder with two small L-shaped pieces of card fixed together with paper clips to create a rectangle.

Hold this viewfinder a short distance from your eye to frame possible formats. Looking through a small frame in this way allows you to see a number of interesting compositions. You can also adjust your viewfinder to a landscape, portrait, or square format. Observe the height and shape of your objects, and select a format that makes your composition visually interesting.

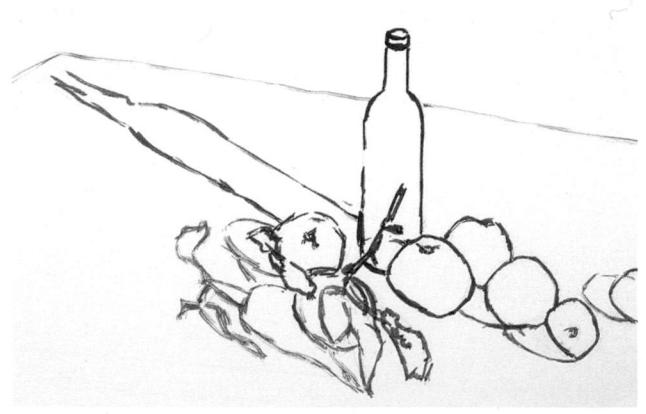

This brush drawing of a still life includes the objects and their shadows in a long, horizontal format. The bottle is placed in the center of the composition, which is not the best use of the picture space because it divides the composition too rigidly in half.

SELECTING THE BEST FORMAT FOR A STILL LIFE

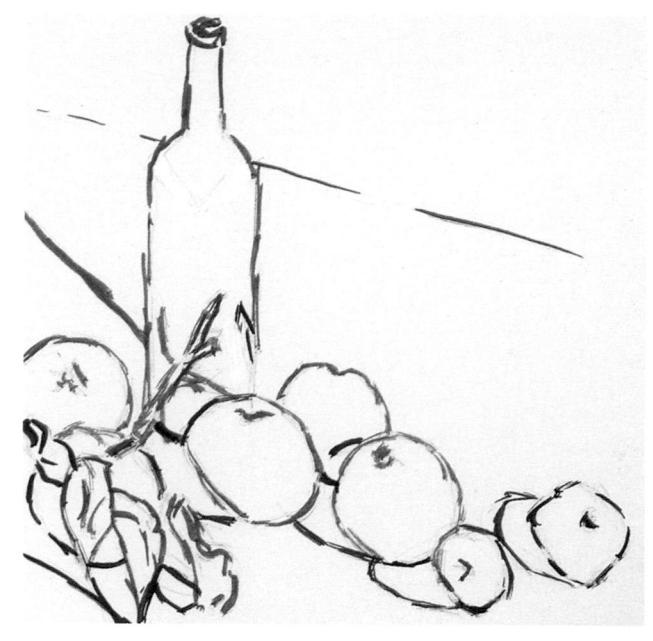

In this square format, the bottle is to the left, and the apples spread across the foreground in a pleasing, gentle diagonal. This is a formal, calm composition that draws the eye in a sweeping curve from the top of the bottle to the right-hand apple.

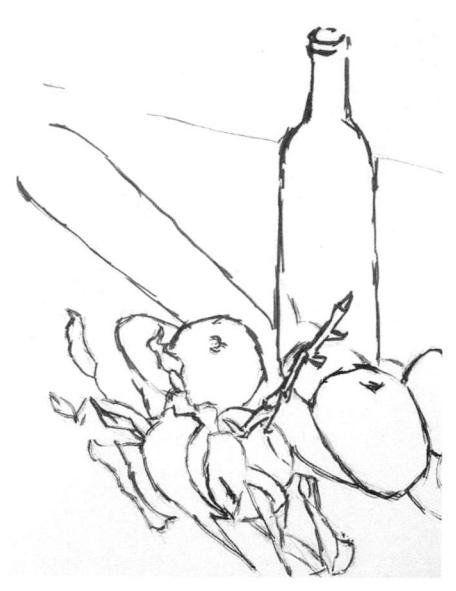

In this study, the format is a vertical rectangle, commonly called "portrait format." The bottle is now on the right, leaving space for its shadow to take the eye toward the top-left corner of the picture space, creating a more dynamic composition.

Giving objects a believable three-dimensional form

Three-dimensional form is created by the play of light and shade. Any object can be given depth if it is rendered with both a lit and a shaded side and given a cast shadow—one cast by an object onto a surface. Observe the objects carefully, noting where the light and shade fall and how gradually the tones move from light to dark.

Gradual darkening usually denotes a curve, whereas a sudden shift from light to dark is most likely to occur at a hard edge. You may find it easier to see these effects if you light the objects with a spotlight so the shadows are very pronounced.

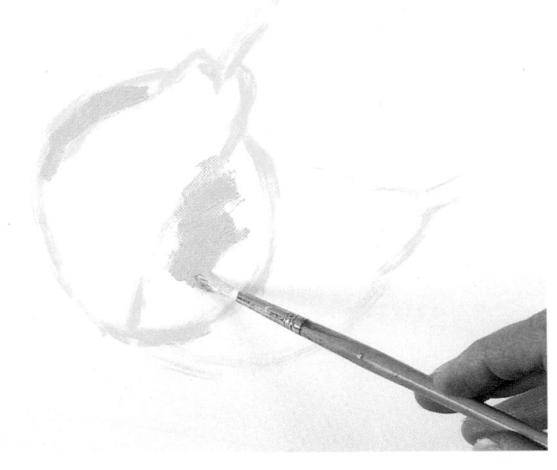

Draw the outline of the pear using one of its palest colors. Placing a heavy edge on the light side is a common error and renders an object more two-dimensional. Block in the pear with mid-tones, palest where the light hits and darker in the shadow.

GIVING OBJECTS A BELIEVABLE THREE-DIMENSIONAL FORM

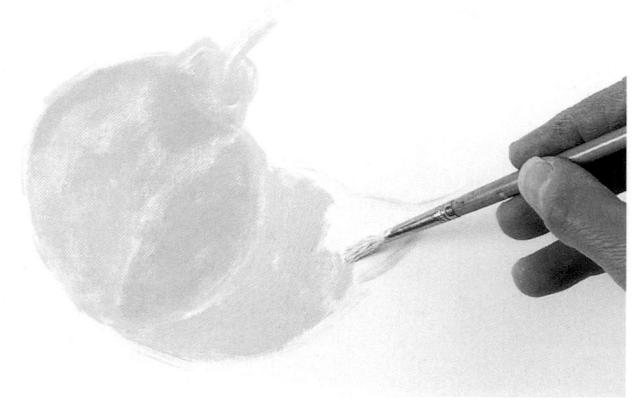

Next block in the cast shadow. The color of the shadow will give an impression of the quality and brightness of the light; the shape of the shadow will suggest the position and direction of the light source.

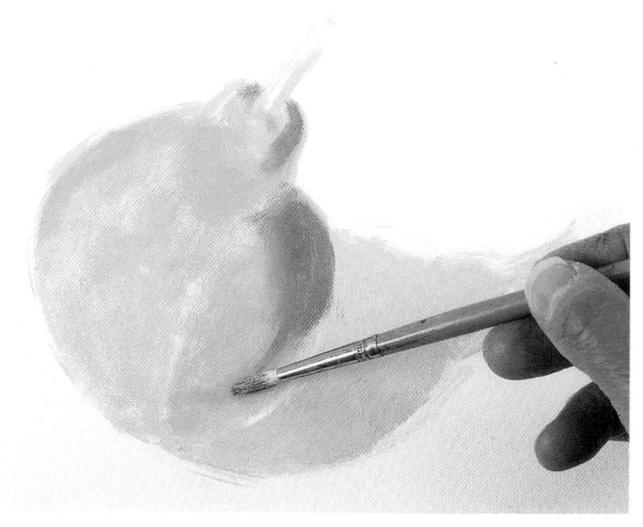

The shadow sides of objects are not usually one color, nor are they necessarily simply a darker version of the color in the highlights. To give the sense of a curved surface, gradually lighten the shadowed color of the object slightly as you paint toward the light.

COMPOSING AND PAINTING STILL LIFE

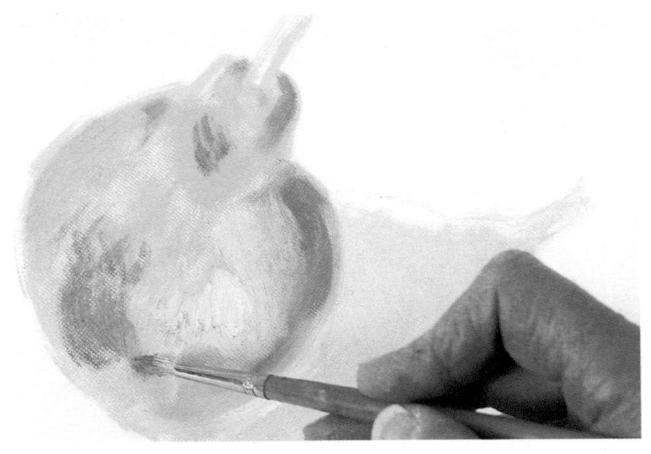

Now paint the areas that are neither fully lit nor fully in shadow. The movement from dark to light will create the form of the object. Note here that the underside of the pear is not the darkest area, as some light is reflected back onto it from the tabletop.

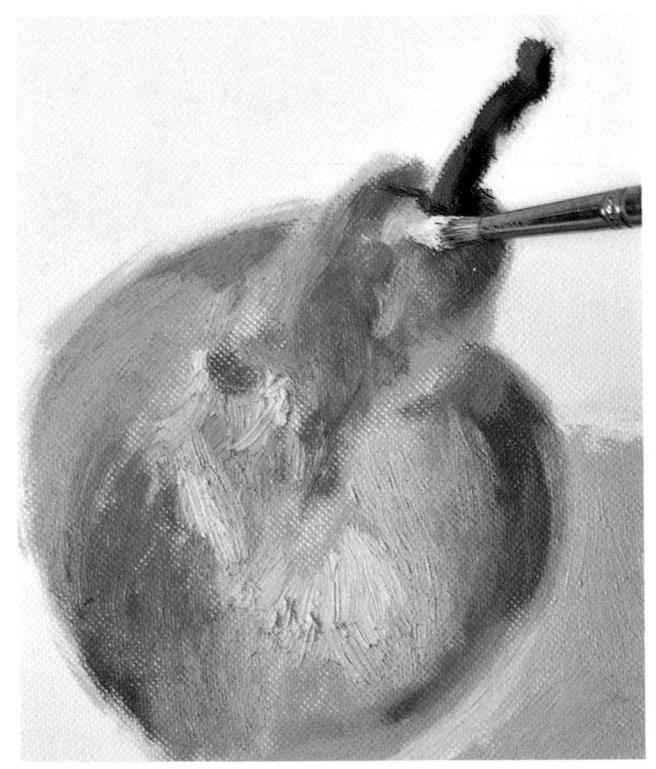

Add highlights to the areas where the light is strongest. Once the body of the pear has a three-dimensional look, turn your attention to the stem. The same rules apply, but the colors will be darker.

GIVING OBJECTS A BELIEVABLE THREE-DIMENSIONAL FORM

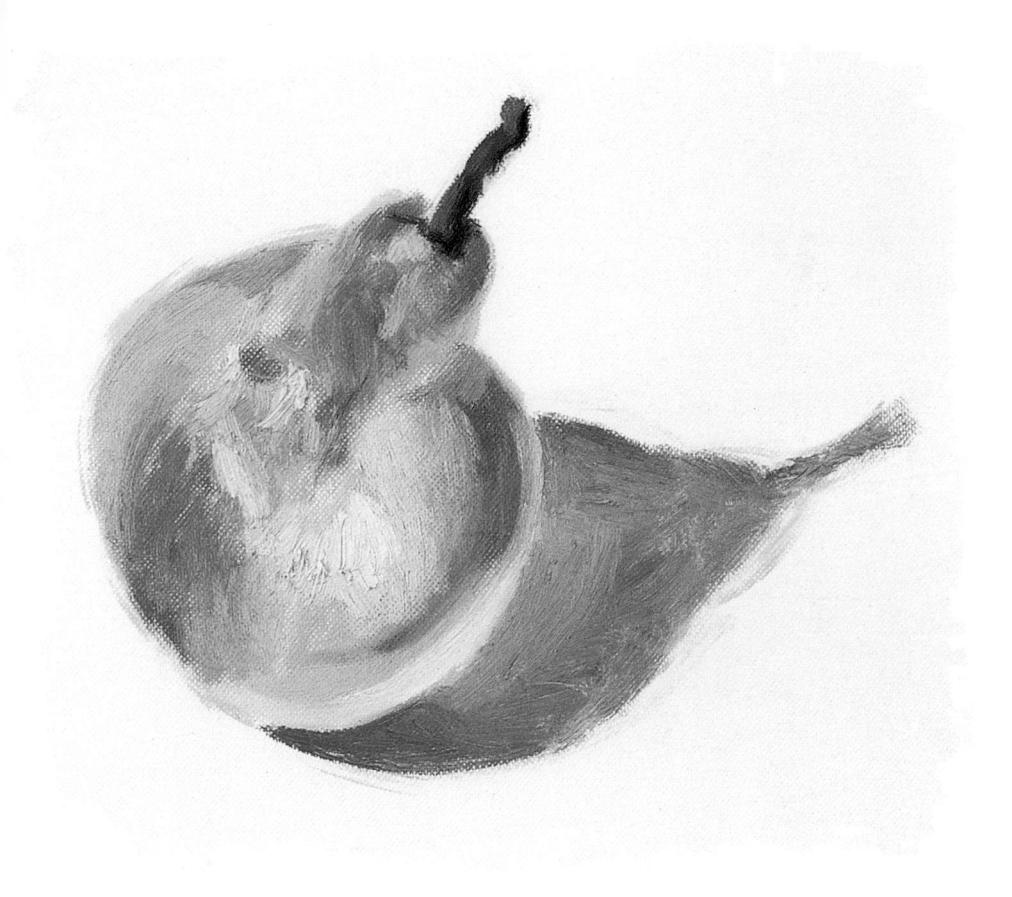

Finally, paint the cast shadow directly under the object. Gently blend the colors of the shadow to show that it gets lighter the farther from the object it is. Be subtle—too much contrast from light to dark in the shadow will look unnatural.

What are negative spaces?

Negative spaces are the gaps between objects. Often, too little attention is paid to negative space because the focus is on the objects themselves. However, these spaces link one element of a composition to another, and so they need careful scrutiny.

When you are organizing a composition, pay equal attention to all its parts, whether or not they contain something tangible. The shapes created by negative spaces are as precise as the shapes of any solid objects, and they help define the objects' forms. Practice painting only the negative spaces in a composition to see clearly how the shapes of the objects are revealed.

In this study of a small glass and two bottles, the negative spaces between the objects have been blocked in with rose madder without any outline sketch. The objects appear as white cutouts, yet their shapes are clearly recognizable.

Adding minute details to groups of flowers

With a complicated subject, such as a bouquet of flowers or dense foliage, you must decide whether to paint every petal and leaf or whether to interpret the subject more simply. If you choose the latter, you can still make your flowers look realistic and delicate without painting every detail. Use color and brush-stroke techniques to manipulate the paint and imply the shapes of the petals and leaves. Blend colors to add depth to your flowers and give them shape without becoming too fussy about accurately rendering each petal.

Paint a rough sketch of the flowers with a mix of zinc yellow diluted with turpentine. Keep your drawing quite loose and free, and avoid getting caught up in the fine detail.

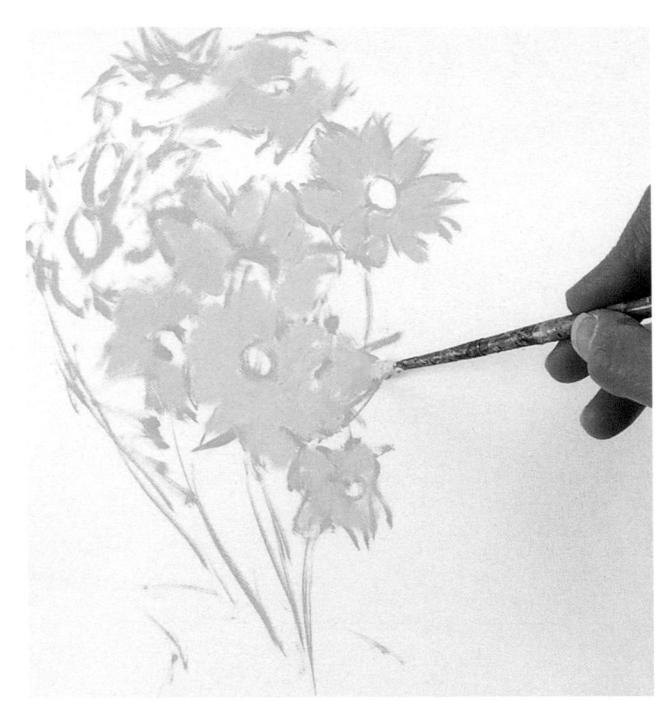

Block in the flower shapes with a mix of zinc yellow and titanium white. Apply this mix quite freely, still ignoring the details of the petal shapes.

artist's note

Mixing colors for flowers takes a little practice. Keep the colors you mix together to a minimum; mixing too many colors together can make your colors muddy. Do not add black or brown to the petals to create a shade; instead, add a touch of blue. For yellow flowers, use mauve or yellow ocher to darken them subtly.

ADDING MINUTE DETAILS TO GROUPS OF FLOWERS

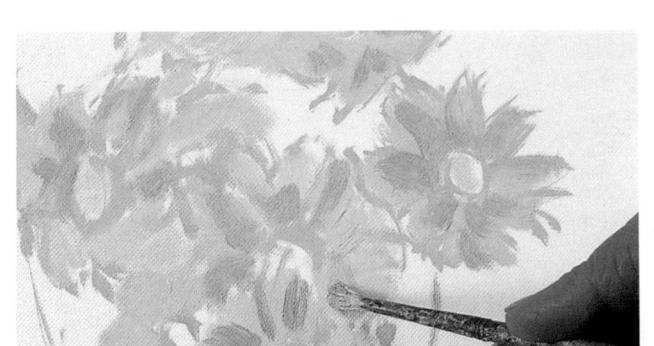

You can create the impression of petals by applying shadow. Use a cooler color to paint the shaded petals—here, a mix of permanent mauve, zinc yellow, and titanium white has been used.

Using a mix of cadmium yellow and zinc yellow, define the centers of the flowers. Add this lighter color to some of the petals to give them a hint of definition.

COMPOSING AND PAINTING STILL LIFE

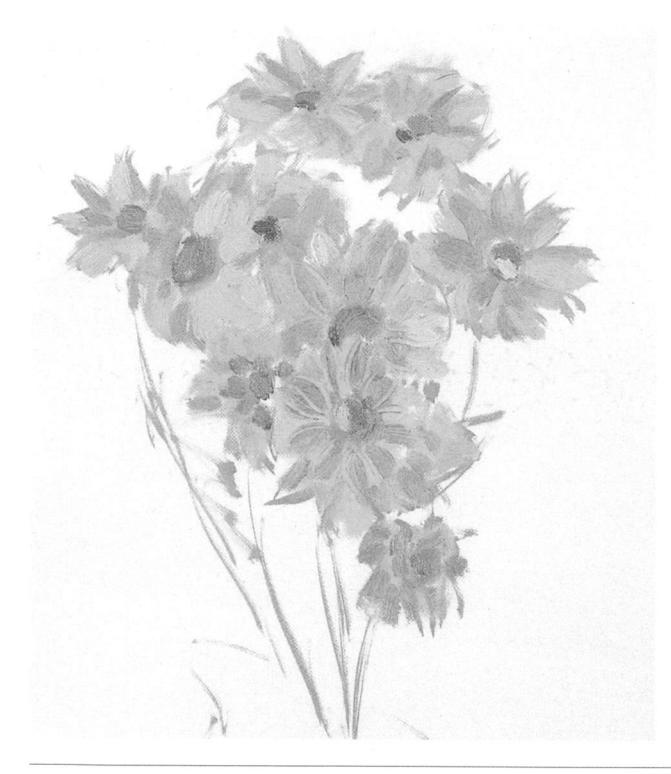

Leave some of the yellow drawing visible in places at the edges of the flowers. This will help define the shapes of the petals.

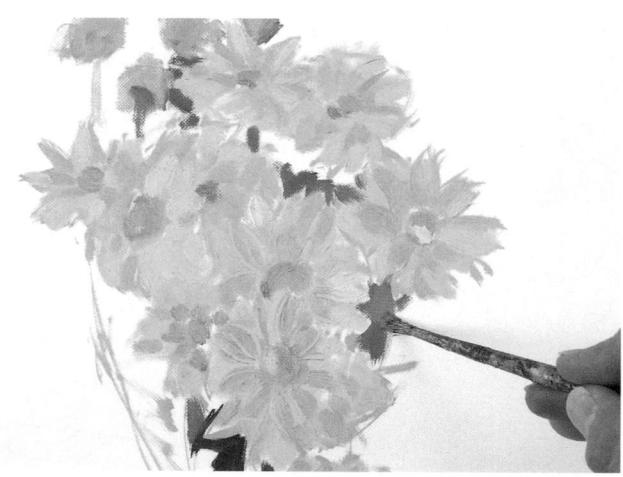

Next add the leaves.

Instead of painting each one in great detail, create a mix of zinc yellow, titanium white, and green and paint each leaf in varying tones.

ADDING MINUTE DETAILS TO GROUPS OF FLOWERS

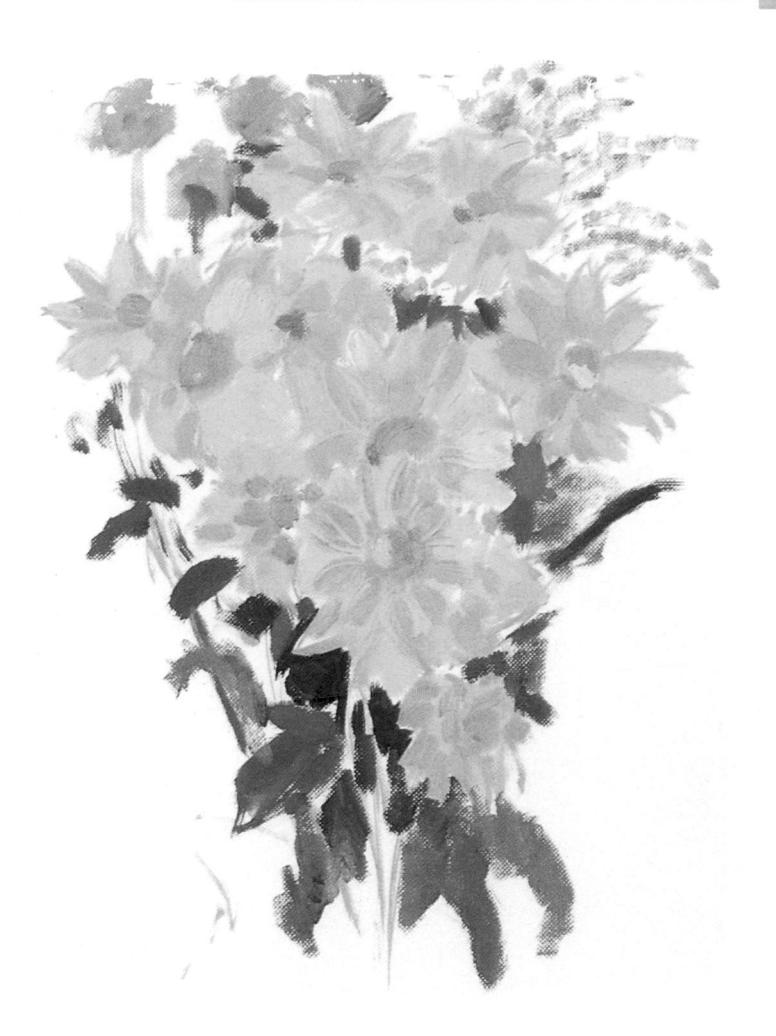

A splash of color will hint at the flowers and leaves that are not entirely visible. Very little detail has gone into this painting, but it is still immediately recognizable as a group of flowers.

Imbalanced results

Whatever subject you choose to paint, it is all too easy to create imbalance in a painting. This can be caused by too much detail in one area, colors that sit uneasily together, or perhaps a wholly different style of painting from one area to the next.

Fortunately, the process of creating a painting can be simplified into a few logical steps. If you follow these and apply them to the canvas as a whole, your paintings will develop a sense of unity. Once you are familiar with the guidelines outlined here, you will be able to apply them to any subject.

Paint the main outlines of the objects in a pale midtone. Include outlines of shadows, as these are an integral part of the composition. Do not leave any area for later. You need to have an overview of the painting from the outset so that you can remedy any problems of composition or format as early as possible.

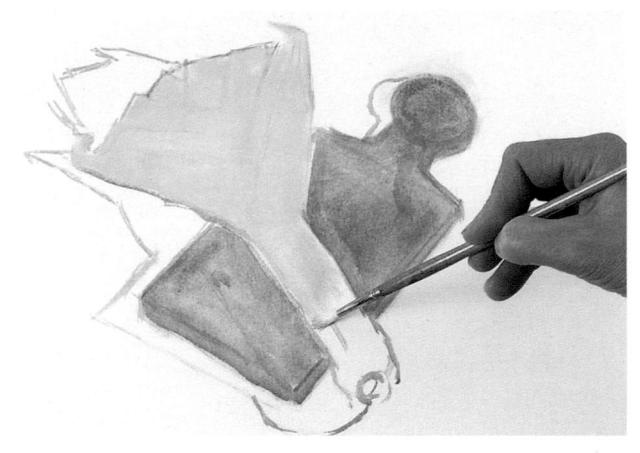

Block in the main areas of color using a pale hue or mid-tone color found in the object. It is always easier to darken a hue than to lighten it. Block in each area so that you can see how the colors interact.

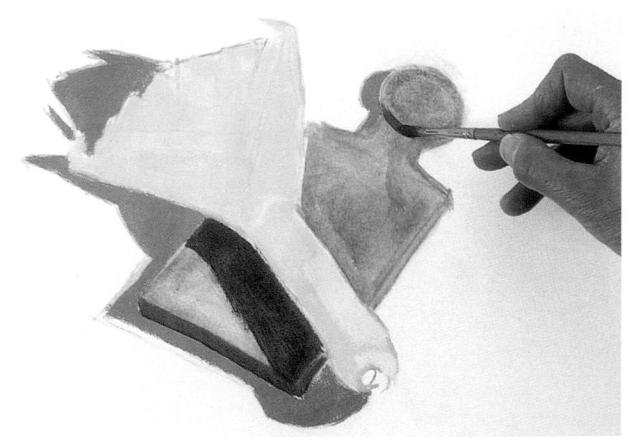

Next, block in the areas of shadow throughout the entire composition. Keep the shadow tones even—the lightest and darkest areas of shadows from the same light source will have the same density, even if they are cast in different colors.

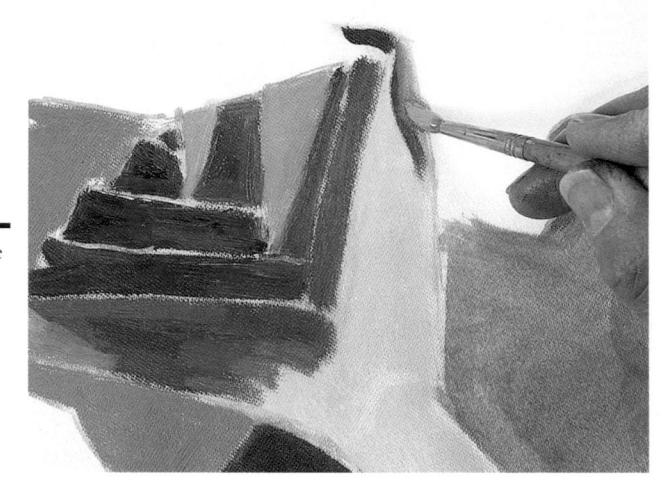

Now paint the more specific areas of color, comparing each new color or hue to the painting as a whole. Blend and vary the tones from light to dark, building up the color and form of the objects.

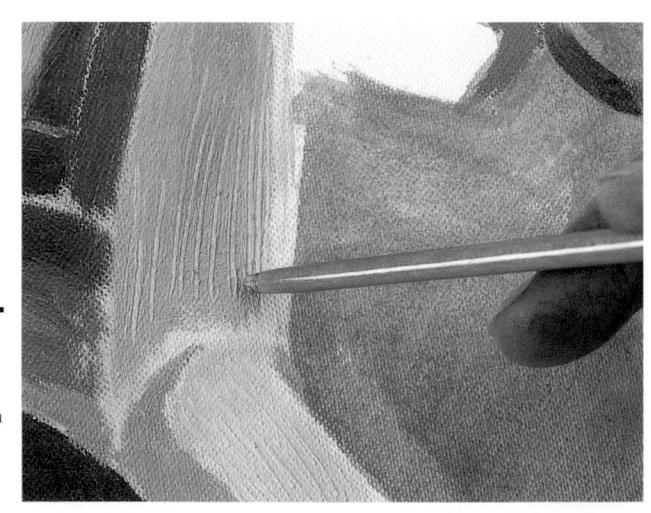

Once the main colors are correct, add the fine details and finishing touches, such as detailed texture. Don't overwork any single area of the painting.

Finally, check the tones of the shadows again now that the objects are finished. The shadows may need darkening to balance the colors.

Painting glazed white crockery

Painting glazed white crockery presents two challenges: developing believable forms, and recreating the texture of glazed china. First tackle the shapes. Viewed from the side, the top of a cylindrical object is foreshortened from a circle to an ellipse. An ellipse is not an oval, which is horizontally and vertically symmetrical; thus the back curve of an ellipse is flatter than the front curve.

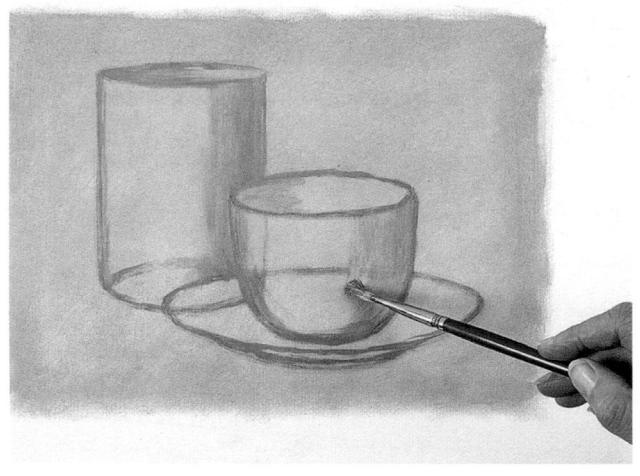

Paint the background first with a mix of titanium white, raw sienna, and cobalt blue. Using a darker mix of the same colors, draw the basic outlines of the mug. cup, and saucer. To get the correct shapes, draw the complete ellipses—the bottom of the mug and the rim of the saucer. Using the same colors but with more raw sienna, indicate the shadows-even though they won't be visible.

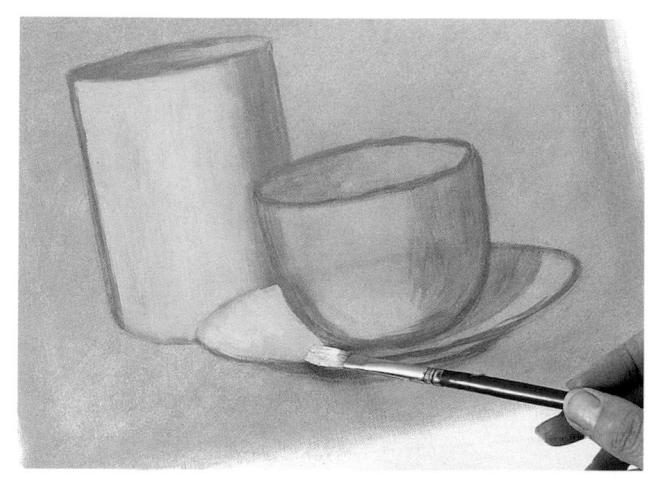

With a slightly paler but warmer mix, block in the objects completely, obliterating the unseen sections of the ellipses. Also, blend the color into the darker tone as you work. This will make the objects appear solid.

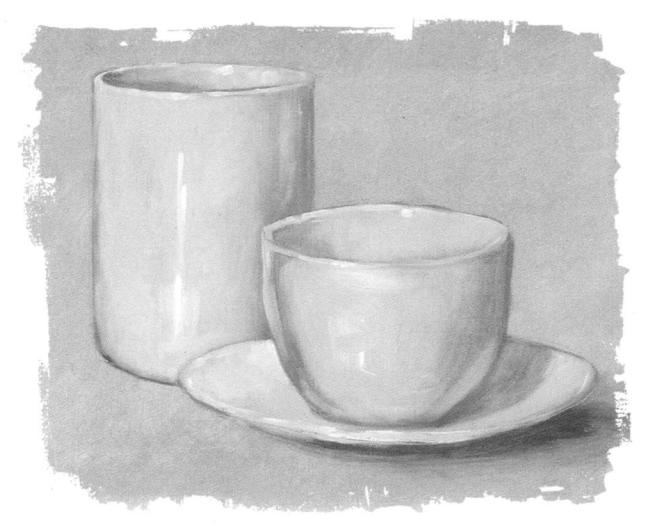

Finally, apply the highlights with pure titanium white to bring the glazed china surfaces to life. With a slightly darker color, add some light in the shadow areas, where it is reflected back from the surroundings.

Painting folds in cloth

Fabric is often thought of as a difficult subject. The more complicated the folds and wrinkles, the more likely you are to get lost trying to draw it. Begin with something simple, and use a single light source to keep the shadows and highlights separate. Apply the base color first, and then start to build up the shadows on the cloth; these will define the folds. Then you can start painting the highlights, which will further define the undulations and creases in the cloth.

artist's note

Cloth—folded or creased—is a common element of still-life paintings. Use white cloth to show up cast shadows and choose patterned cloth to reflect back onto shiny or white objects, giving more color interest to a painting. The folds in cloth can also be used to lead the eye around the composition.

Draw a basic outline and apply the base color with a round hog brush and a mix of cadmium orange and painting medium. Let this layer dry.

Sketch the basic folds of the cloth and then work on the shading with the same color. Use a more concentrated mix where the shadows are darkest, and lighten the color by brushing more thinly over the lighter parts of the cloth.

Paint the highlights with a mix of titanium white and a touch of the base color. This helps to define the gentle curves of the cloth.

Creating the sense of uniform stripes or pattern

As with plain fabric (see previous pages), drawing is the key here. You will find it easier to draw the folds first, and then add the pattern. The pattern on a piece of cloth follows the peaks and troughs of the folds so, rather than being continuous, the lines of the pattern will stagger as they pass out of sight and back into view. Paint the main colors first and enhance the folds of the cloth with shading and highlights.

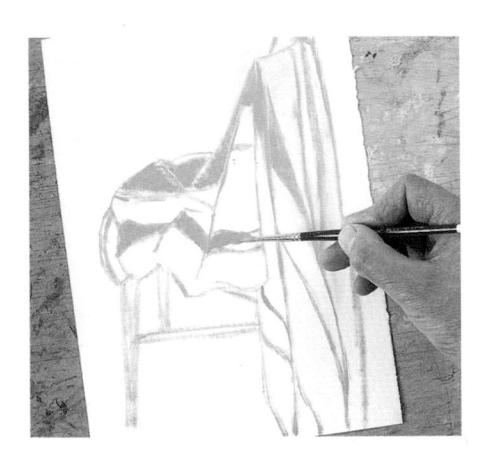

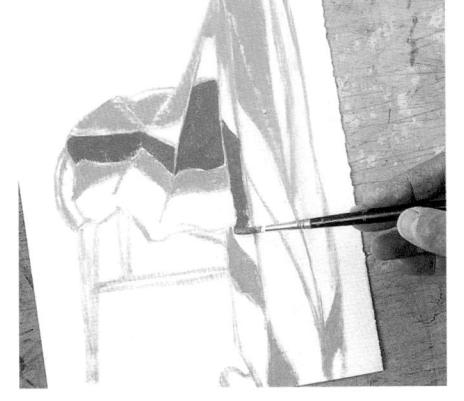

Draw in the outlines of the objects with a mid-tone color of the cloth. Any solid forms should be apparent beneath the fabric—the folds of the cloth will not make sense by themselves. Draw the shapes made by the folds first, then draw the stripes or pattern. Apply your first block of color with the mid-tone you used for the sketch.

Apply the second major color—in this case, a mix of red violet, cadmium red hue, and titanium white. Look carefully at the cloth and faithfully repeat the staggered lines of each stripe.

CREATING THE SENSE OF UNIFORM STRIPES OR PATTERN

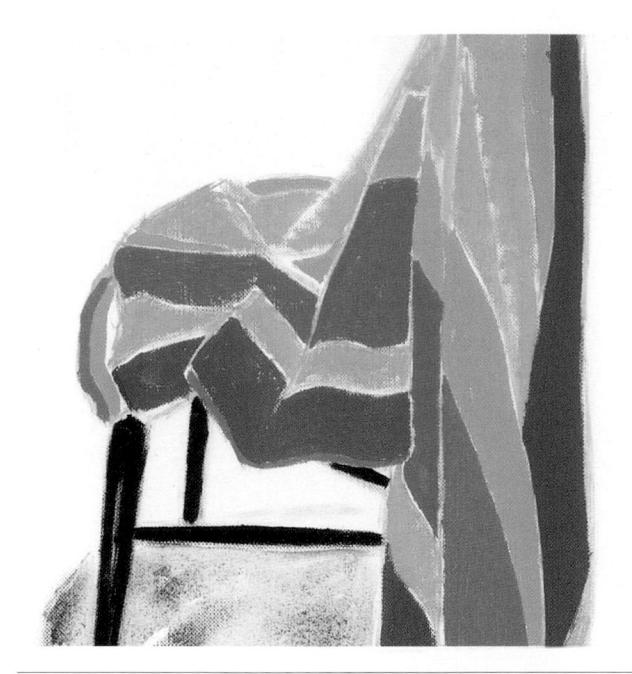

Block in the rest of the pattern colors so that the overall form takes shape. Here, the green stripes were painted next, then the purple, and then the dark structure of the chair. For the chair, mix cadmium red hue and ivory black. Use the same color, thinned with turpentine and painting medium, to lightly brush in the cast shadow of the chair.

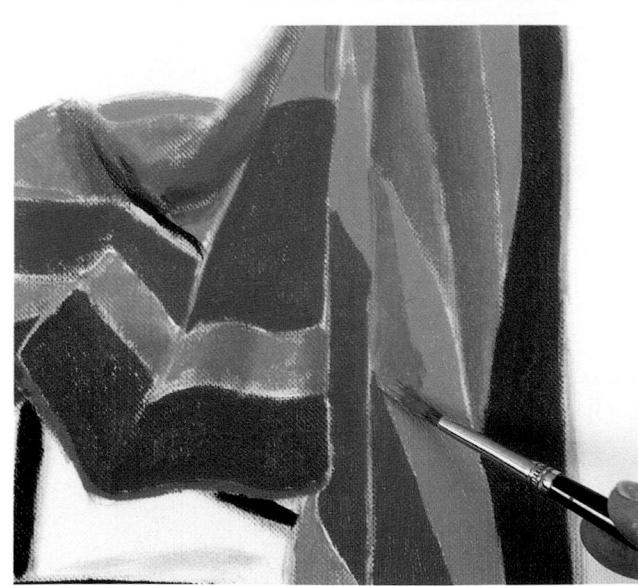

Study the areas of light and shade.
Using slightly darker mixes of the original colors, add shading to suggest the folds in the towel.

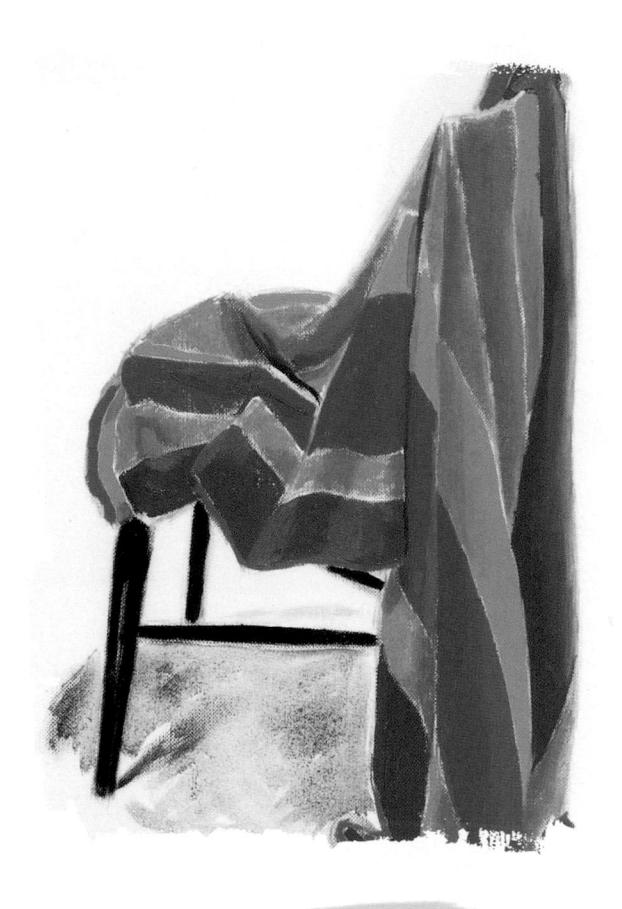

Mix the color of each stripe with titanium white to add the highlights. The highlights should be placed along the top of each crease and fold.

when choosing patterned or striped fabric for a still life, consider relationships of color, for interesting spatial fabric overwhelm the objects or dominate fabric overwhelm the objects or state of the painting. Look for interesting spatial the painting. Look for interesting spatial ambiguities, such as a fabric pattern that echoes ambiguities, such as a fabric pattern that echoes the colors or shapes of the objects.

Capturing the glint of glass

Just as a window reflects the light, which is what makes it visible, so any glass object will reflect light, bending the light rays to its shape. Anything behind the glass object will show through it but will also be distorted. However, you need to be selective when you paint. There are various degrees of brightness, and there may be a multitude of details. Focus on the most prominent light and dark shapes. Start with a basic outline of the glass and apply the darker tones first and the brightest highlights last. These extremes will bring the whole painting together.

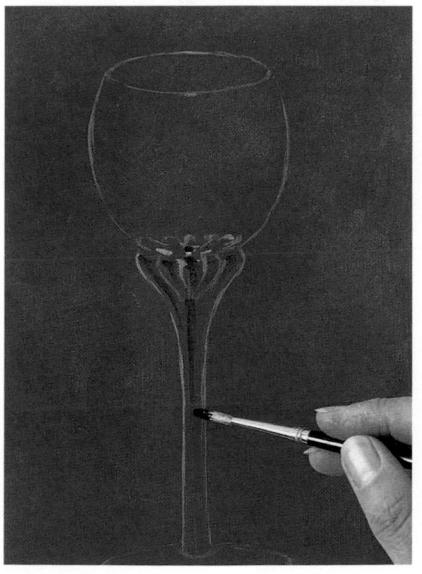

A rich color behind a glass will make the areas of light and dark very clear. This glass is standing on a sheet of deep blue paper to bring out its highlights. Paint the background using a mix of ultramarine and a touch of titanium white. Adding more white to your mix, paint the basic outline of the glass. Use a color that vou know will be used later, so the outline does not look out of place. Then paint the thin core of black glass in the stem with a mix of monestial blue and permanent mauve.

COMPOSING AND PAINTING STILL LIFE

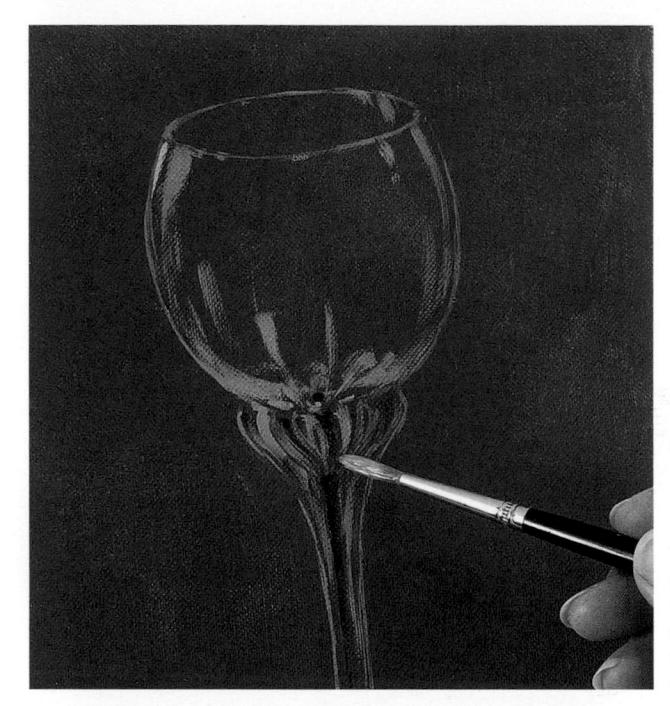

Add the first highlights with the same pale blue used for the outline of the wine glass. Do not apply pure white yet. You should establish the darker tints first and then work toward the brightest highlights.

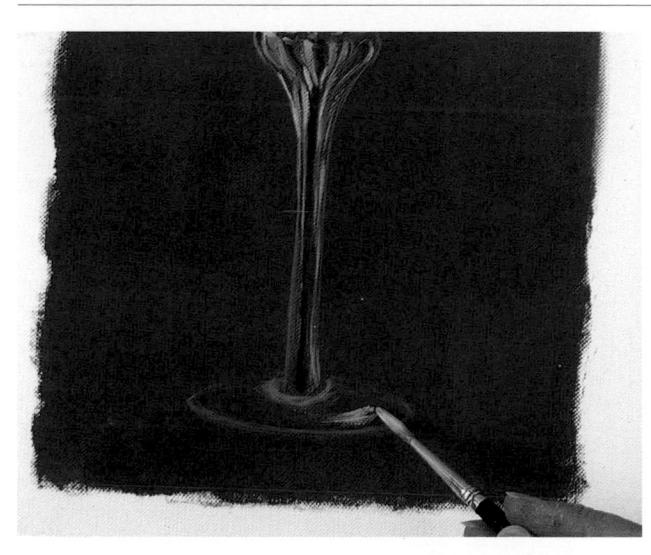

The highlights in the glass are not all the same color; the reflected light will be affected by the light source and other colors around the glass. Mix titanium white and a little yellow ochre with the pale blue mix, and apply the warmer highlights to the stem and base of the glass.

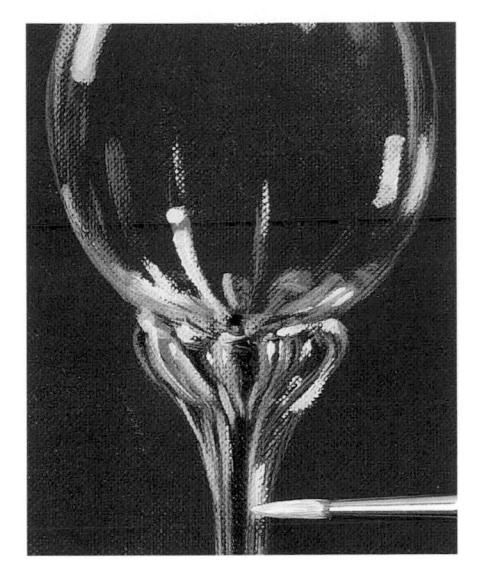

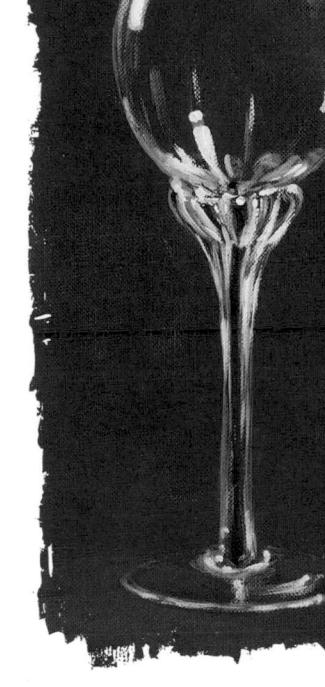

In this case, the brightest highlights are also warm. Using a mix of cadmium yellow and titanium white, create a bright but warm white and apply these highlights next.

The light source is at the front, and the reflections that are visible on the far side of the glass are comparatively soft. The light on the rim of the glass is not one continuous color but brighter where the light catches it. Delicately paint this highlight with a fine rigger brush for the final touch.

Making metal look shiny

First, shiny metal reflects the lights and colors that surround it, bending their shapes and creating distortions that are difficult to anticipate or invent. Also, the light source—whether artificial or natural—may be warm or cool, creating a color cast on the reflections. And some metal surfaces have a high shine, while others are duller, whether from age or finish.

Furthermore, the colors of copper and brass will tint all the reflections, whereas polished silver and steel will reflect color the way a mirror does. The key is to paint exactly what you see, even if the distortions look very strange. Practice drawing setups with simple shapes and strong colors, such as the one shown here, to get a feel for the changes in shape and color that reflections in metal can take.

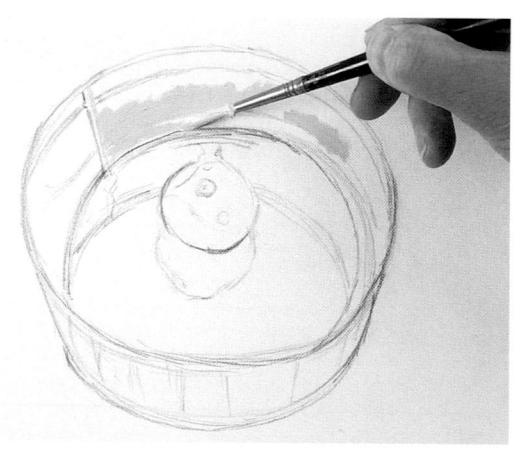

Draw the whole composition in pencil, including the principal shapes of the reflected colors. Here, the pale ceiling color is reflected in the base and sides of the metal pan. Paint these areas with a mix of titanium white and yellow ocher.

MAKING METAL LOOK SHINY

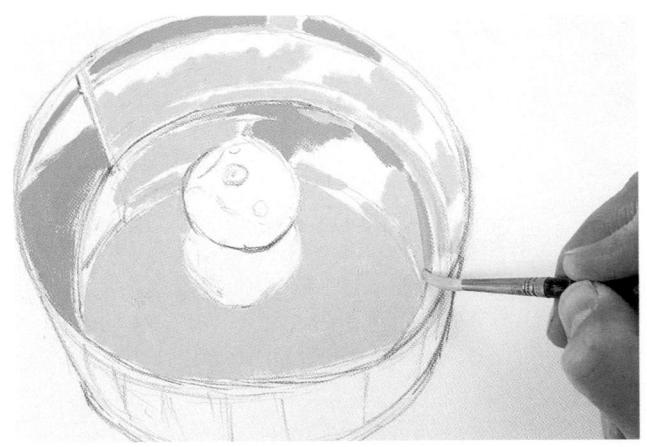

The pan is made from "white" metal—one with no hint of yellow, such as silver and steel—so where it is reflecting part of its own surface, the reflected color is a medium gray. Apply the gray using a mix of titanium white and ivory black.

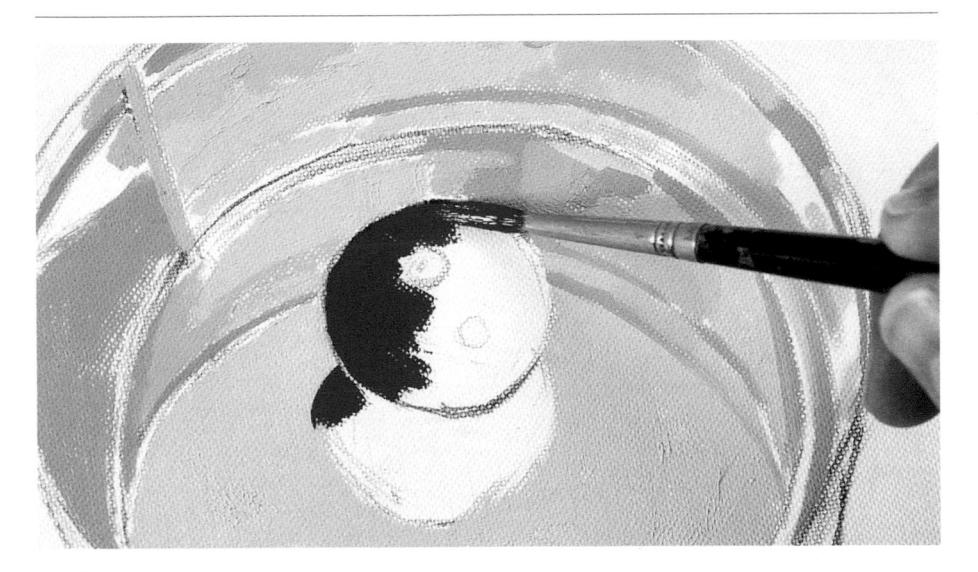

The medium red of the tomato is dark against the lightness of the pan. Using a mix of cadmium red and permanent red, start to paint the tomato. Also, begin painting the reflection underneath in the same color, as white metals do not influence the colors of the reflections.

COMPOSING AND PAINTING STILL LIFE

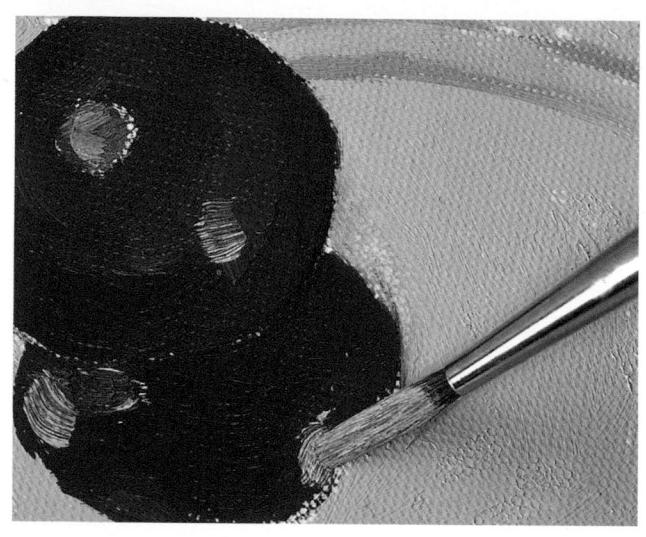

Paint the darker reds on the underside of the tomato and its reflection using alizarin crimson. For the yellowish highlight on the tomato, use a mix of cadmium yellow, cadmium red, and permanent red. Then, gently brush thin titanium white into the wet paint, blending it slightly so that the color is not too crisp.

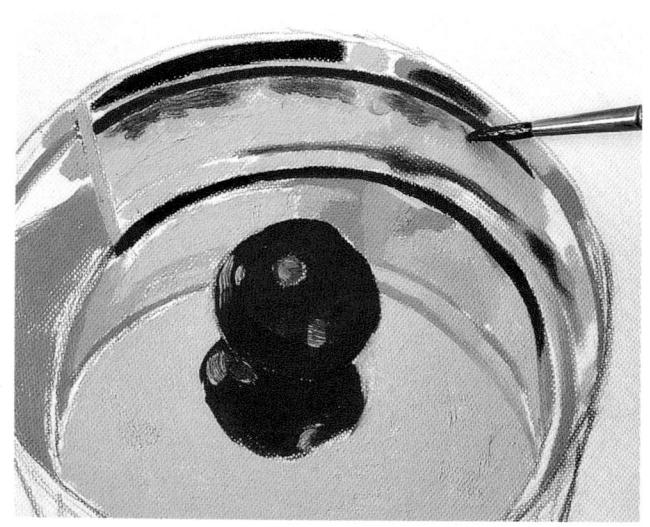

The tomato is also reflected under the rim of the pan. This reflection is a darker, cooler red than the tomato itself because the underside of the rim is in shadow. Paint this with a mix of alizarin crimson and the gray which you mixed previously.
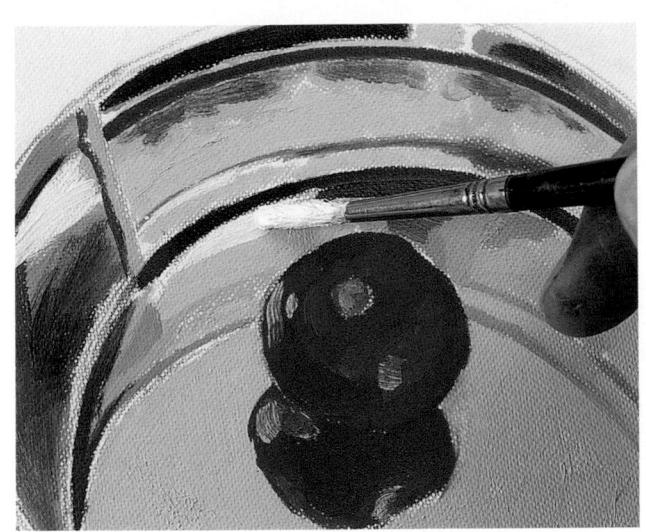

At this stage, the gray and the cream colors need some more light and dark variants to imitate the shine. Add some ivory black to the gray mixture to paint the darker shades. Work lighter tints into the cream area with titanium white, and use white straight from the tube for the highlights. The highlights will not gleam brightly unless the shaded areas are dark enough.

Paint the tabletop and add a touch of ultramarine to indicate the cast shadow of the pan. Then paint the outside of the pan with ultramarine, working in some yellow ocher wetinto-wet. The warm ocher background sets off the shine and reflective quality of the metal pan.

Demonstration: Pumpkin still life

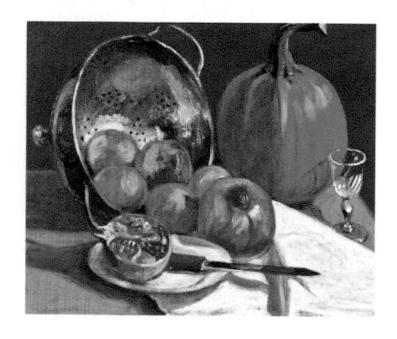

In this still life, the arrangement of natural objects with various kitchen utensils creates a lively composition. The metal colander reflects the vibrant colors of the apples and pumpkin, while the knife and white cloth create interest in the foreground,

drawing the eye toward the more colorful objects farther back in the painting. The rich background color creates a dramatic contrast.

For this painting, add medium to all the colors. First, paint the red-violet cloth of the background with a mix of mineral violet and painting medium. The cloth provides an exciting color contrast to the fruit. When dry, draw the composition and block in the light areas with a mix of cerulean blue and titanium white.

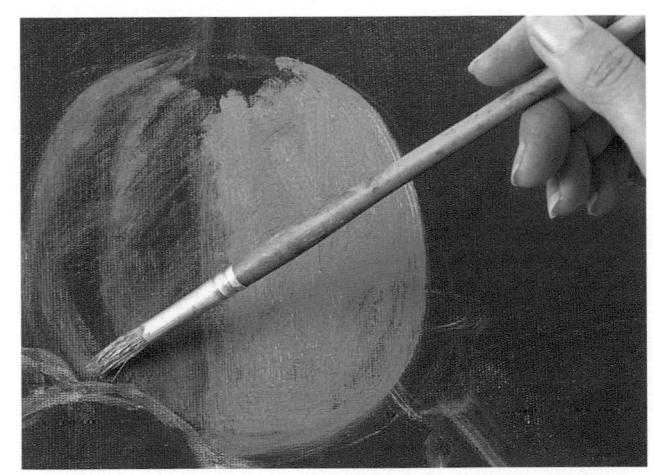

Establish the main colors early on.
Paint the pumpkin with cadmium orange, applied thickly at the right and thinly on the left, where the pumpkin is in shadow. The red-violet underpainting will show through the thinner paint, creating an impression of a shadow.

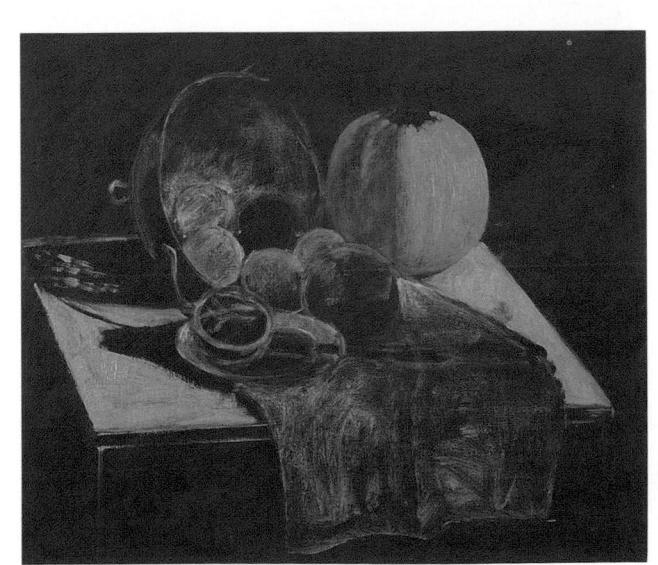

Apply yellow ocher to the pine box and the apples. Work around the cast shadows, leaving them as the red-violet underpainting for now. Also leave small areas of light from the holes in the cast shadow of the colander.

COMPOSING AND PAINTING STILL LIFE

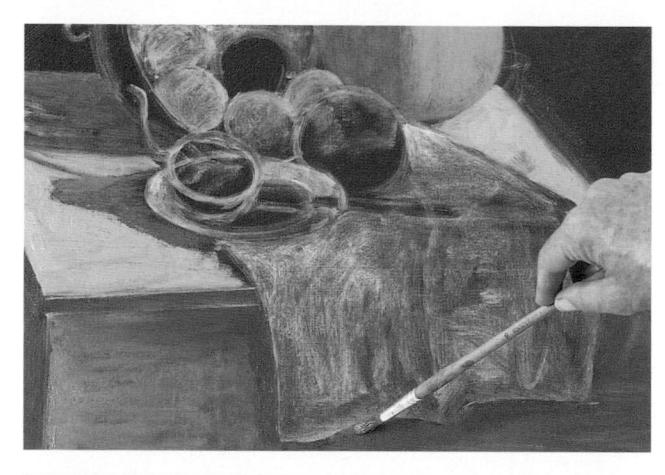

Paint the sides of the box with a mix of yellow ocher and a little monestial blue. Apply the paint thickly where the box is in the light, and drag the color on thinly where there are shadows. Paint the cast shadows with the same mix.

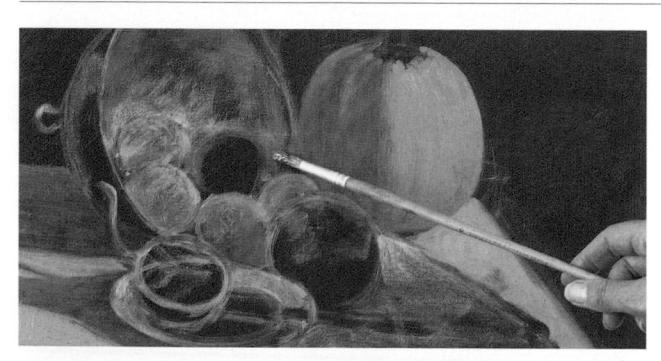

The inside of the colander reflects the various colors of the fruit. With a mix of yellow ocher and monestial blue, create a dull tertiary green and block in the reflected shapes.

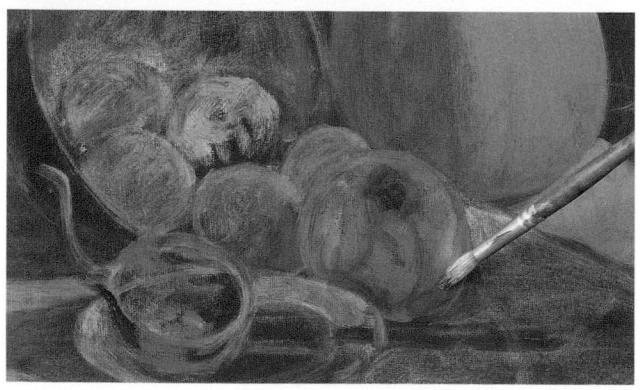

Paint the apple with a bright green mix of lemon yellow and monestial blue. Then paint the pomegranate in lemon yellow combined with carmine and titanium white. With the same color, suggest the pips on the cut half. Add touches of pure carmine to further define the shapes, working wet-into-wet.

DEMONSTRATION: PUMPKIN STILL LIFE

Let your brush strokes follow the curves of the rounded forms, such as the apple, to create a sense of volume. Then add a touch of carmine to give depth to the shadowed side.

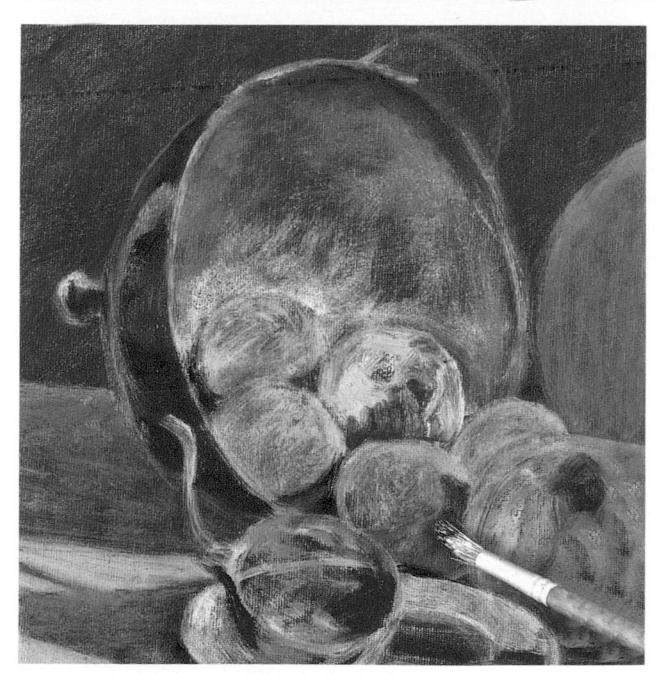

Working wetinto-wet, blend permanent mauve into the green of the apples to create shadows. Use the same color to paint the dark reflections on the back of the colander.

COMPOSING AND PAINTING STILL LIFE

With the same color again, add touches of shadows to the pumpkin. The permanent mauve will blend with the cadmium orange to produce a dull green.

The original outline of the glass has been covered over with paint, so use the handle of your brush to scratch in a new rough outline.

With a mix of yellow ocher and white, draw the creases on the cloth. Follow these lines to block in the light and shadow on the cloth, where it falls over the edge of the box.

DEMONSTRATION: PUMPKIN STILL LIFE

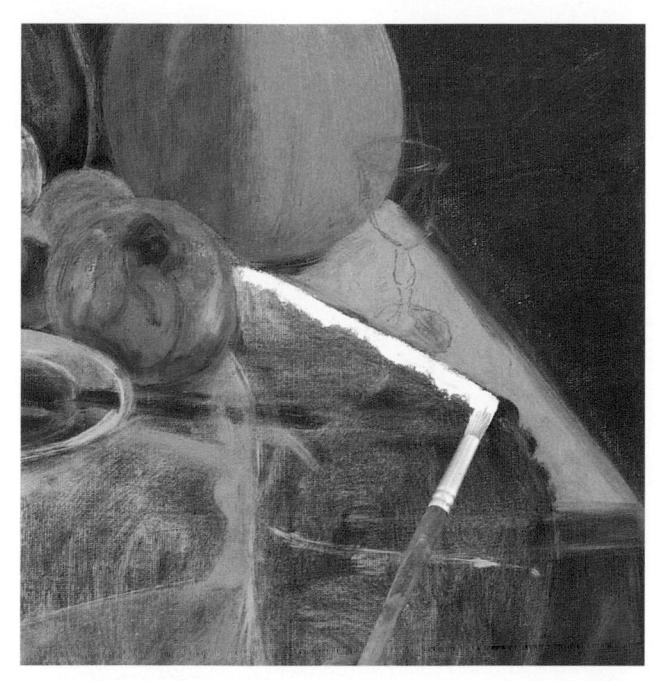

Paint the shadows on the plate and cloth with a mix of monestial blue, yellow ocher, and white. With a small touch of cadmium yellow mixed with titanium white, paint the lit side of the cloth. Drag less color on where you want the violet ground to show through, to create little shadows. Also, leave parts of the greenish mix to indicate shade.

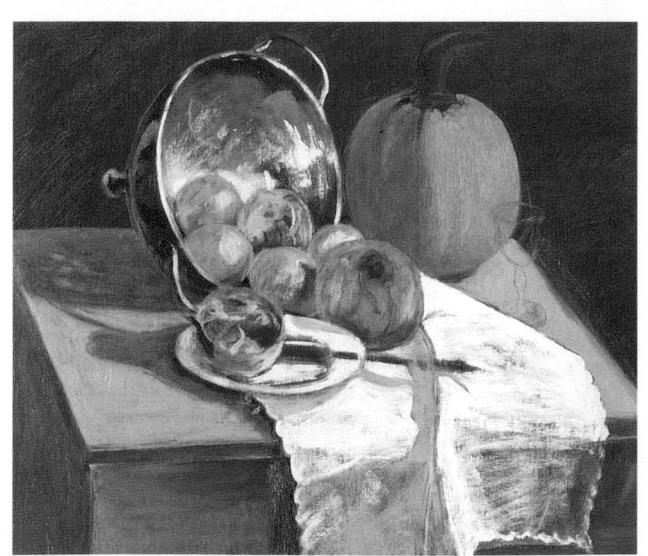

Use the warm white to develop shine on the colander, as well as the light on the plate and cloth and the moist highlights on the cut pomegranate. Don't make these highlights continuous blocks or lines of color; instead, suggest the reflection with a broken line.

COMPOSING AND PAINTING STILL LIFE

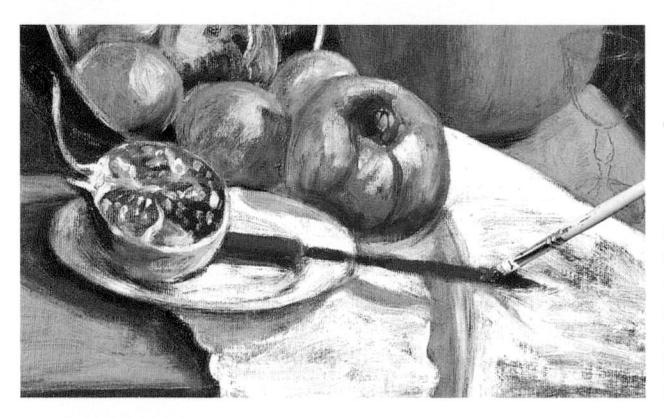

Paint the knife with a mix of cadmium orange, permanent mauve, and titanium white. Vary the tone to capture the areas of shade and light on the knife handle and blade to give them a three-dimensional solidity.

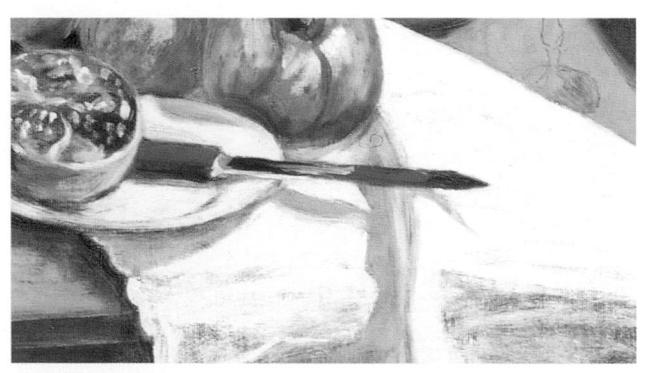

15 Using a mix of titanium white and cadmium yellow, work some more highlights into the cloth. This will strengthen the folds and make the knife look more solid in comparison.

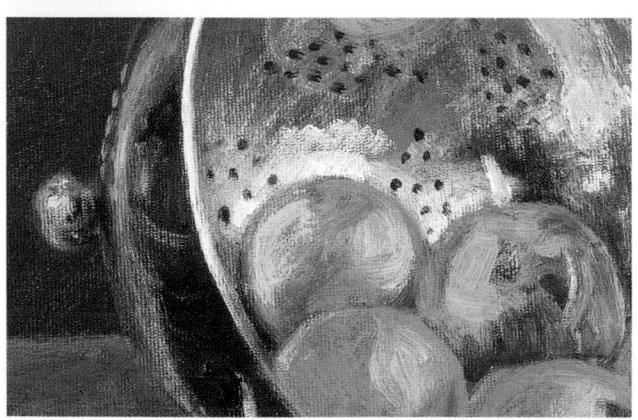

Using a rigger brush, stipple the holes into the colander with permanent mauve. You will find it difficult to draw the holes around the curved surface of the colander. Don't worry about making them perfectly precise. The impression of the colander will be enough.

DEMONSTRATION: PUMPKIN STILL LIFE

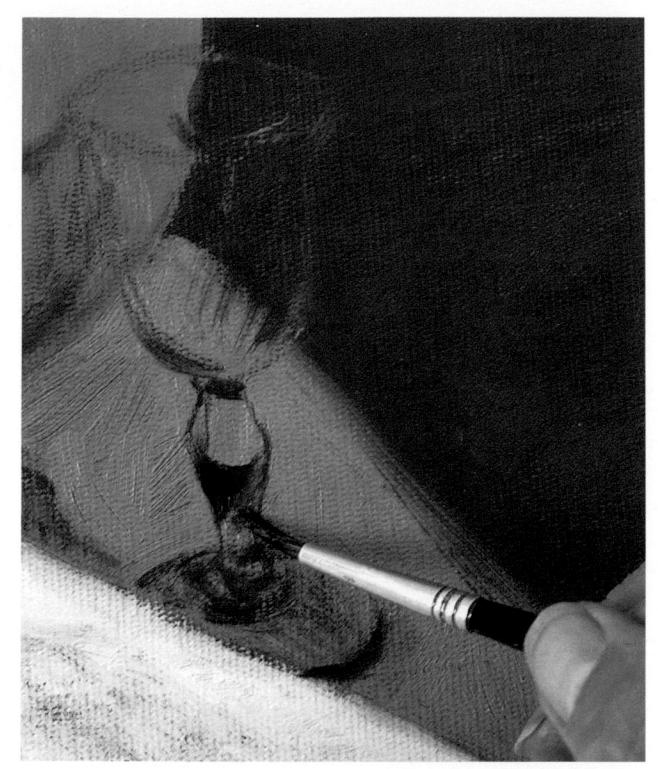

Following your scratched-in outline, paint the dark areas of the glass with a mix of permanent mauve and transparent gold ocher.

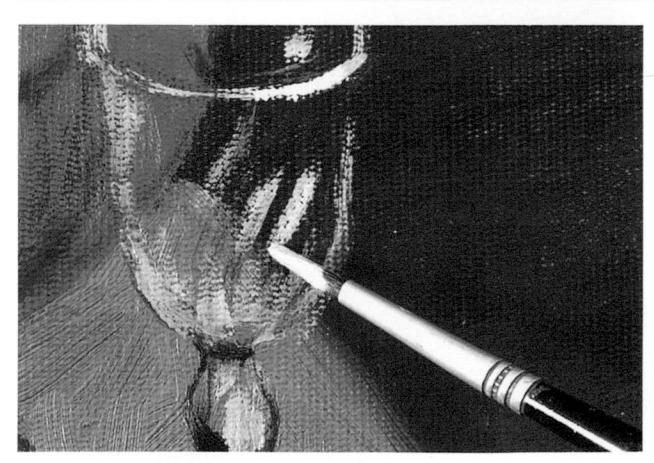

18 Add a touch of titanium white to the previous mix, and touch in the darker highlights.

COMPOSING AND PAINTING STILL LIFE

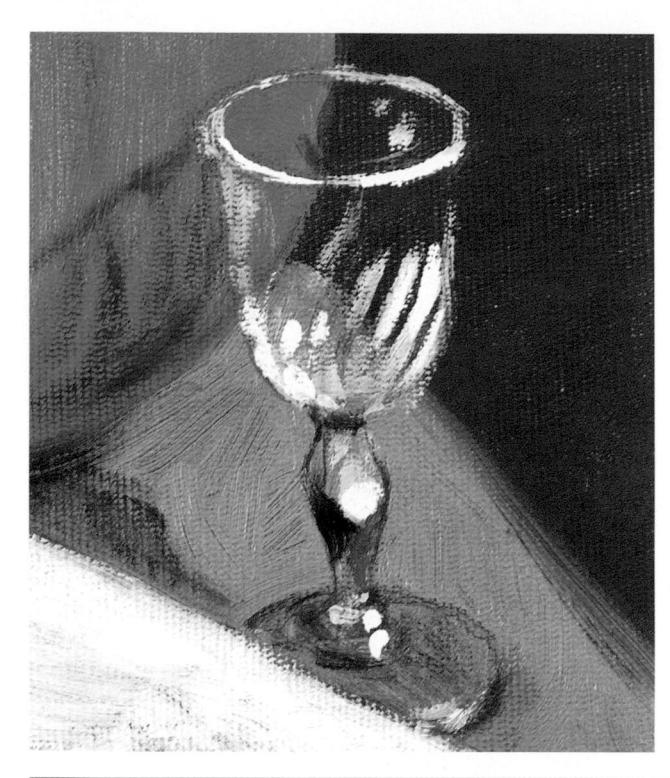

1 Using a mix of yellow ocher and titanium white, paint the warmer highlights on the light side of the glass.

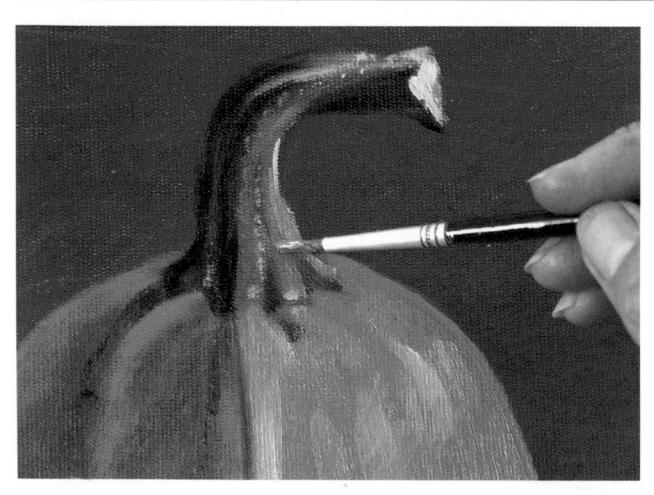

Paint the shadow side of the pumpkin stem with a mix of monestial blue and yellow ocher. Blend these into the cadmium orange and titanium white for the lit side. For the brighter highlights, use mineral violet and titanium white.

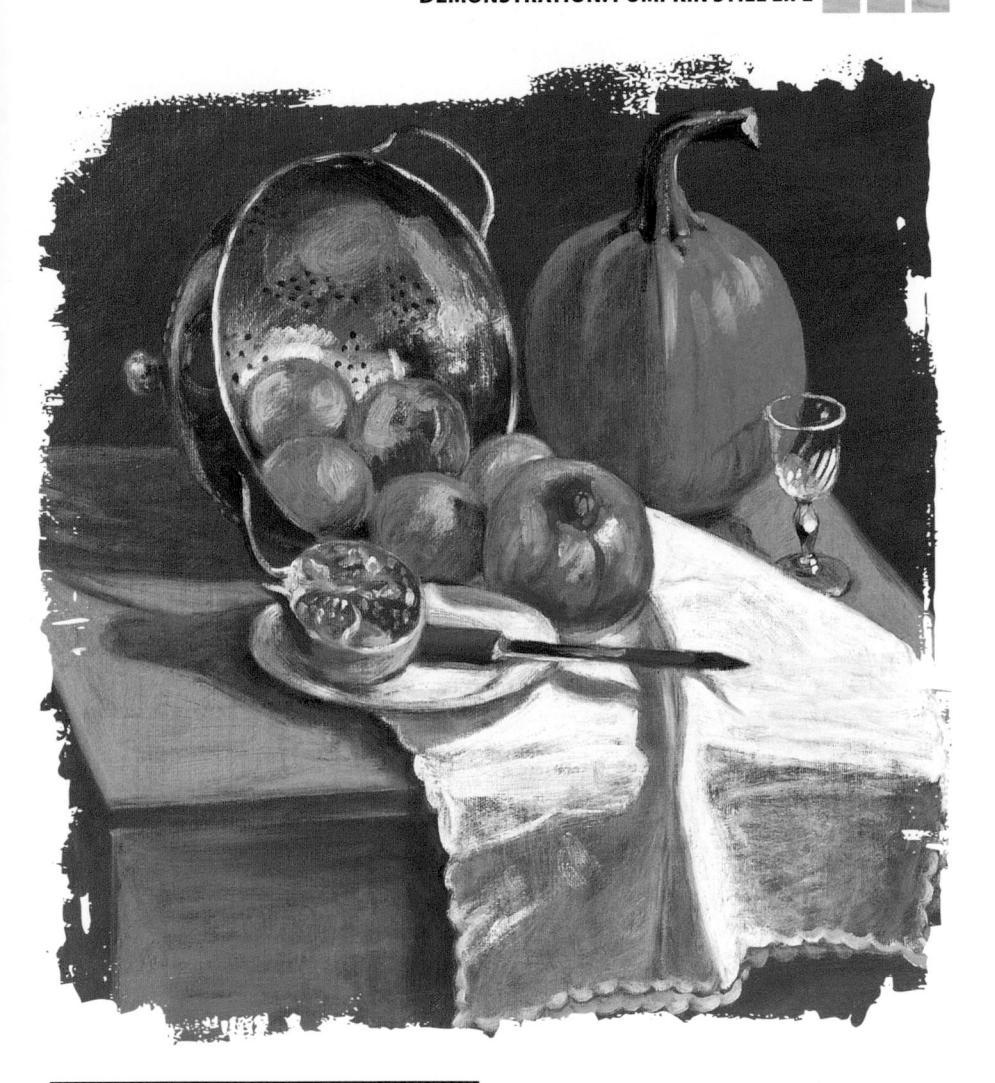

The finished painting is a balanced but lively composition, partly due to the complementary interaction of orange and yellow ocher with red-violet. Also, the knife adds a strong, straight edge to an otherwise curved and elliptical selection of objects.

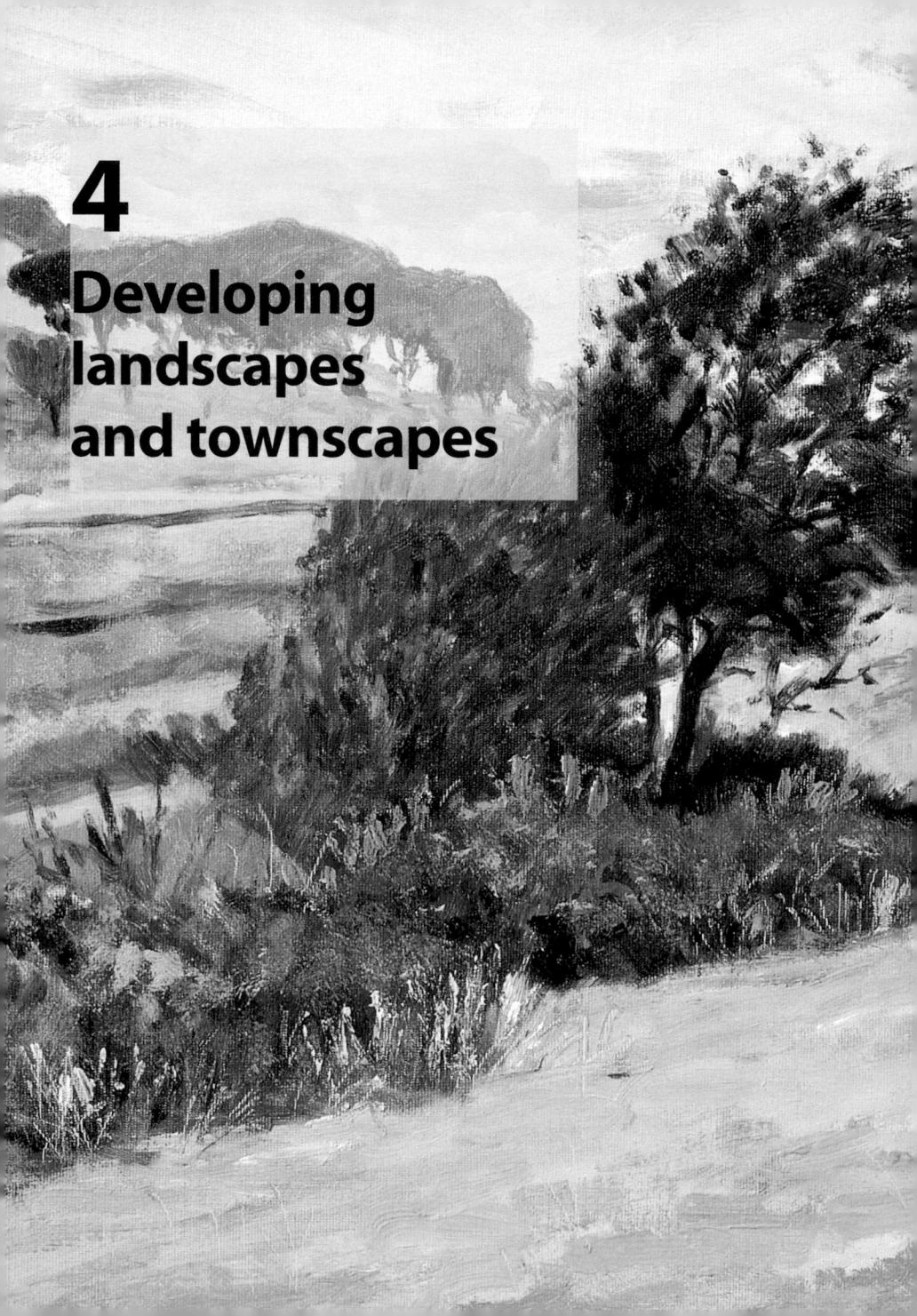

The key to painting any subject is careful observation. This is particularly true with landscapes and townscapes, whether or not you paint from life. Many amateur painters work from photographs. This can be a useful prelude to working out of doors, but it should not replace it entirely. It is only by accepting the challenges of the changing light and weather that we can develop the natural quality of brushwork that is a result of real risk-taking.

If you are intimidated by painting outdoors, start off in a garden, before heading into the country or onto the street. A garden offers intimate spaces to paint, which can be a useful first step toward the wide spaces of a landscape or the complexities of a townscape.

Finding a composition that appeals from the mass of possibilities can be a problem. In the eighteenth century, it became popular among the middle classes to walk in the countryside, looking for the perfect composition in nature. Walkers would climb hills or mountains and inspect the view through a viewfinder, which could isolate a "picturesque" or "sublime" composition from the surrounding views, much as we do now with our cameras.

Use the techniques in this chapter, and draw on your knowledge of color and composition from previous chapters; then go out and paint landscapes and townscapes to your heart's content.

Clearly defining the foreground, middle ground, and background

Some scenes—such as seascapes, prairies, and deserts—are so flat that it is hard to define the space in terms of these three divisions. For the foreground, use a larger brush and bolder strokes to bring things forward. In the middle distance, use smaller brush strokes and blend your marks. Be sure to scale objects accurately: a leaf nearby can be described with one brush stroke, whereas the same-sized mark in the distance could describe a hill. Make the foreground more detailed, painting less detail in the background to help it recede into the distance. And remember that warm colors advance and cool colors recede—so keep your warm tones in the foreground.

Start by applying a colored ground of yellow ocher mixed with titanium white. Then, sketch a rough outline of the landscape in raw umber. When this is dry, paint in the sky with a mix of titanium white and alizarin crimson.

CLEARLY DEFINING THE FOREGROUND, MIDDLE GROUND, AND BACKGROUND

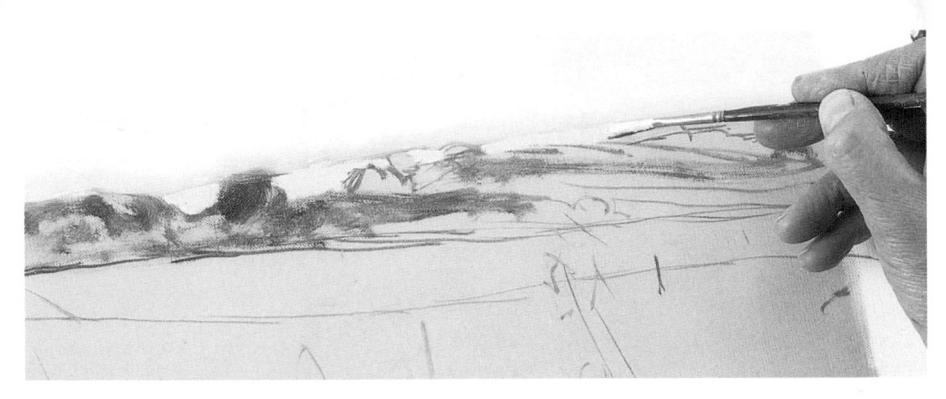

Develop the sky on the horizon using a deeper mix of titanium white and alizarin crimson. The glow of the alizarin crimson gives the impression of the sun setting behind the hills. Then block in the hills with a phthalocyanine blue mixed with titanium white and alizarin crimson.

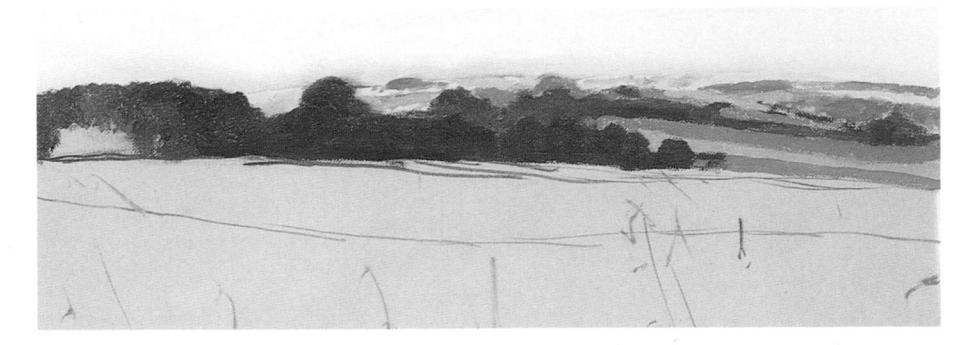

Develop the hills using the previous mix as a base but adding a medium green and phthalocyanine blue to make the blue hills seem farther away. Paint the trees in the middle distance using a mix of raw umber, green, and cobalt blue. The warmer, darker tones bring the trees forward into the middle distance.

DEVELOPING LANDSCAPES AND TOWNSCAPES

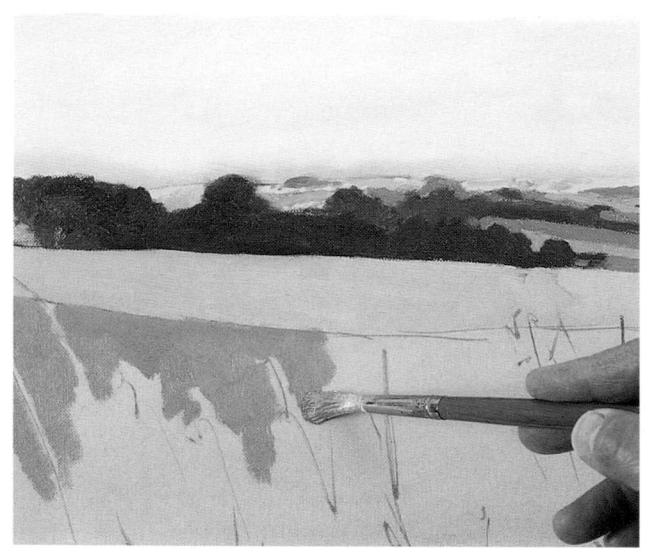

Paint the field in the middle distance with a mix of yellow ocher, titanium white, and a touch of phthalocyanine blue. Use a higher proportion of yellow ocher to make a much warmer color for the field in the foreground. Paint carefully around the corn in the immediate foreground using a mix of yellow ocher, raw umber, and titanium white.

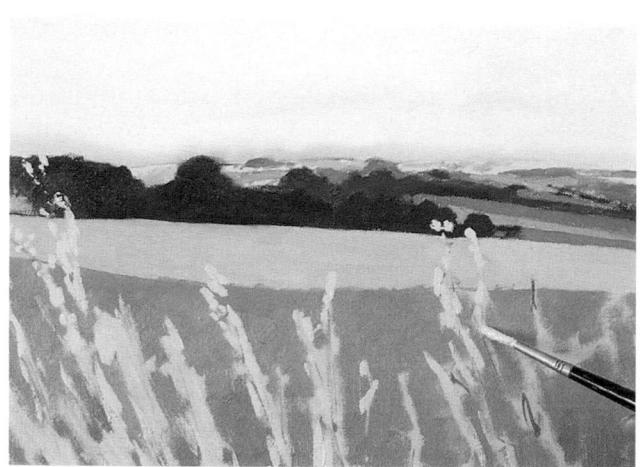

Highlight the wheat in the foreground with a pale mix of titanium white and phthalocyanine blue. Then paint the shadow detail with a mix of yellow ocher and raw umber. This detail will bring them forward in the picture.

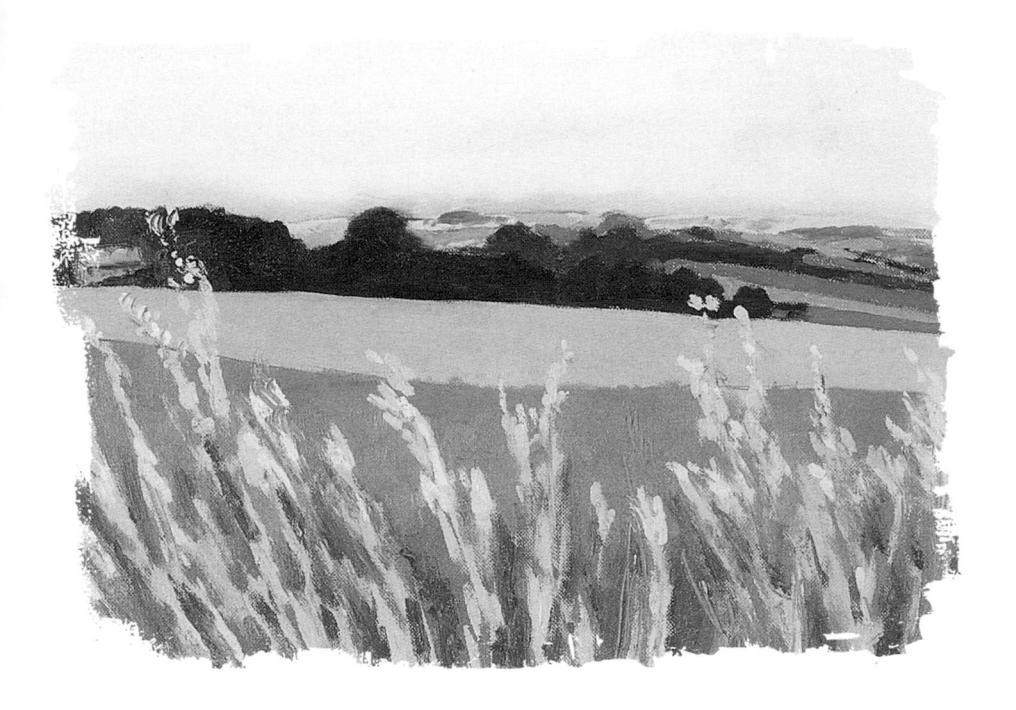

To define the tall, ragged stalks of barley, paint the negative spaces between them. Then paint each stalk individually so they stand out from the landscape. This establishes a low viewpoint and intensifies the sense of distance.

Atmospheric, or aerial, perspective

When you stand in front of an open landscape that unfolds into the distance, you will notice that the colors closer to you are much stronger and the light and shade are more clearly defined than in the distance. This effect is known as atmospheric, or aerial, perspective. As light passes through the water vapor and dust particles in the atmosphere, the haze absorbs the warm end of the spectrum of light rays reflecting back off hills, and so only the cooler, bluer rays are visible. Therefore, colors in the distance tend to appear more blue, and the tonal values are much closer to each other and paler. A misty atmosphere creates an even more exaggerated effect.

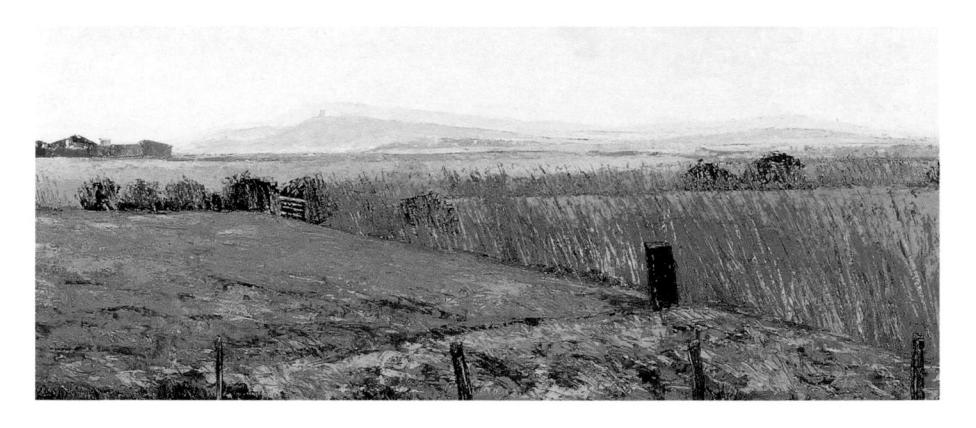

In this painting by Rosalind Cuthbert, the effect of aerial perspective is clear. As the hills recede, the colors become cooler and bluer, giving the impression of distance.

Using the effects of aerial perspective in your painting enables you to create a sense of depth and distance in a landscape. Add more blue and white to your mix for distant objects. If there are warm colors in the distance, such as a hill covered with heather or a plowed field, compare these with warm colors in the foreground, and mix in some cooler colors so the background still recedes.

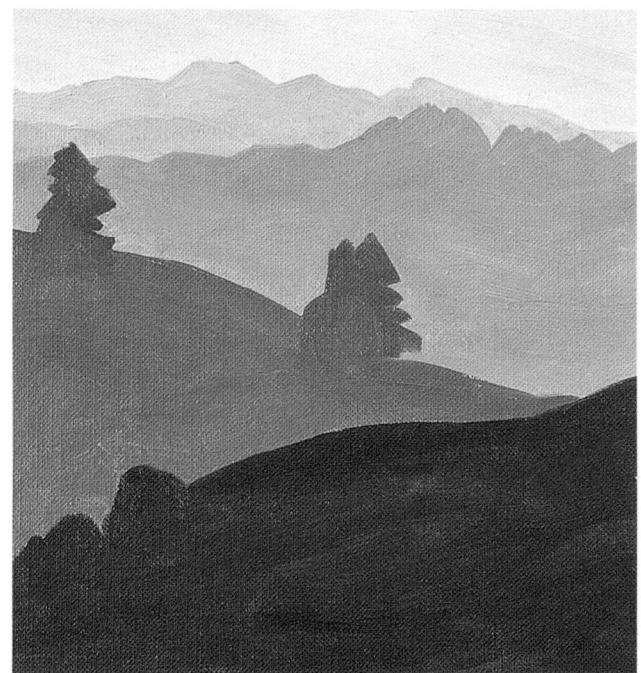

This painting of a range of hills shows how you can create an impression of space by fading and cooling the color mix for each receding hill.

Foreground: Use more yellow other in the mix t

yellow ocher in the mix to keep the colors warmer.

Middle ground:

Reduce the quantity of yellow ocher and add more monestial blue and titanium white. **Background:** Use almost no yellow ocher, if any—just monestial blue and titanium white. Although the hills are simply cut-

the color mix for each hill suggests a sense of changing distance.

out silhouettes, adjusting

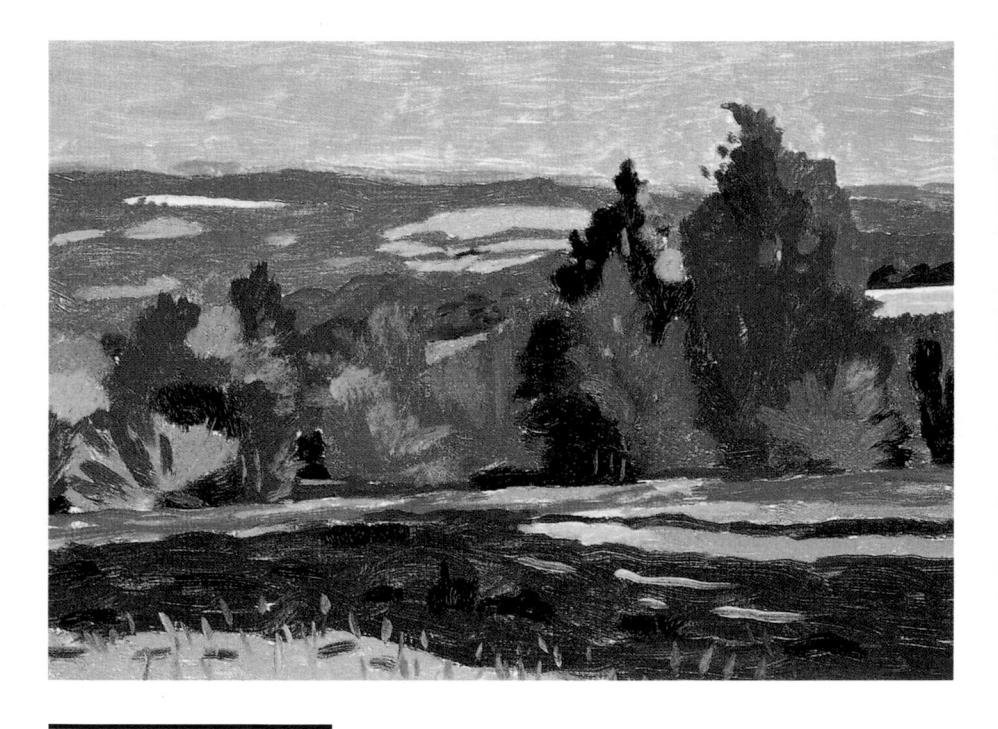

The foreground of this picture by Jeremy Galton is painted with warm colors, bringing it forward in comparison to the cool hills in the distance.

Painting realistic clouds

Clouds come in many shapes, colors, and sizes. Bobbly cirrus clouds can be stippled into wet paint, whereas large cumulus clouds will require rougher and more textured brushwork. The colors of your clouds will vary according to the weather conditions and the time of day—darker tones for rainy weather and late afternoon and evening, and paler hues for clear, sunny days and morning and early afternoon.

For cirrus clouds, first paint the sky with a mix of cerulean blue and titanium white. While it is still wet, dab white paint onto your paper in a circular motion, copying the pattern of the clouds. Let the two colors merge together, creating a soft, slightly out-of-focus effect.

Larger cumulus clouds require a slightly different approach. First, paint the negative spaces of the sky with a mix of blue and white, leaving a rough shape of the cloud unpainted. Then block in the cloud with titanium white, blending the edges into the blue of the sky as you work. Add some shadow to the bottom of the cloud with a mix of monestial blue, titanium white, and cadmium orange.

DEVELOPING LANDSCAPES AND TOWNSCAPES

With stratus clouds, less sky is visible. First paint the negative spaces of blue sky with a mix of ultramarine blue and titanium white. Then paint the general cloud shape with titanium white, and blend in the shadow color with a mix of titanium white, yellow ocher, and a touch of alizarin crimson. Apply the paint with horizontal strokes to suggest wind.

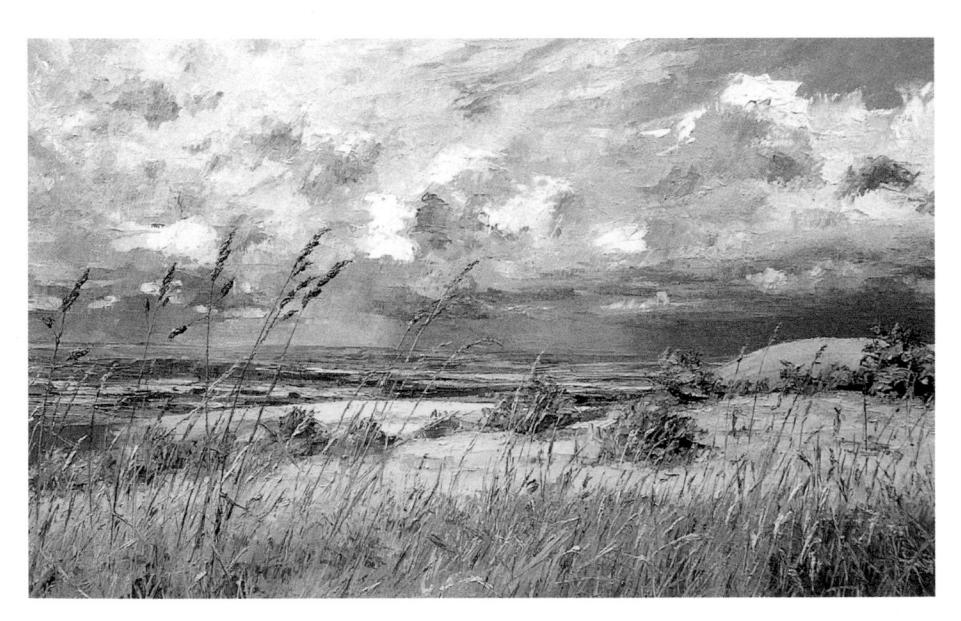

In this painting, Brian Bennett has painted clouds roughly with a painting knife to give a stormy effect. Bands of light and shadow just above the horizon give a sense of the storm passing by.

PAINTING REALISTIC CLOUDS

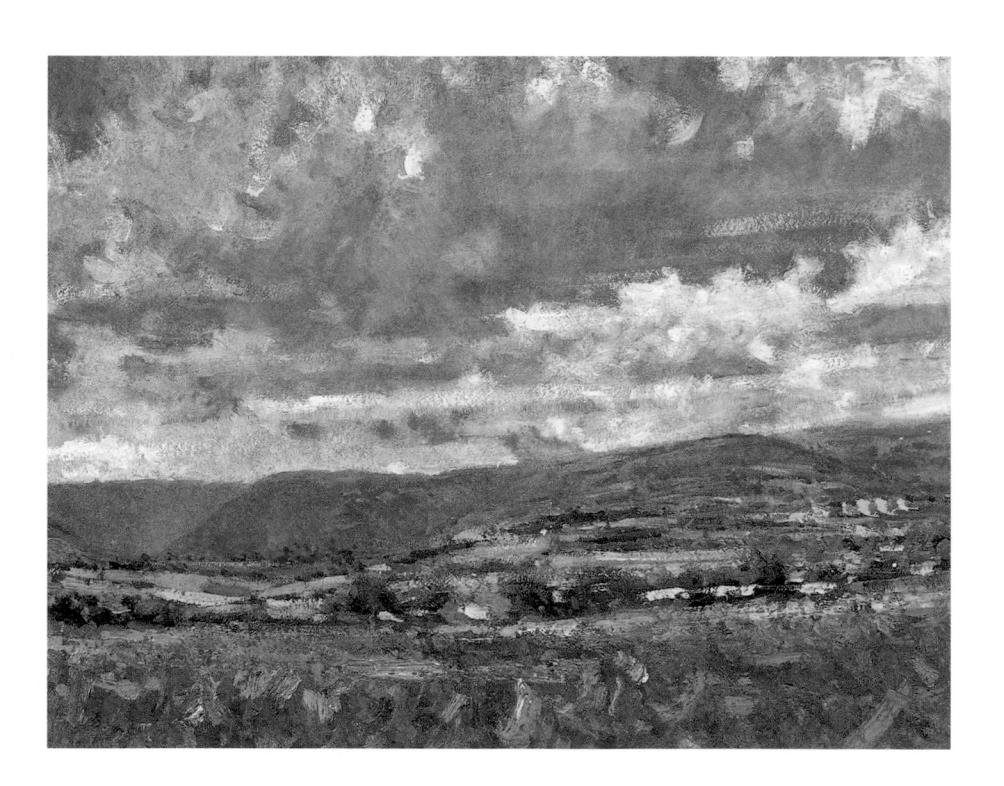

In this painting by Arthur Maderson, an unusual effect is visible: the nearest cloud is painted in cooler shades than the distant ones—the opposite of the rules of atmospheric perspective.

Creating a sense of distance with trees and foliage

Detail—or lack of it—is the secret to painting foliage to give a sense of receding trees. Paint the trees closest to you with the most detail; paint those farthest away with mere suggestions of form and color. To help create the impression of distance, make the trees and other foliage in the background smaller in size as compared to the elements in the foreground.

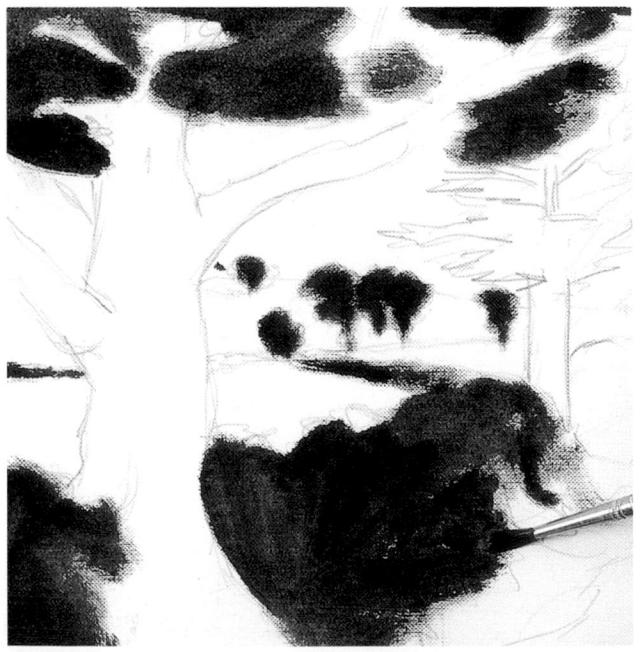

First sketch your composition in pencil, noting that the trees closest to you will be only partly visible because they are so large, whereas trees farther away will be tiny in comparison. Block in your first color with a mix of Hooker's green and burnt umber. (Because they are much farther away, the trees in the distance will consist only of this color.)

CREATING A SENSE OF DISTANCE WITH TREES AND FOLIAGE

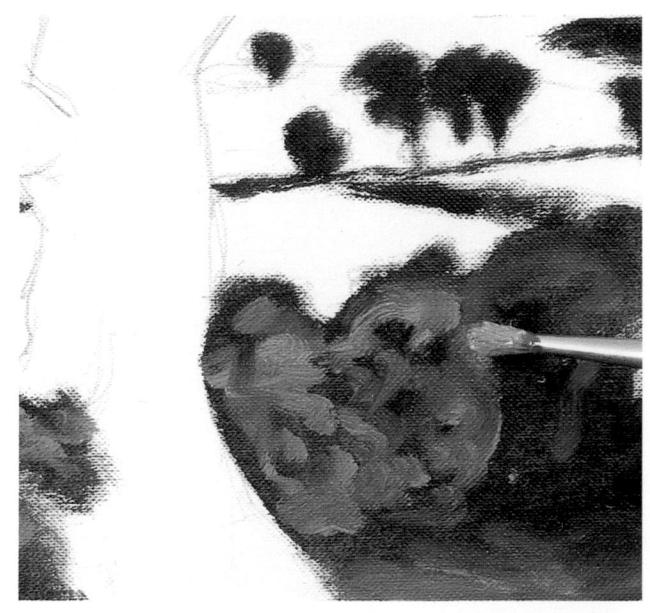

Add more detail to the foliage in the foreground with a mix of zinc yellow, Hooker's green, and burnt umber. Apply only subtle touches of the light green to the foliage as it gets farther away. This will give the impression that it is receding.

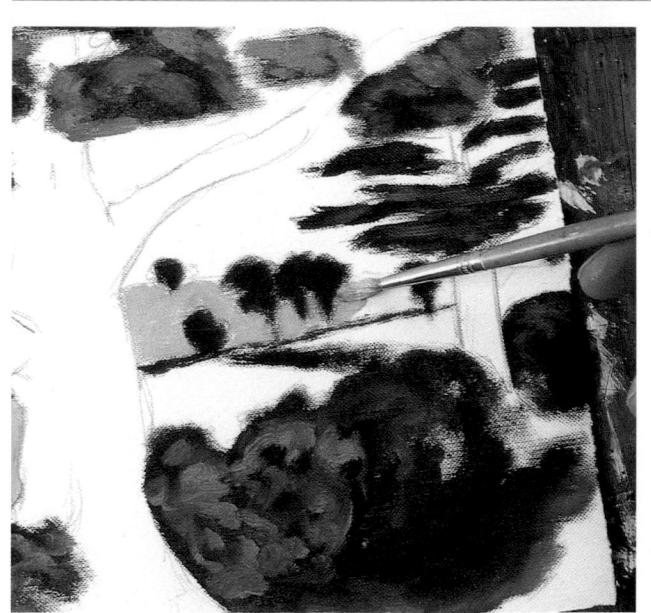

Use the same light green to paint some lighter-colored foliage on the two closest trees. The foliage on the second tree should be less detailed because it is farther away. Add some zinc yellow to the light green mix to paint the fields. This color, and versions of it, will link all the different areas of the picture together.

DEVELOPING LANDSCAPES AND TOWNSCAPES

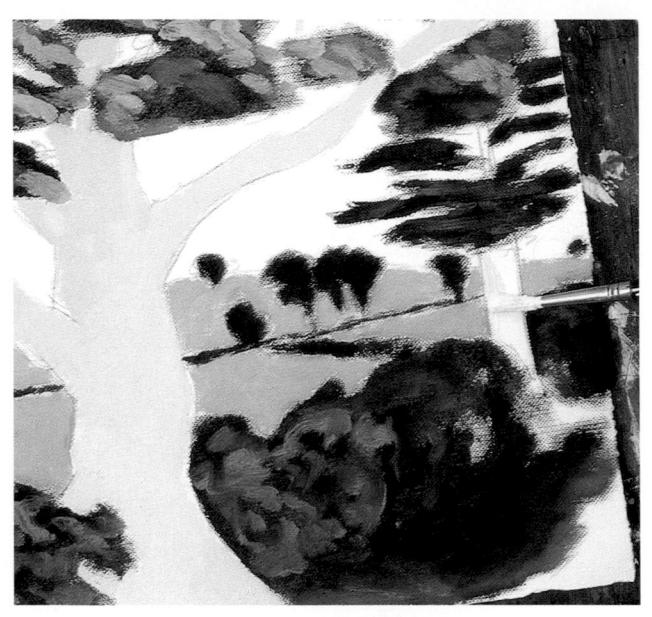

Apply a smooth underpainting to the tree trunks with a mix of red-violet, translucent gold ocher, and titanium white. Even though the palette in this example is restricted, there is still a strong sense of recession, created by the reduction in size of the objects as they recede in the picture plane.

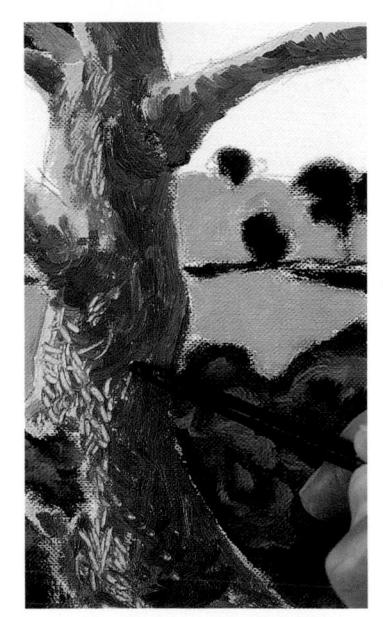

Use a hog brush to loosely apply a mix of burnt umber, translucent gold ocher, and red-violet to the tree trunks. Then scratch through the paint layer with the handle of your paintbrush to reveal the lighter color beneath. This detail brings the tree forward in the landscape.

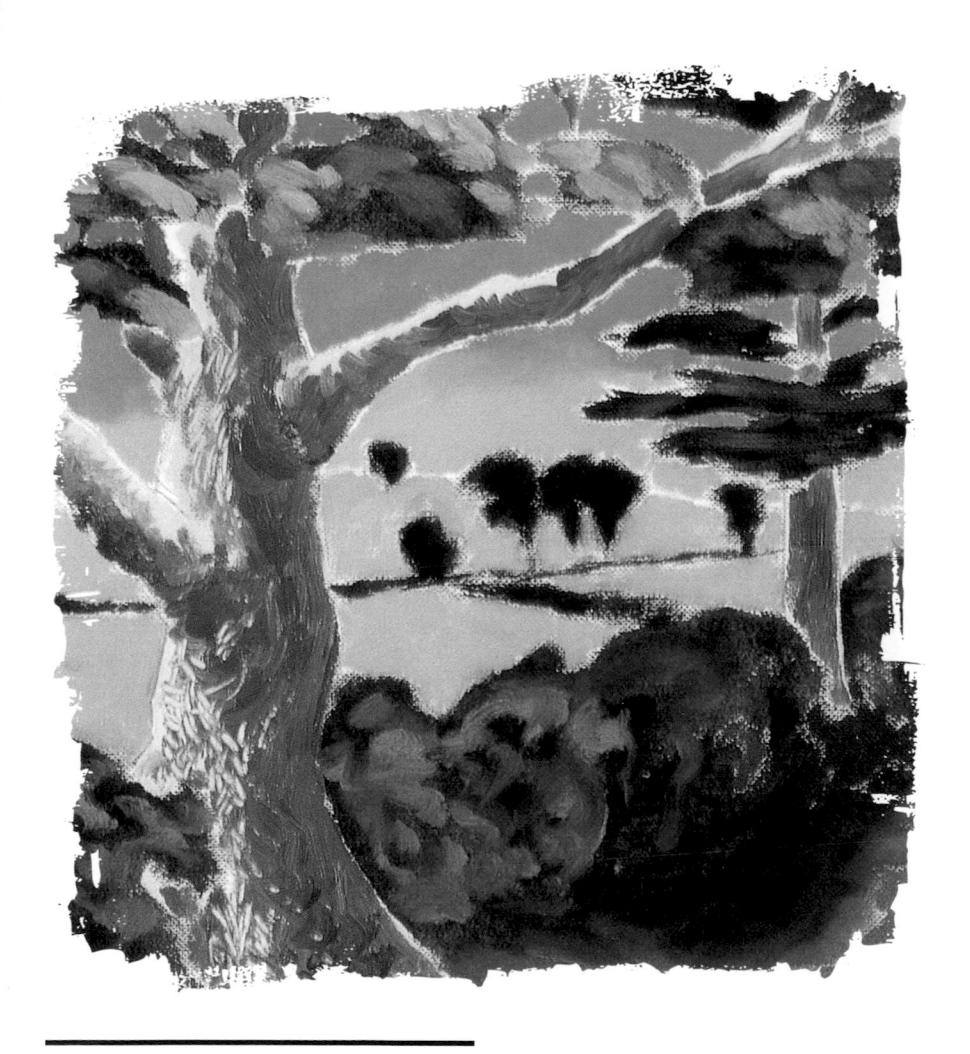

Lessening the detail of the trees and the bushes farther back in the picture plane helps to create an impression of distance.

Landscapes shrouded in fog

Fog casts a soft focus over an entire landscape; only the very closest objects have any definition at all. In the middle distance, objects appear pale; but farther into the distance, tonal contrasts diminish further, and everything takes on the gray silhouette characteristic of fog. To create this hazy effect, blend all the colors of your landscape together.

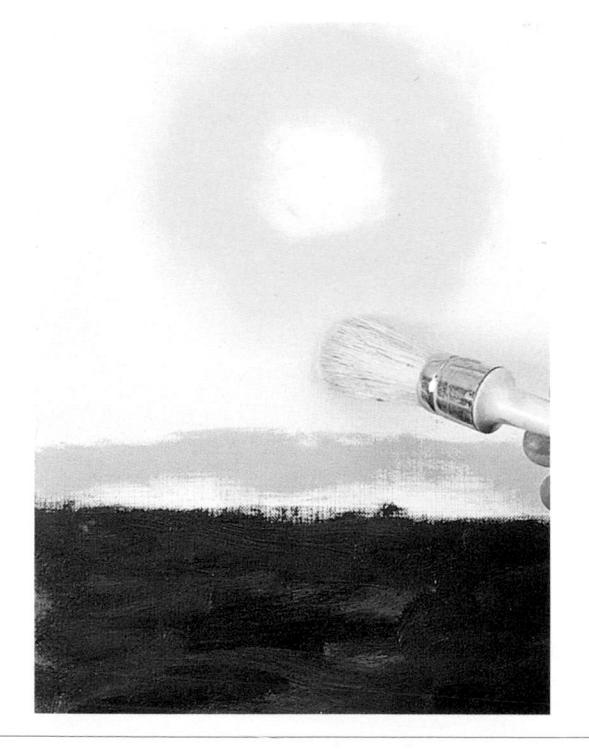

First, paint a generous layer of a mid-tone color onto primed paper. Then, apply a mix of titanium white and a little permanent mauve for the sky. Below this, paint a band of phthalocyanine green mixed with titanium white for the middle ground. Apply the final color with a mix of permanent mauve and a little white for the foreground. At this stage, the colors look quite bold, but this will change once you blend in the paler tints. Next paint the sun with lemon yellow and use a round decorator's brush to gently blend it into the pale mauve of the sky.

LANDSCAPES SHROUDED IN FOG

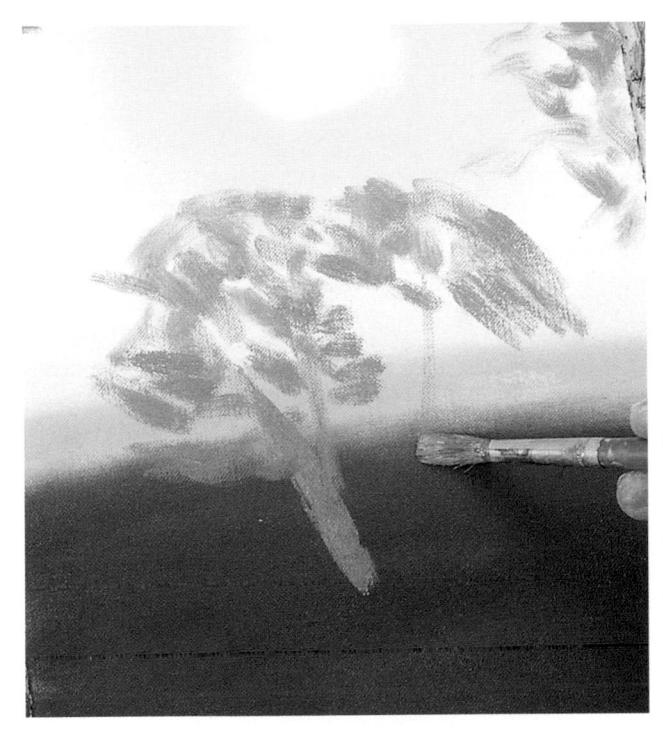

Still using the decorator's brush, blend the three bands of color together so they look slightly blurred. Then, using a round hog brush, paint the focus of the painting—here, the tree—with a mix of white and permanent mauve.

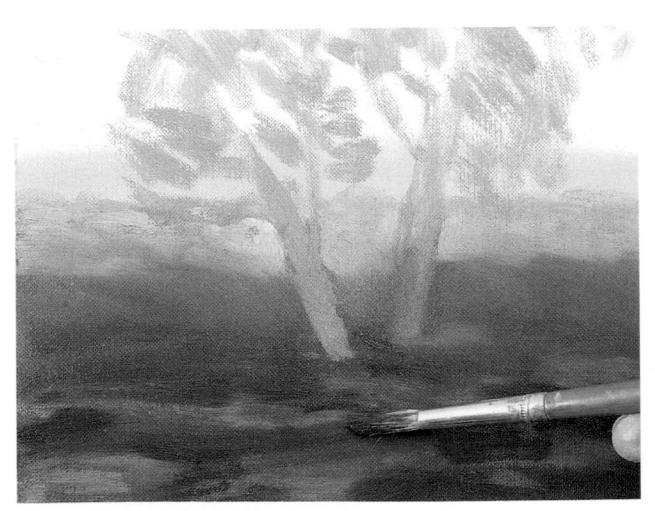

Suggest fallen leaves by making broad sweeps of the brush to apply a mix of cadmium orange and alizarin crimson.

DEVELOPING LANDSCAPES AND TOWNSCAPES

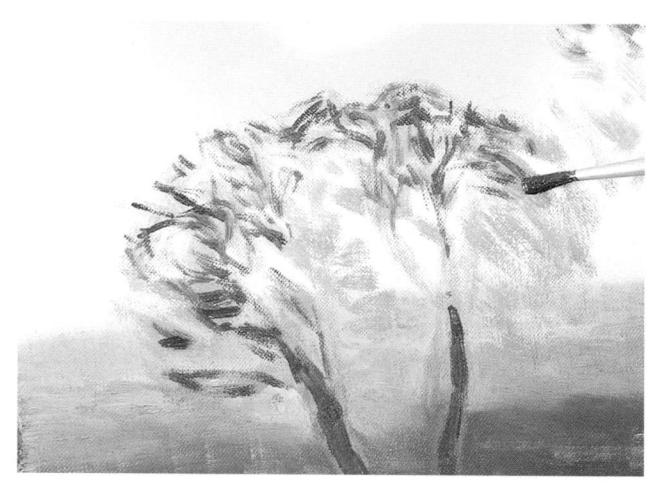

Next, use a medium round sable brush to add fine detail to the tree with a dark mix of phthalocyanine green, permanent mauve, and titanium white. With the light-colored sun behind it, this color will appear very dark.

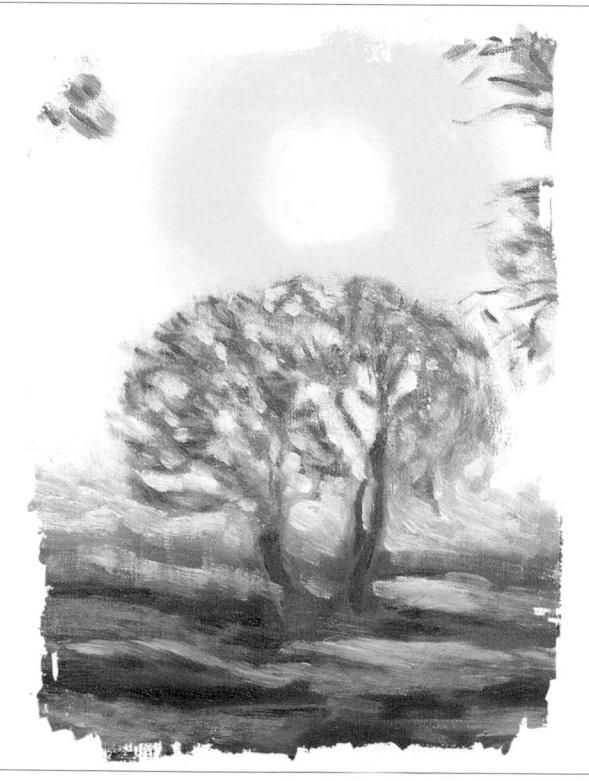

Blend and stroke a mix of titanium white and violet into the wet paint where a softer focus is needed. Add pockets of mist on the ground, so the mist looks as though it is creeping forward.

LANDSCAPES SHROUDED IN FOG

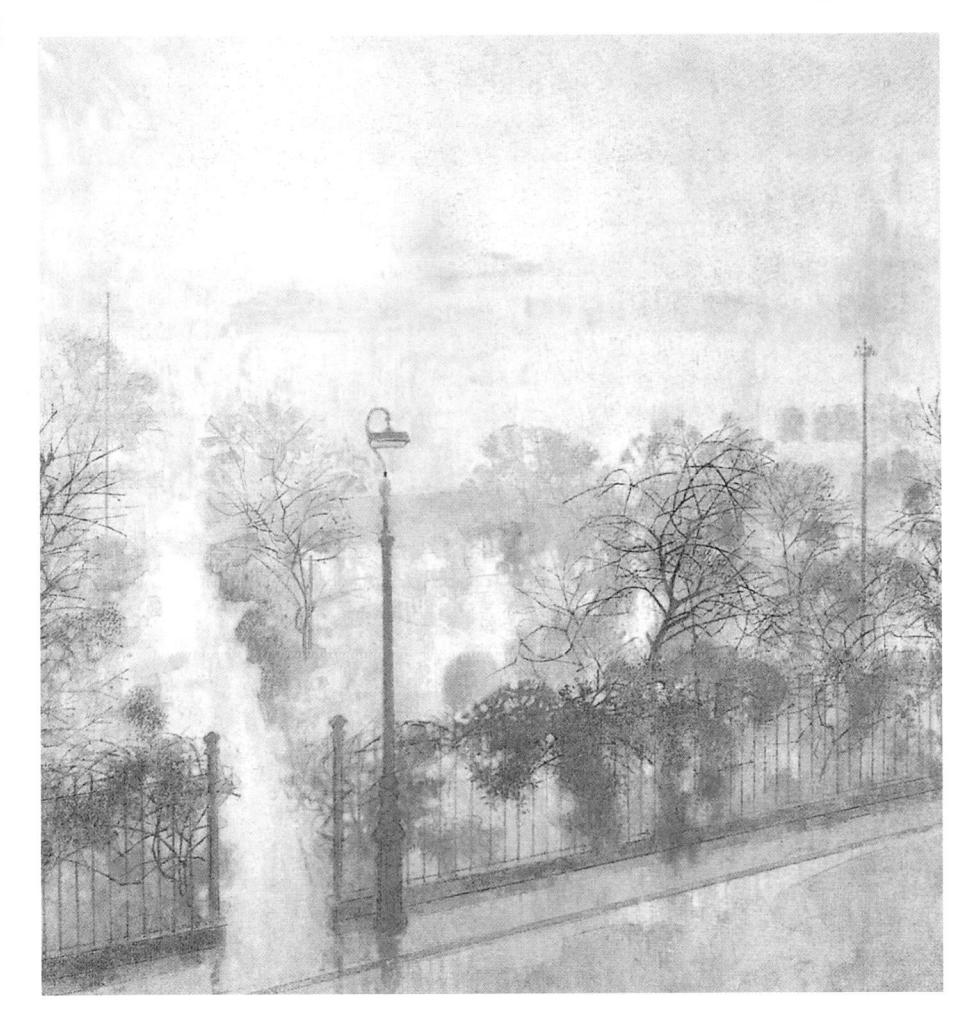

In this painting by Derek Mynott, delicate, calligraphic line work over a layer of softly scumbled pale blues and yellows creates an impression of light penetrating the mist and illuminating the foreground.

Demonstration: Outdoor landscape

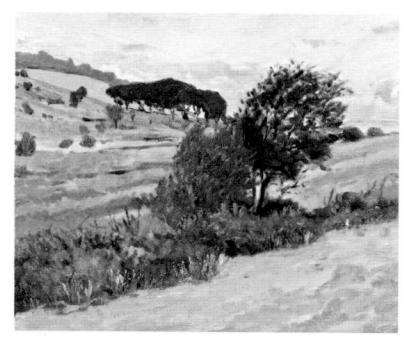

The pleasure of painting in the open air inspires many people to take up painting. However, the first time you paint outside, it will probably feel quite strange. There are so many possible subjects to choose from that the experience can

be confusing, and even a little daunting. It is a good idea to first develop your drawing and painting skills indoors, learning to observe closely and to create compositions of interesting still life arrangements. Next, try painting in your garden and neighborhood, where you can choose a small corner to start with and gradually increase the complexity of your compositions as you gain confidence.

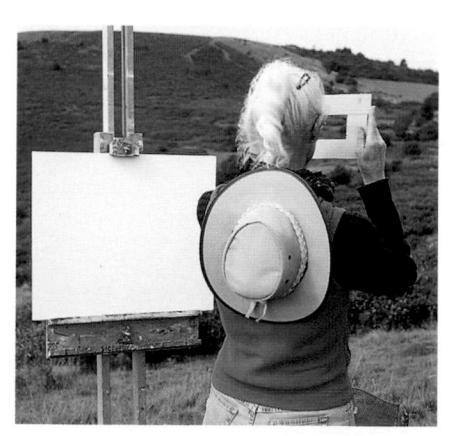

Once you have set up your easel, use a viewfinder to scan the area around you for an interesting composition. You can adjust the viewfinder to a square, portrait, or panoramic (landscape) format.

DEMONSTRATION: OUTDOOR LANDSCAPE

Equipment for painting outdoors

- · A light, tubular steel or wooden easel
- · A light folding chair or stool
- A light canvas bag or knapsack
- A few selected tubes of paint. Suggested colors: titanium white, lemon yellow, cadmium yellow, yellow ocher, cadmium red, alizarin crimson, ultramarine, cerulean blue, viridian, Hooker's green, burnt umber, and raw umber. You can mix most colors from just these few and add or remove colors as your own preferences develop.
- A few small painting boards or an oil sketchbook (try this on your easel first)
- A small palette
- A dipper
- A small bottle of pure turpentine
- · A small bottle of mineral spirits
- · Painting medium
- · A cotton rag

- · A few hog bristle brushes
- Think about a means of carrying your wet paintings; some shallow cardboard boxes can be useful. Some artists make their own carrying cases to fit a certain size of painting board. Whatever you use should be light enough and small enough to carry along with the rest of your equipment.
- You should be able to fit everything into a knapsack, leaving your hands free for the easel and stool. Some artists do without an easel, finding it convenient to work on their laps.

This list may not be perfect for you, but it will give you a good starting point. After a few forays, you will discover what you can leave behind or what else you might need.

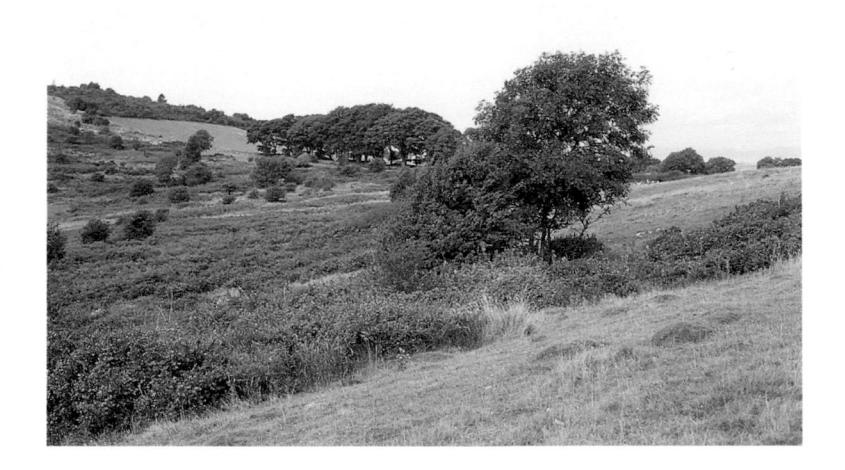

Take your time selecting an interesting composition. Make sure that it is not only visually interesting but also balanced in terms of tone and color.

DEVELOPING LANDSCAPES AND TOWNSCAPES

Begin by sketching your composition in lemon yellow, using a fairly large round hog brush. Lemon yellow is easily incorporated into subsequent layers of paint and gives the painting a feeling of sunlight from the outset. Thin the paint with a little turpentine, and add painting medium to speed up the drying process. (Add painting medium to all the colors.)

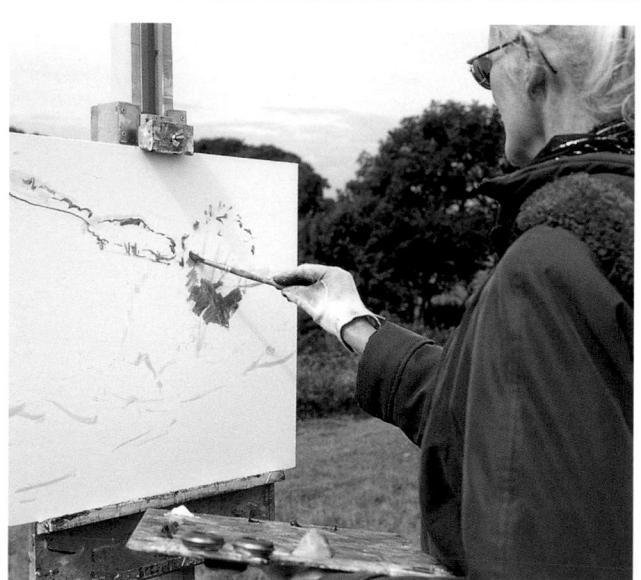

Once you have established the composition, paint over the strongest lines of the landscape with monestial blue. Then block in the dark areas with the same color.

DEMONSTRATION: OUTDOOR LANDSCAPE

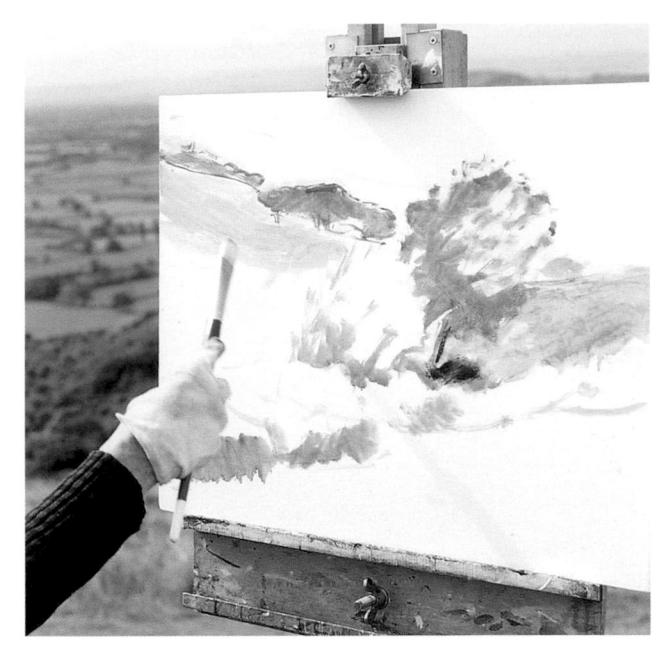

Block in the grassy areas by adding touches of crimson lake, monestial blue, and a little yellow ocher to the lemon yellow. Keep your paint thinned with turpentine and painting medium. Make broad, flowing sweeps with a large flat hog brush.

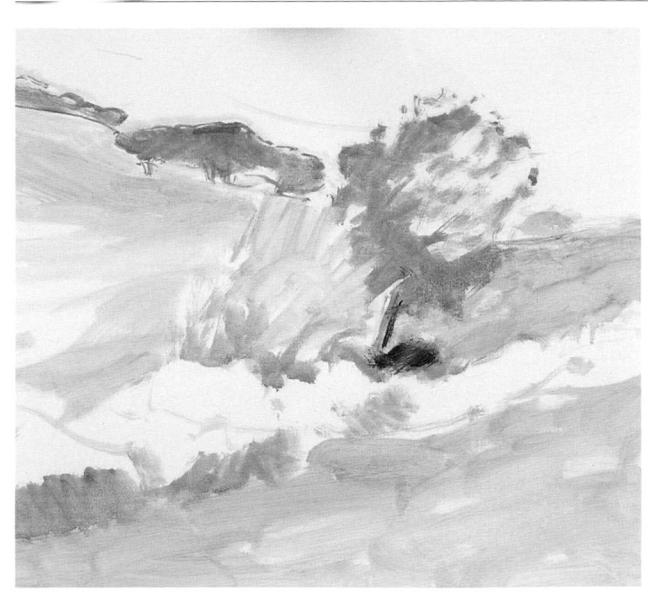

At this stage you have established the main areas of light and shadow and have a strong base to work on.

DEVELOPING LANDSCAPES AND TOWNSCAPES

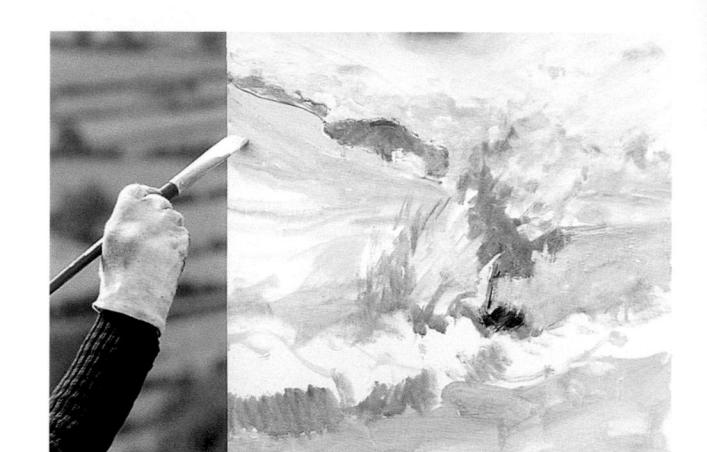

Working quickly, paint the sky with a thinned mix of monestial blue and crimson lake.

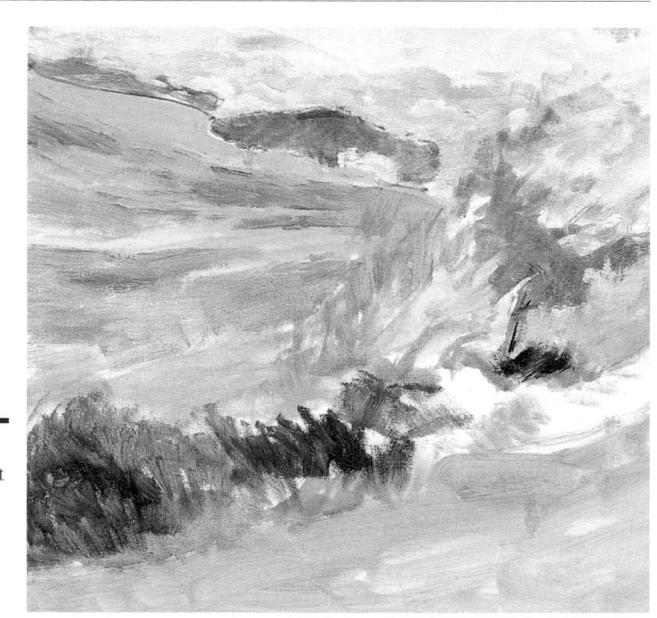

Paint the sky early so that you can paint foliage on top of it. It is not impossible, but it is more difficult to paint expanses of color around detailed objects.
DEMONSTRATION: OUTDOOR LANDSCAPE

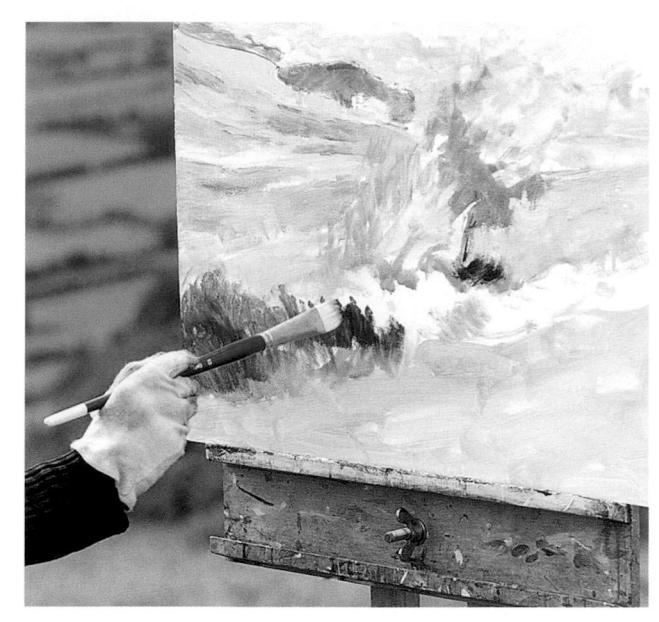

Next, add some
Hooker's green and
viridian—pale in the
middle distance and much
darker in the foreground.
Add *impasto* medium to
bulk out the paint, and
make your brush strokes
more obvious from now on.

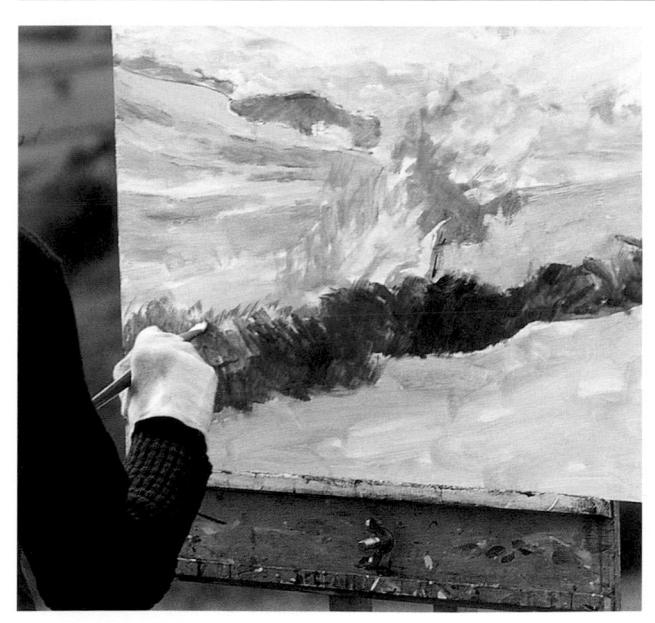

Paint the dark green bushes in the foreground using short, brisk brush strokes to capture the details of the foliage. Keep the brushwork lively by painting quickly.

DEVELOPING LANDSCAPES AND TOWNSCAPES

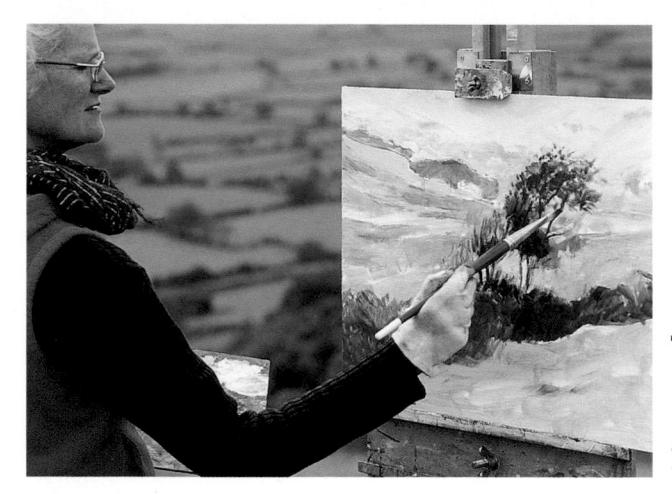

Next, use a mix of monestial blue and a little alizarin crimson to darken the foliage of the trees.

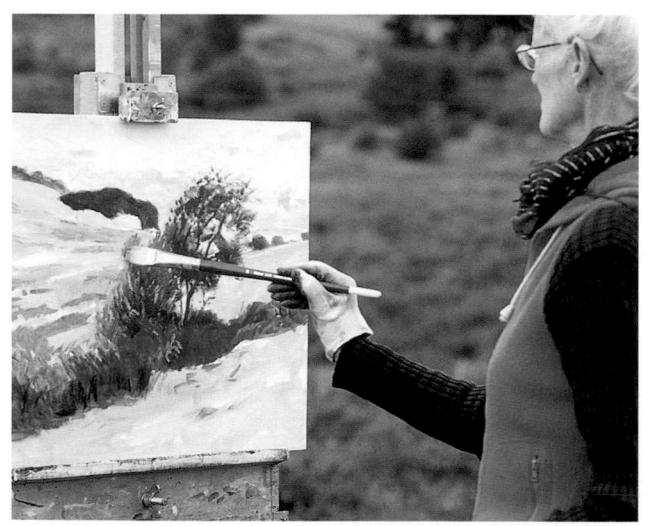

Mix together several colors—yellow ocher, a bit of viridian, cadmium red deep, and titanium white—to make the warm browns of the bracken and the small bushes.

DEMONSTRATION: OUTDOOR LANDSCAPE

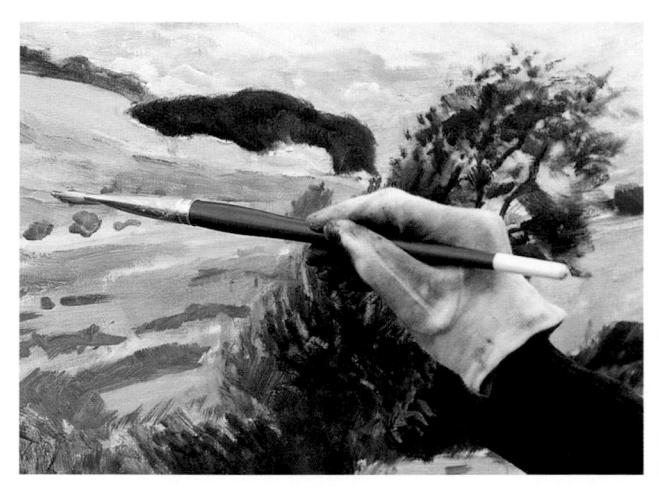

Hint at the undergrowth on the hills in the middle distance with little flicks of the brush.

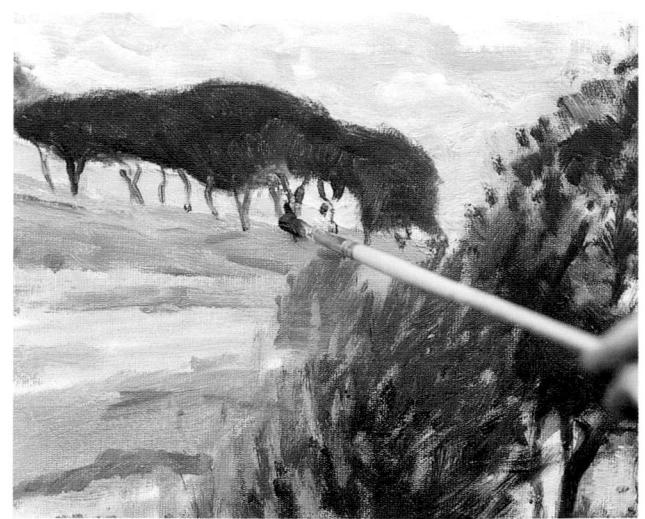

Use monestial blue to paint the trunks of the large group of trees in the distance.

DEVELOPING LANDSCAPES AND TOWNSCAPES

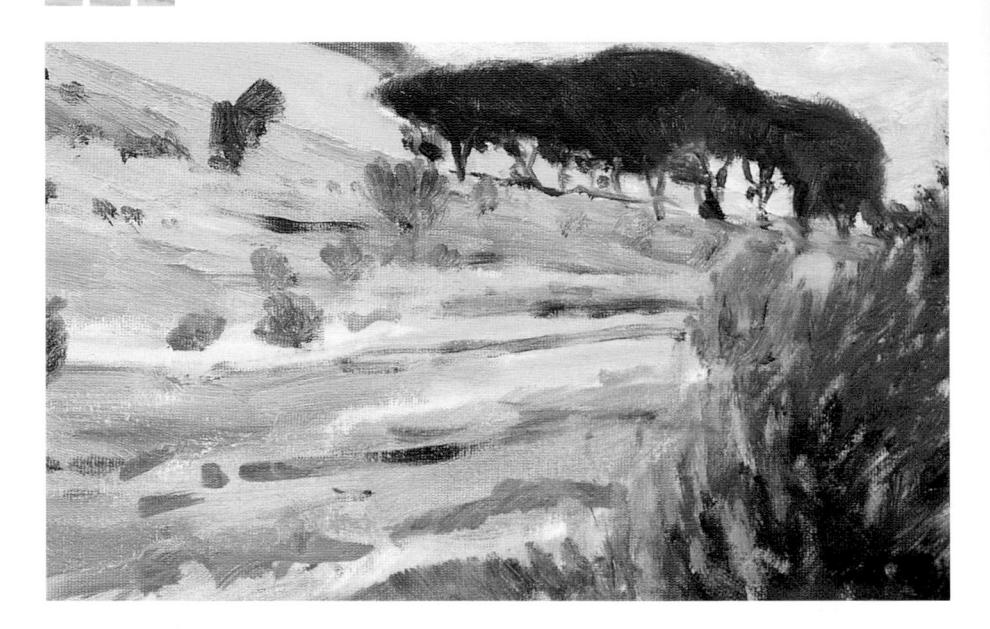

15 Mix a pale mauve from some monestial blue, alizarin crimson, and titanium white. Use this color to block in the distant wall and add details to the main tree.

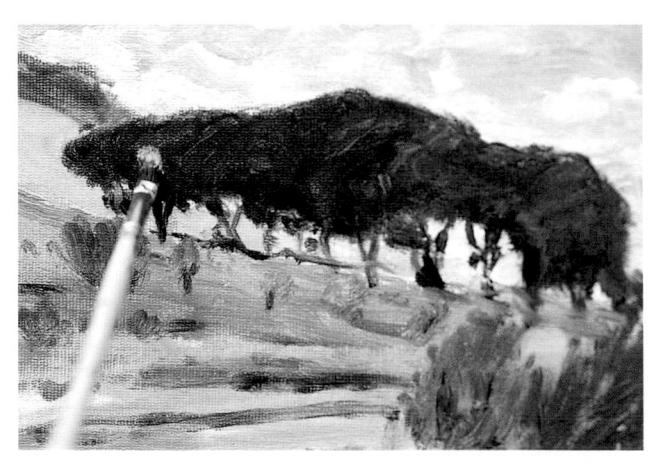

16 Lighten the outer foliage on the trees in the middle distance with cadmium yellow deep mixed with white.

DEMONSTRATION: OUTDOOR LANDSCAPE

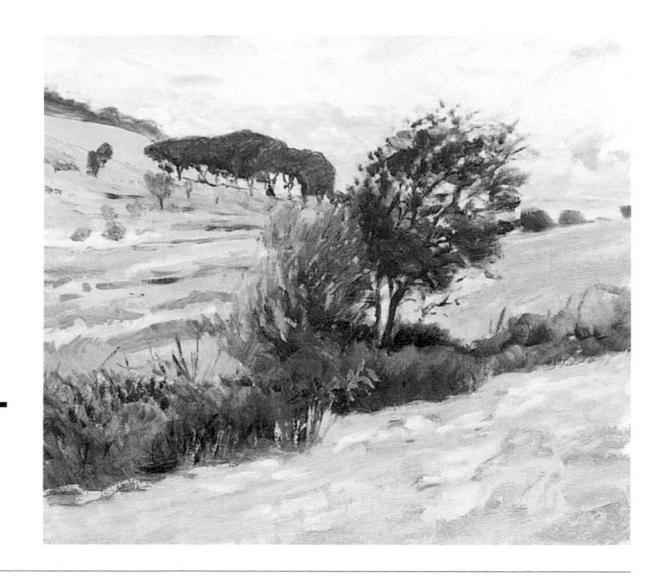

The foreground and middle ground are almost complete, but there are still details to finalize.

1 Susing white warmed with a little yellow ocher, paint some dried grasses using the tip of a round brush. Add color to the immediate foreground in broken horizontal strokes.

Add some more dried grasses with the edge of your painting knife.

Include a little *impasto* medium in the mixes to help build up the surface of the paint.

DEVELOPING LANDSCAPES AND TOWNSCAPES

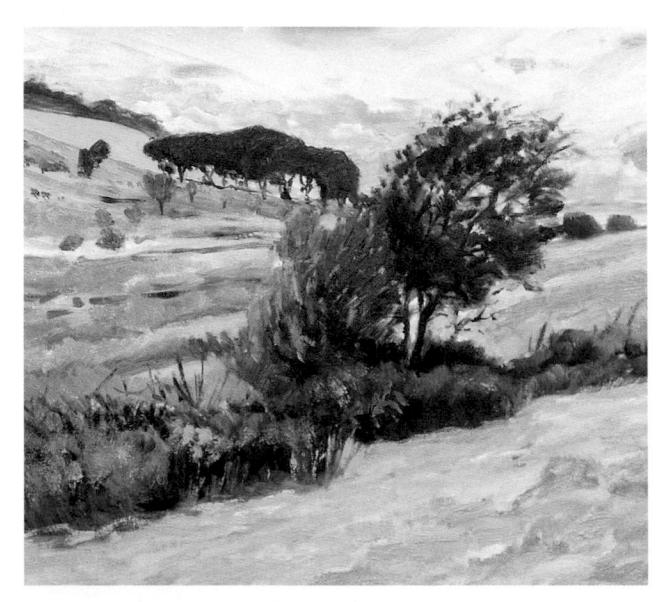

20 Stand back from your painting to take a fresh look at it. Although it is nearly complete, you may still like to add a few small touches.

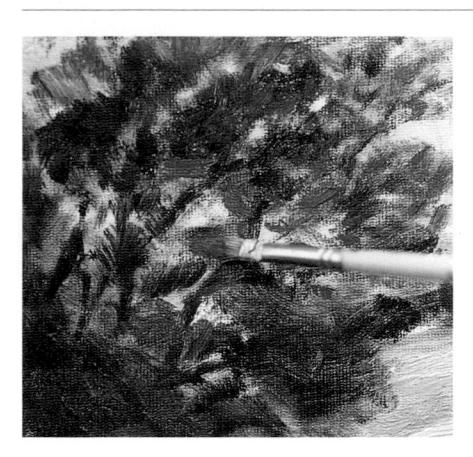

The nearest tree needs a little more color. Load your brush with cerulean blue, and dab it into the darker blues with short, light brush strokes. This will make it contrast more with the reddish bush nearby.

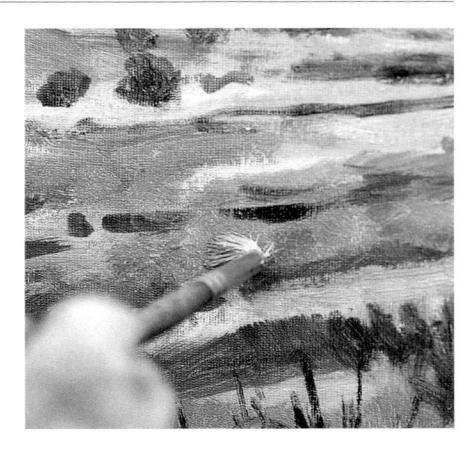

Look at your painting again to decide if there are any areas where you think distinct colors should be blended. Blend colors on the board using a clean brush.

DEMONSTRATION: OUTDOOR LANDSCAPE

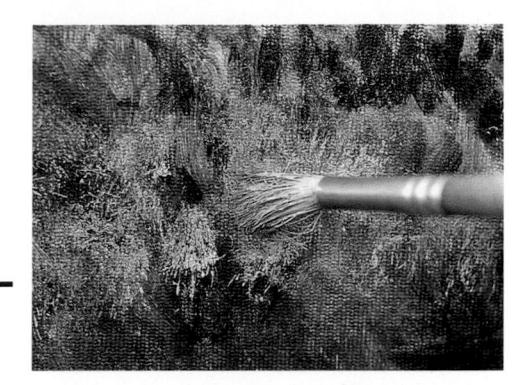

73 Scumble on some cadmium yellow for the flowers.

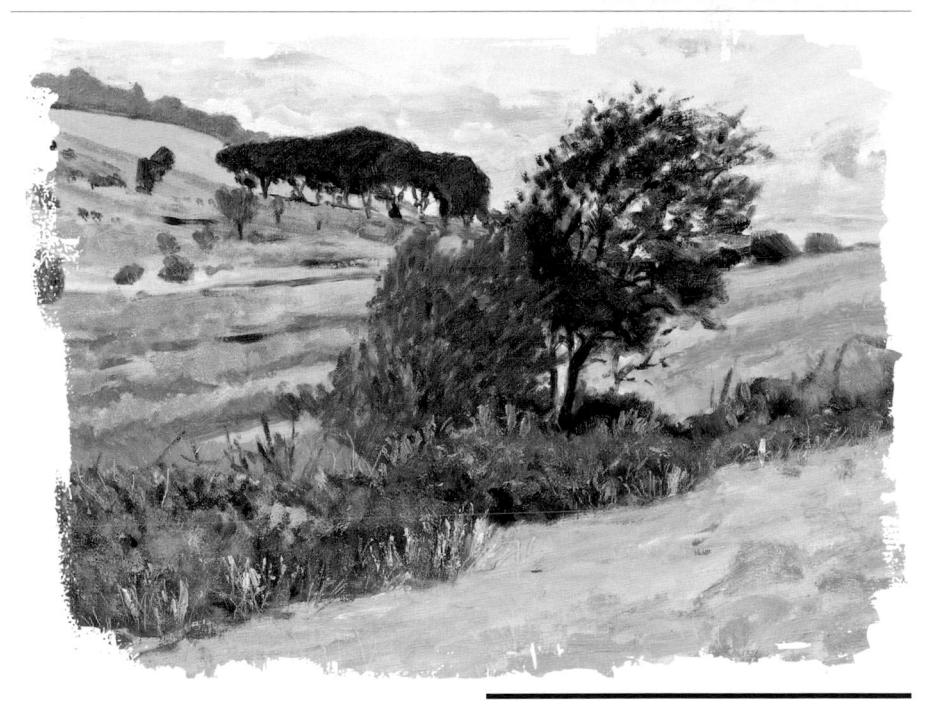

When working out of doors, the light changes through the course of the day, sometimes quite quickly and dramatically. A quick color sketch at the outset can help you to complete your final painting.

Painting realistic windows

A window presents a particular challenge to an artist who is interested in architectural subjects. It might reflect the sky or objects nearby; it might protrude or be recessed; it might be decorated with stone, wooden, or metal details, such as shutters; it might even allow you to glimpse the curtains or the room inside. The most important thing a window adds to a building is a feeling of atmosphere. You can make the viewer believe that a building is a safe, warm place or a derelict, forgotten structure just by the way the windows are portrayed.

Remember to relate each window both to the others and to the shape of the building as a whole. Look for cast shadows to give each a sense of solidity, and carefully observe the reflections in the glass to describe the light and conditions of the rest of the scene.

Sketch a window in pencil, and then block in the main surrounding colors.

PAINTING REALISTIC WINDOWS

Pick out some of the details of the brick- or stonework around the window, like these large stones in several shades of gold ocher and titanium white. Then, paint the mortar with a darker tint of the same colors. These will be your base colors for the frame and shutters.

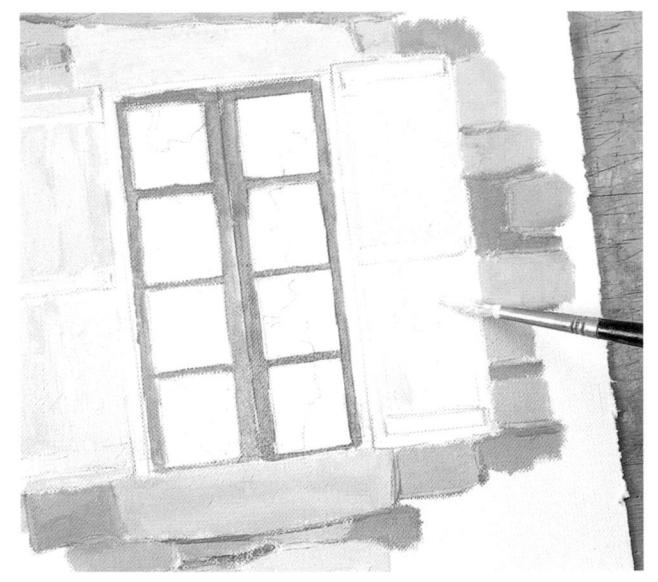

Give the window frame an initial underpainting of gold ocher. Then paint the shutters, blocking in color to offset the windows.

DEVELOPING LANDSCAPES AND TOWNSCAPES

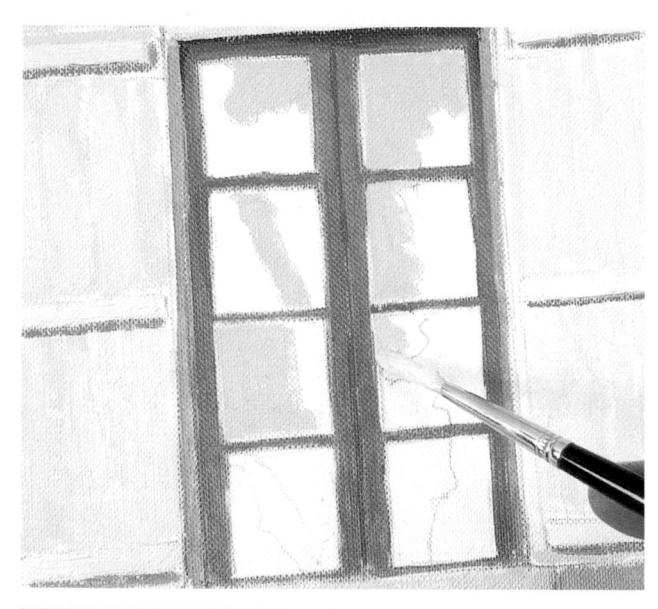

Add shading to the window frames with a mix of burnt umber and ivory black to give the wood a three-dimensional look. Apply the lighter areas of reflection in the glass panes with a mix of cobalt blue and titanium white.

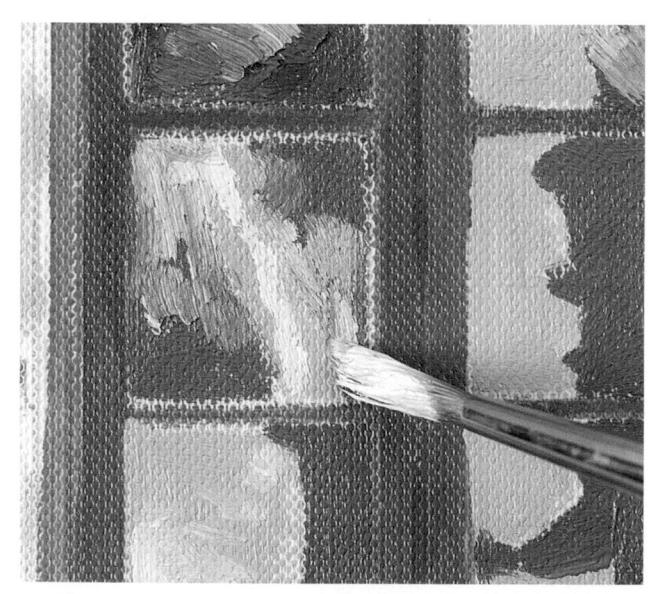

Paint the dark areas of reflection in the glass with a mix of ultramarine, ivory black, and titanium white. Then, paint the lightest areas by blending titanium white into the other colors.

PAINTING REALISTIC WINDOWS

Shade areas of the brickwork with a mix of burnt umber and ivory black to define the shape and depth of the bricks. For the final touch, paint the shadows cast onto the wall by the shutters. The reflections in the finished piece show the abstract patterns that light often casts on glass.

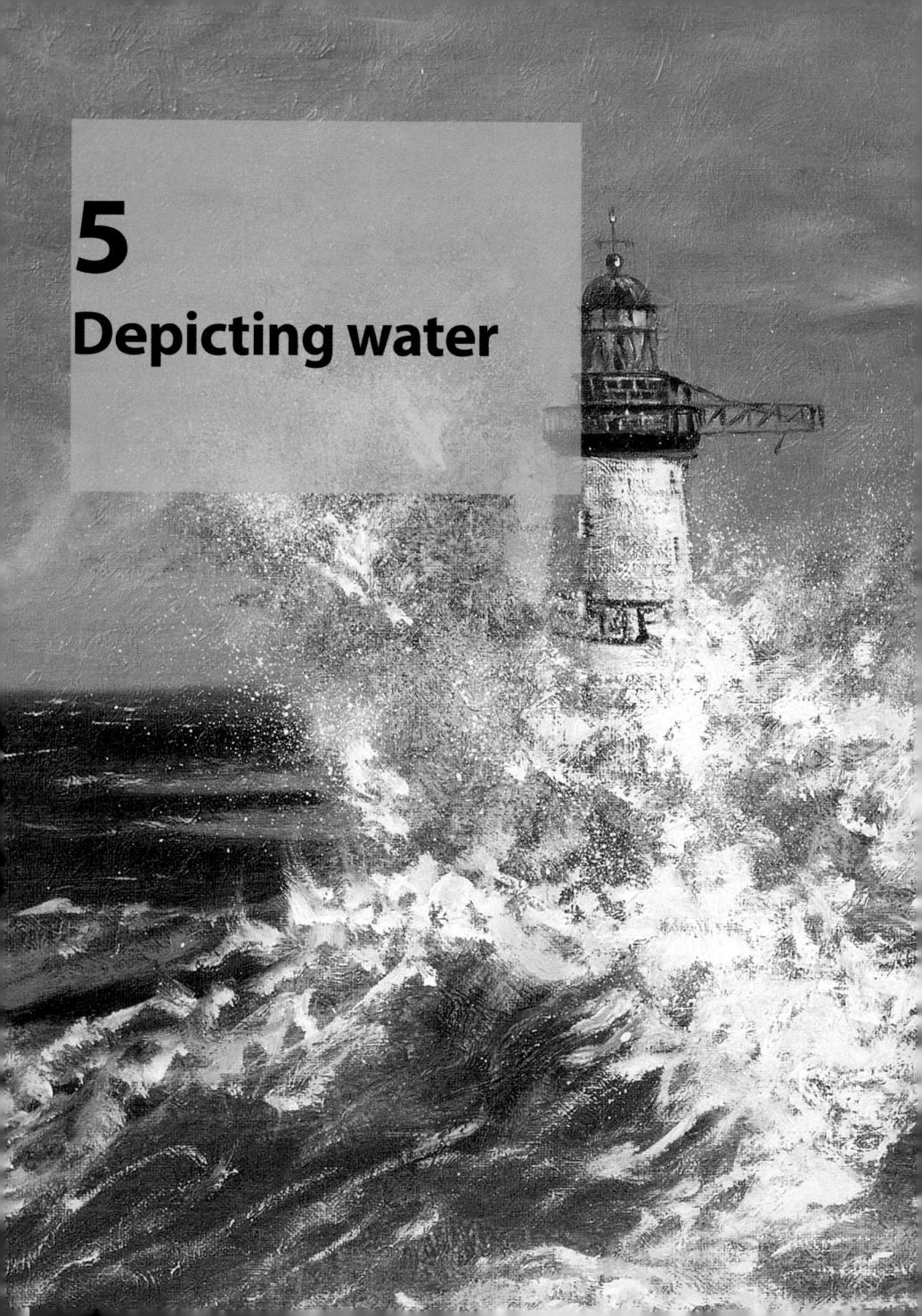

As you will discover in this chapter, the key to painting water it's a waterfall in constant agitated movement, a choppy sea, or a still lake with mirrorlike reflections—is observing the essential features.

These features include the main colors and tones, the patterns made by ripples and the direction in which they move, and the shapes of waves and the way they curl over the top, showing the dark underside below the white crest.

Possibly the most expansive of subjects to try to paint is a view across an ocean. Its form is constantly changing, especially with rough seas. Many artists work from photographs so they can spend time catching the true character and shape of the waves.

Painting rivers, streams, and lakes can present challenges as well. Still water can contain complicated reflections that are disturbed and distorted by ripples. However, this chapter will help you overcome these difficulties, giving you advice on how to sketch these complicated forms, how to manipulate color to create waves and reflections, and which brush techniques to use to create both rough seas and reflections.

Painting still water

The key to painting clear, shallow water is being able to capture the distorted objects below its surface. Because the objects are wet, they look darker; and, as the water deepens, they take on a bluish or greenish color cast.

Mix cobalt blue, titanium white, and painting medium to create a warm, bluecolored ground. Draw the outlines with ultramarine mixed with carmine.

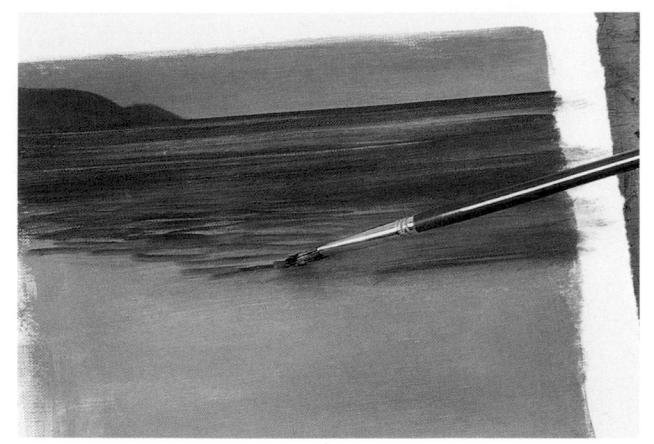

Paint the sky with a mix of cerulean blue and white. Block in the distant peninsula, and darken the distant water with ultramarine blue.

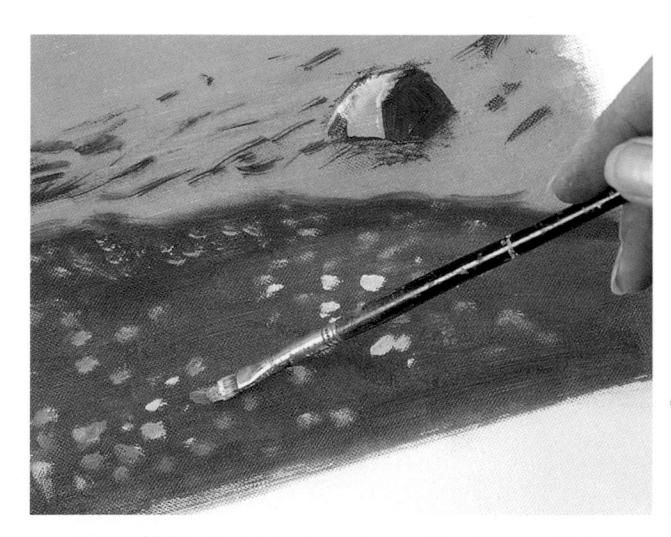

3 Use the same color in the foreground to darken the foreshore and mark the water's edge.

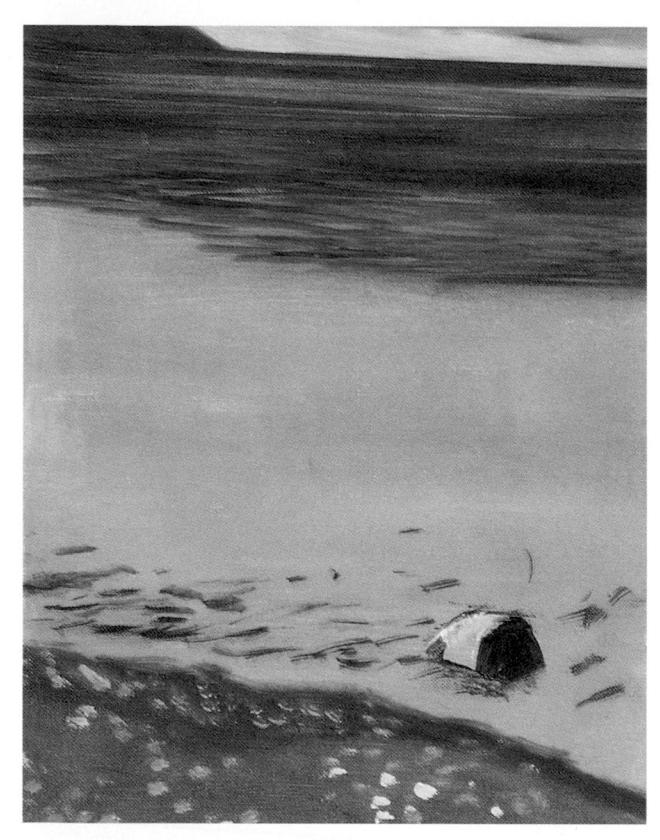

Paint the pebbles on the shore in varying tones of cerulean blue, titanium white, and yellow ocher. The sharpness of the pebbles on the shoreline will form a contrast to the blurred pebbles under the sea.

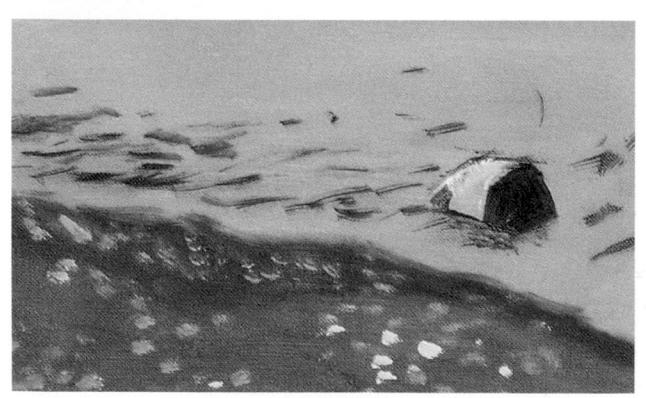

Mix lemon yellow and emerald green to paint the seaweed. For the water's edge, mix cerulean blue with some titanium white, and paint some of the dry pebbles on land with titanium white.

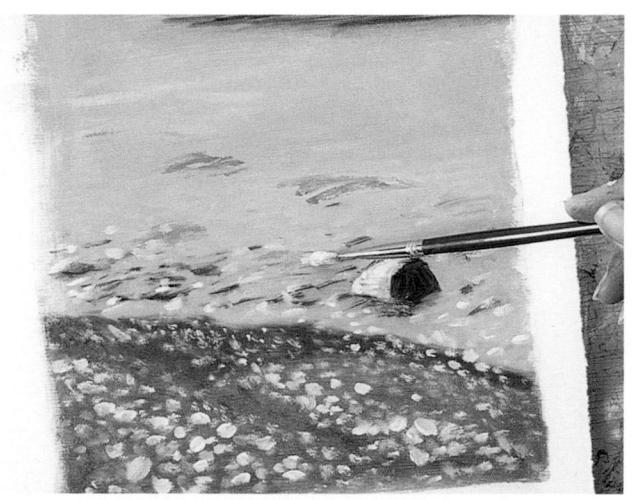

Use cerulean blue, titanium white, and emerald green in varying mixes to paint the sea, giving the impression of the water deepening farther back. Suggest clumps of seaweed using the same mixes.

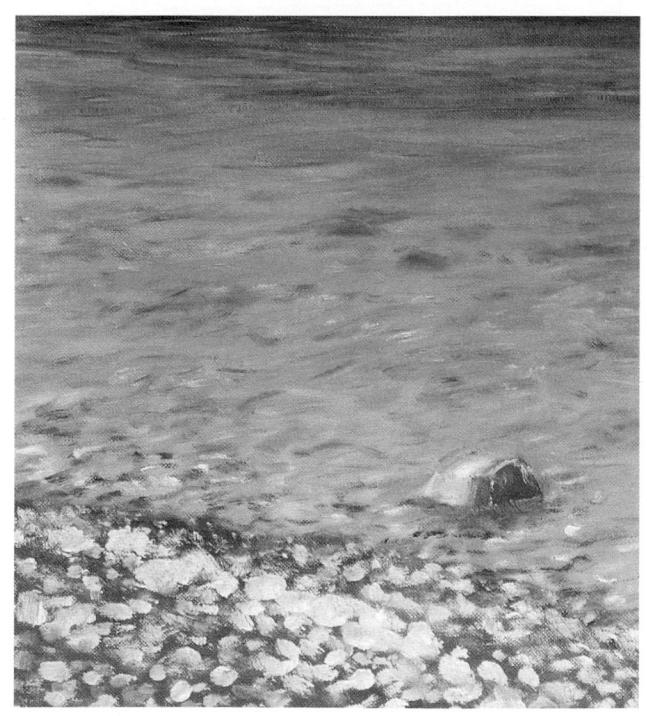

Develop the impression of sunlight on the dry pebbles in the foreground with strokes of titanium white and touches of cerulean blue and yellow ocher. In the shallows, add more cerulean blue to suggest some pebbles beneath the water, but blur and distort these with your brush. Also, tone down the seaweed slightly with touches of blue to give the impression that it is underwater. Then add a bit of ultramarine to break up the water's edge.

Painting reflections on water

Water usually reflects whatever surrounds it. Reflected colors are a little darker than their source colors, and, if the water is muddy, this too has an effect. The type of light also affects reflections. For example, sunlight bounces off ripples breaking up the colors and shapes of any objects reflected in the water.

A cloudy day, on the other hand, makes reflected colors seem much darker, and the calmer the water, the more perfect the reflection. Reflections in still water seem to drift downward and become slightly elongated; ripples on water disturb reflections, distorting the object's shape and outline. Observe whether horizontal ripples are all you need, or whether you also need vertical lines. If so, place the vertical lines first and then develop the water surface with horizontal strokes for any further ripples.

For this bridge in late afternoon light, first paint a ground of warm earth-red—with a mix of titanium white, a little light red, and painting medium. Make a quick sketch of the bridge using sepia.

PAINTING REFLECTIONS ON WATER

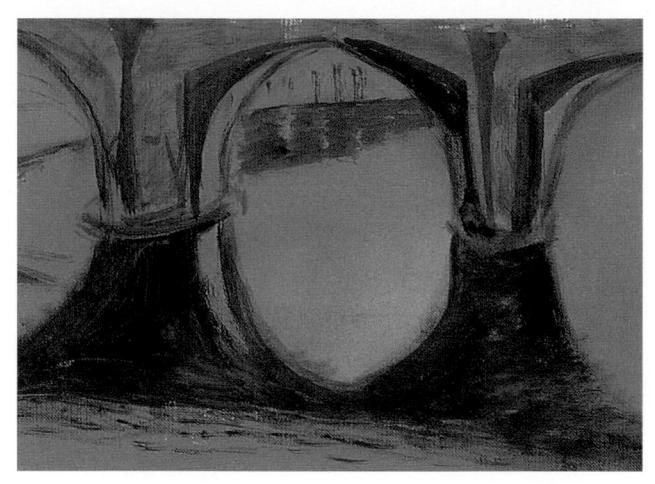

Add the dark reflections cast by the bridge on the water, and the architectural details with a mix of sepia and painting medium to complete the underpainting.

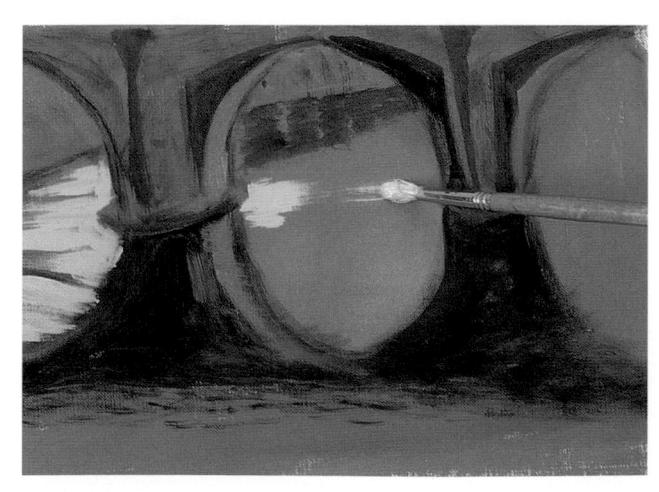

Paint the bridge using a warm mix of cadmium orange, titanium white, and burnt sienna. For the water, start with a cool blue, painting in wavy, horizontal strokes with a mix of cerulean blue, transparent gold ocher, and titanium white.

The ripples define the surface of the water, so cut across the dark reflection of the bridge to imply a sense of movement. Also add some warm tints to the reflection of the bridge's masonry with a mix of cadmium orange, titanium white, and burnt sienna.

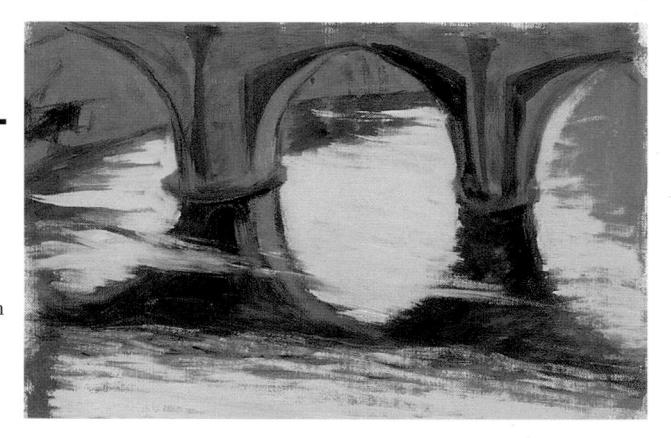

Give a golden glow to the river with horizontal strokes of a mix of cadmium yellow and titanium white. Further define and soften the outlines of the bridge's reflection to create the impression of moving water.

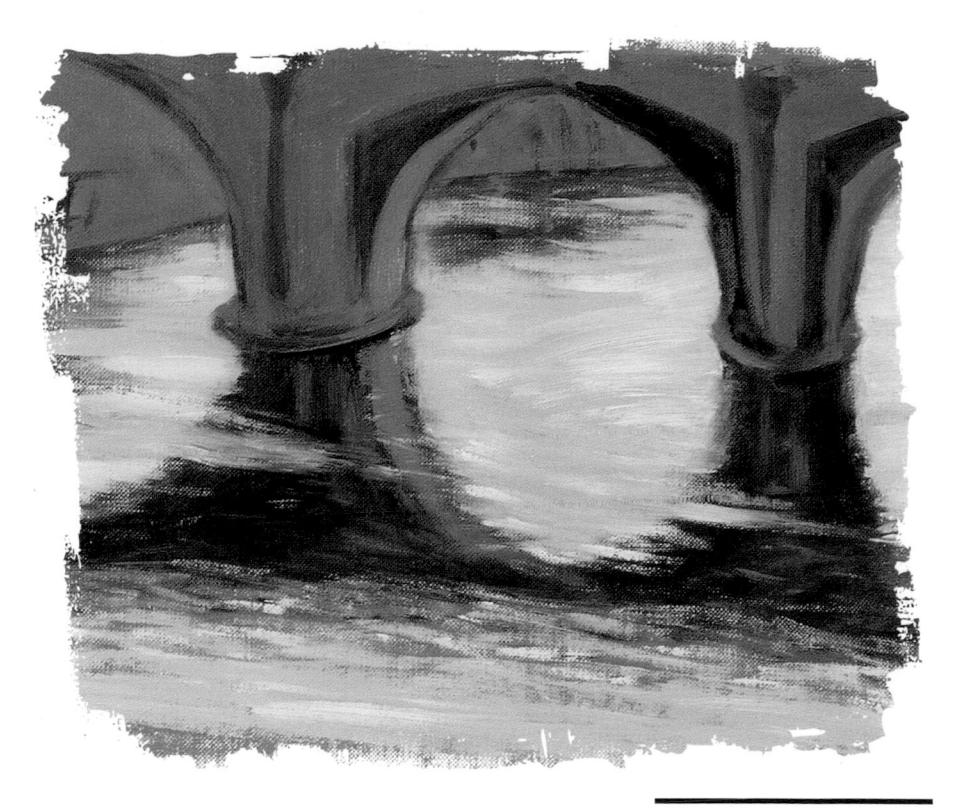

Paint the front of the bridge, which is in shadow, with a mix of cerulean blue, burnt sienna, and white. Leave the inside of the arches the warm tone applied earlier to capture the light shining from behind. Add a few strokes of the same color where it is visible in the dark reflection.

Demonstration: Sand yachts

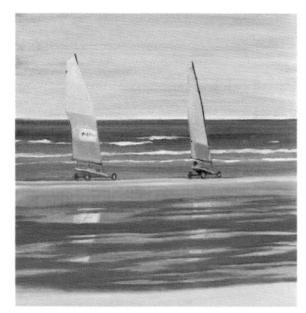

Beach scenes are among the most popular subjects for oil paintings. Umbrellas, towels, and all the paraphernalia of beach games provide endless opportunities for creating interesting compositions. People sunbathing and swimming,

Start by painting parallel stripes of color to represent the sky, sea, and beach. This is easier if you turn the canvas sideways to paint using vertical strokes. Paint the sky with a mix of ultramarine, permanent mauve, and titanium white. For the sea, use monestial blue with permanent mauve and white. Lighten and warm this mix as you come forward in the picture by adding more vellow ocher and white. Blend these two tints together to suggest deep and shallow water. For the wet sand, use vellow ocher mixed with cadmium orange and permanent mauve. For the dry sand, use a mix of yellow ocher, titanium white, and permanent mauve.

DEMONSTRATION: SAND YACHTS

and children playing become models for studying the human figure. And the sea itself—expansive and glittering, swept into mountainous breakers, or lying gray and quiet beneath a blanket of clouds—is an enthralling and challenging subject.

Turn the canvas the right way up and carefully draw the vachts with ultramarine lightened with a little titanium white. Use a mahl stick if you feel you do not have a steady hand; it is important to keep the background colors clean.

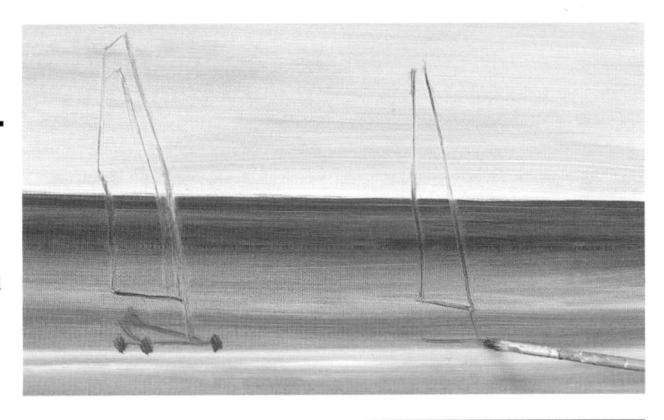

Turn the canvas on its side again and paint the foreground puddles with a mix of ultramarine, titanium white, and a touch of cadmium orange.

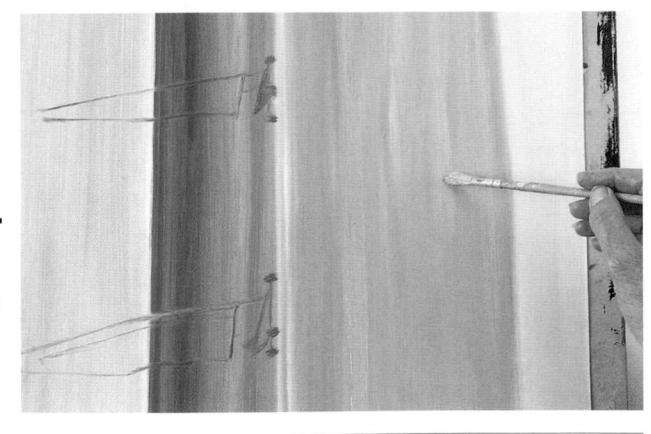

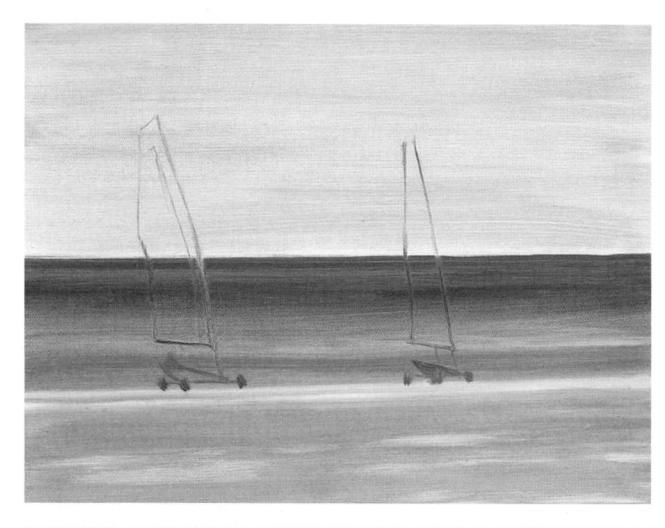

Turn the canvas and apply a paler mix of titanium white and ultramarine on the puddles to create the impression of light reflecting off their surface.

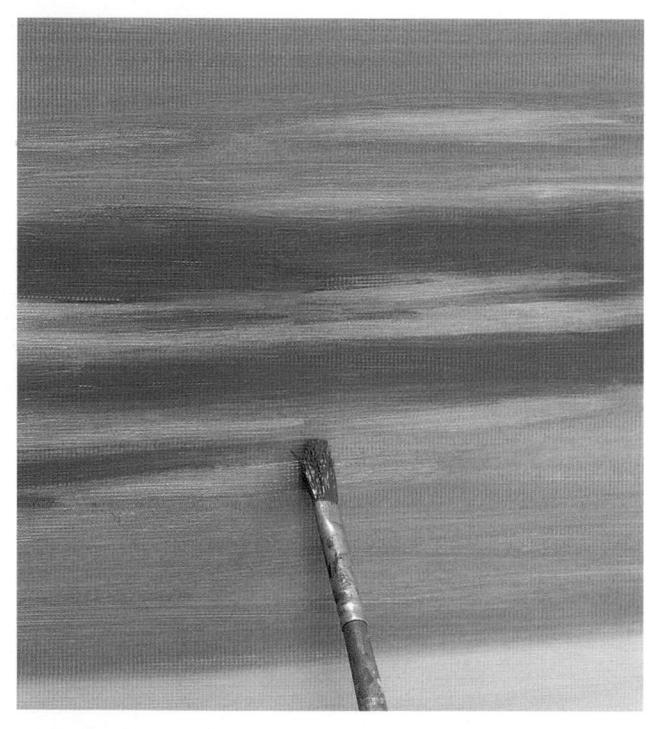

Make the wet sand darker with a layer of yellow ocher mixed with permanent mauve. Look carefully at the puddles to judge the tones correctly so they seem to shine.

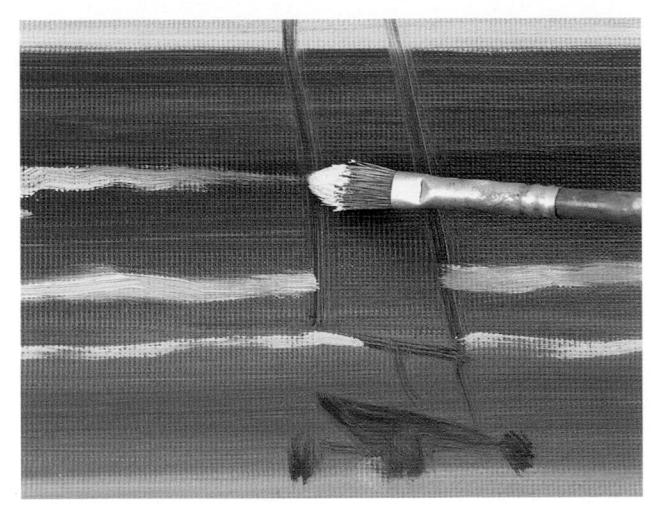

Finish the sea before you start to work on the sails of the sand yachts. Paint the wave crests using titanium white.

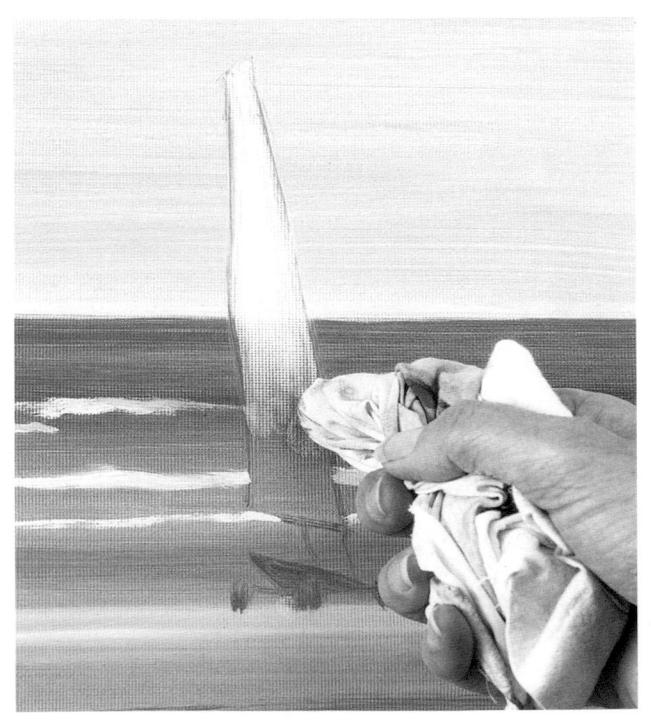

Before you paint in sails, wipe away the underpainting of the sea and sand with a clean rag.

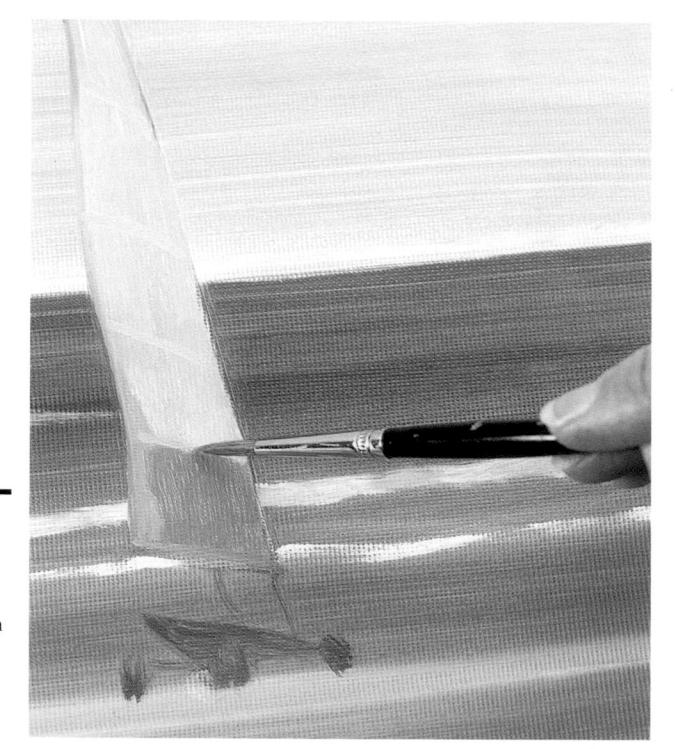

Paint the sails in varying tones of cerulean blue and titanium white, with the darkest tone at the bottom and the lightest shade at the top. Apply cadmium yellow for the yellow borders on the sail.

Carefully add details to the yachts, using a mahl stick to steady your hand if necessary. Paint the buggy and wheels of the sand yacht on the right in a mix of ultramarine and permanent mauve. For the sand yacht on the left, use a slightly paler tint of yellow ocher with permanent mauve and titanium white.

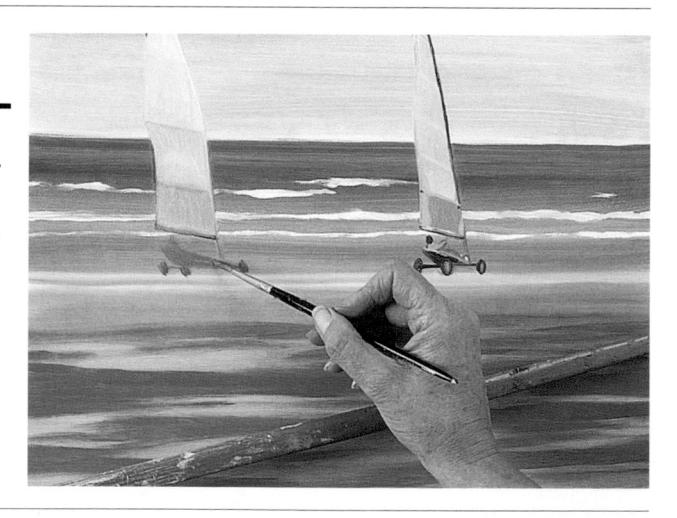

DEMONSTRATION: SAND YACHTS

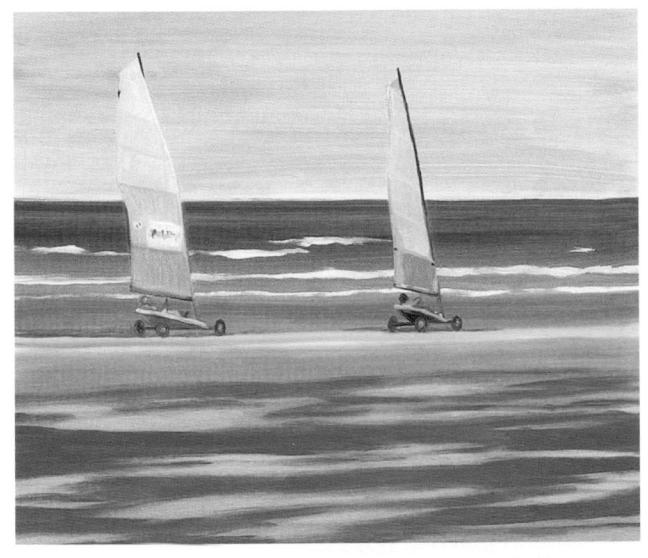

Paint the helmet of the lefthand yacht's driver with cadmium yellow. With the yachts completed, start to add the reflections to the puddles on the sand.

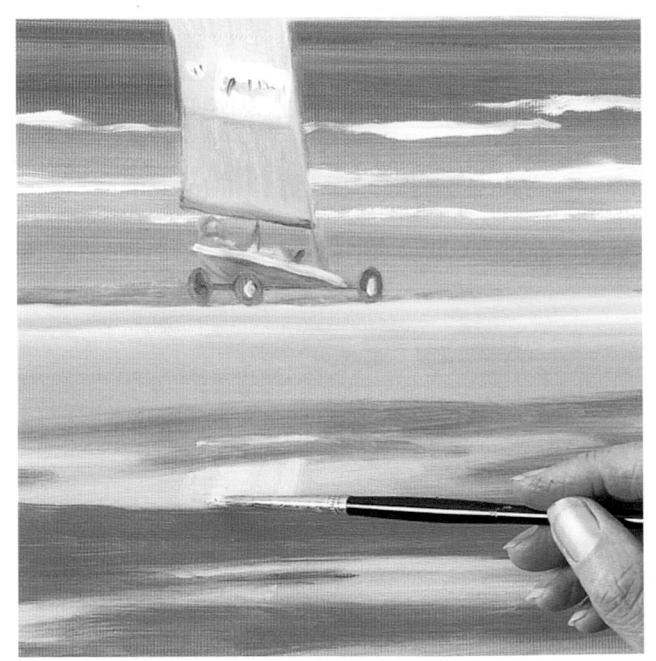

Look closely to get the correct angles for the reflections, or they will look unrealistic. Use a mix of cerulean blue and titanium white, keeping the outlines soft and slightly out of focus.

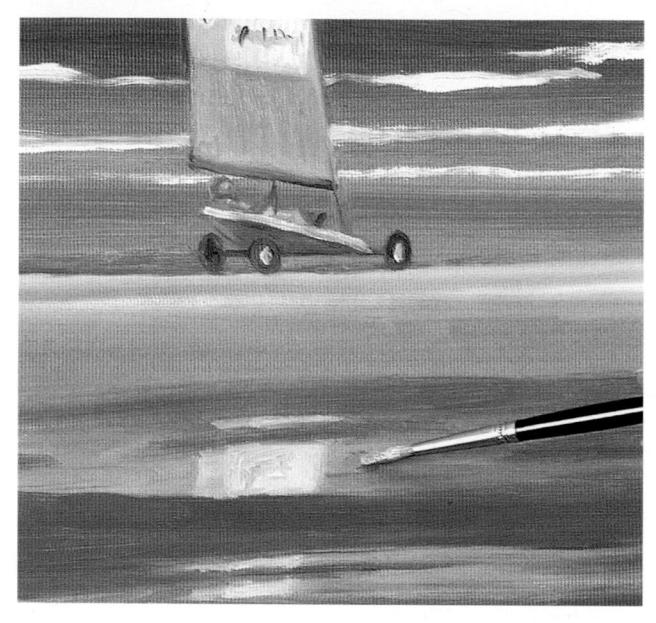

Darken the color of the puddle alongside the reflections with a mix of cadmium orange, permanent mauve, and titanium white. Be careful not to misjudge the color relationships, or the effect of the reflections will be lost.

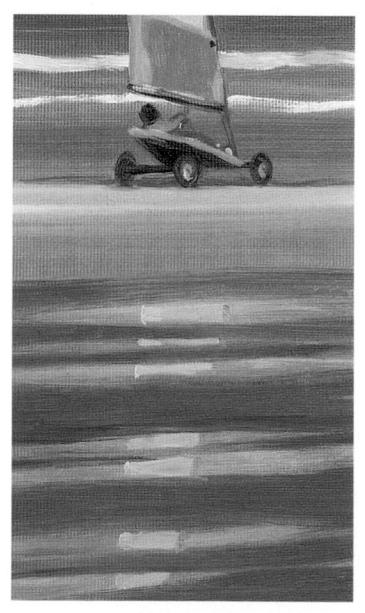

Add some darker color values under the sand yachts and around the puddles with a mix of cadmium orange and permanent mauve. This will highlight the puddles and reflections.

DEMONSTRATION: SAND YACHTS

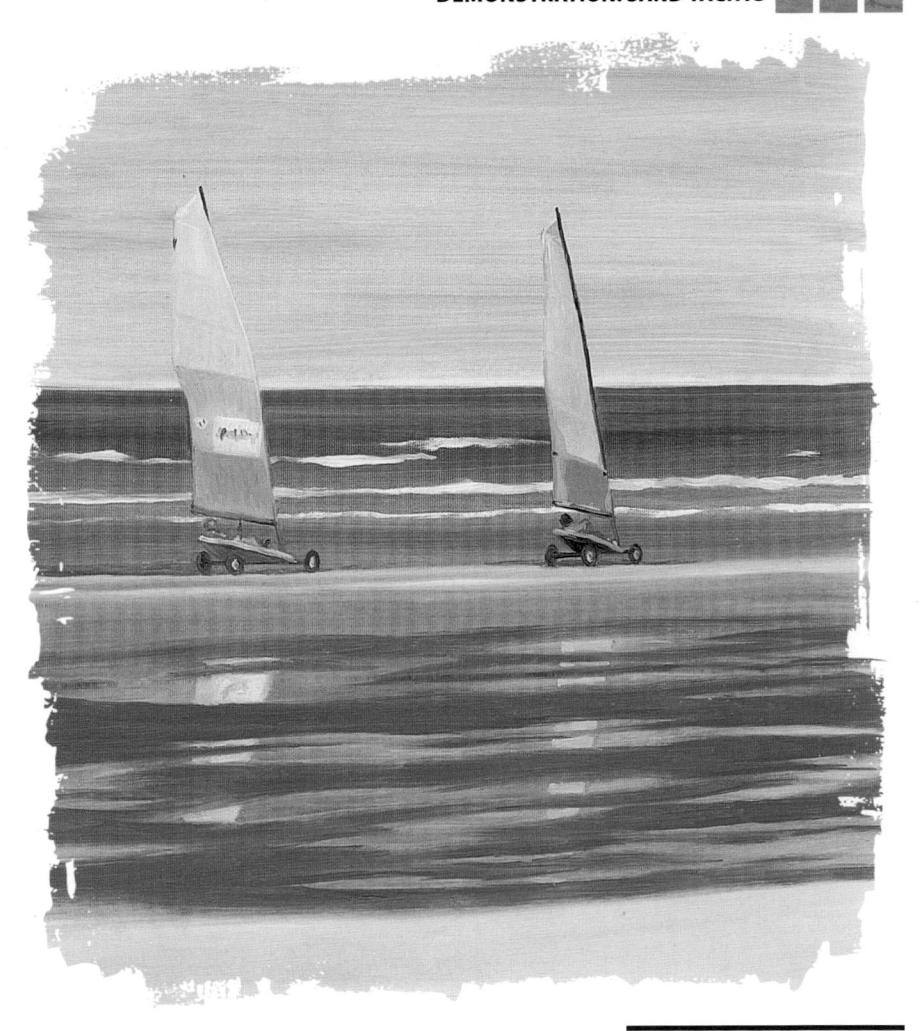

It is possible, as you can see here, to convey a windy day, without resorting to depicting racing clouds.

Also, the tonal variation of the wet sand and shallow water makes it appear as if the tide is going out.

Painting running water

The play of light on water pouring from a faucet, cascading over a cliff, or trickling over rocks in a small stream may seem to be a difficult subject to paint. The first step in such a painting is building up the context—drawing the rocks, the riverbank, or the kitchen sink.

Although it may be clear, water is certainly not invisible because it has mass. Light catches patterns of movement

Paint a tinted ground with a mix of cobalt blue and raw umber, thinned with painting medium. Sketch the outline with a darker mix of the same colors.

on water, and this is what you need to recreate. Spend a while simply looking. Before long, you will recognize the patterns of flow as they repeat themselves. Paint the darker color patterns first, leaving areas as they are where the water appears translucent. Observe where the light catches the water, and gradually build up the highlights. For example, in the painting below, some of the sink is still visible through the water.

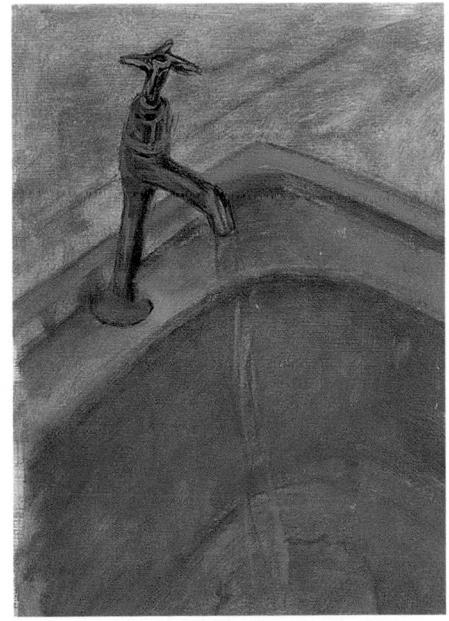

Use a slightly paler mix of the outline color to add depth to the faucet and sink. Then add a few touches of darker brown to the faucet and drain.

To create the metallic color of the sink, add cerulean blue, raw sienna, and a little white to the previous mix, and paint it roughly over the initial underpainting.

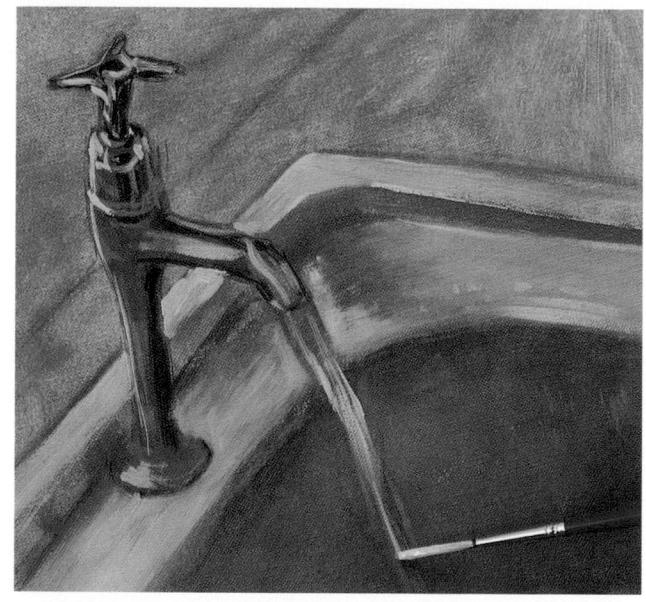

Next, mix a paler and more opaque color of cerulean blue, raw sienna, and titanium white to define the reflections on the faucet, sink, and water. Add more white to the mix to create sparkle in the water. Keep the brush moving to give the marks a fresh and spontaneous quality.

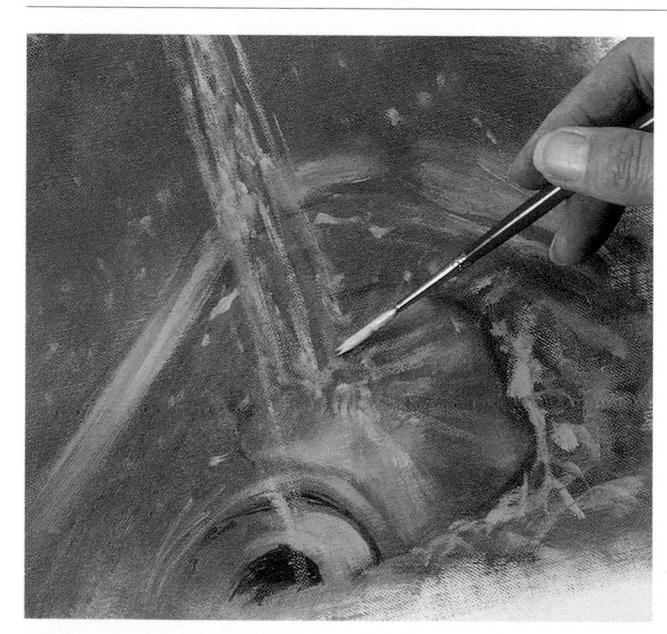

Paint the warmer reflections on the sink with a mix of yellow ocher and titanium white.

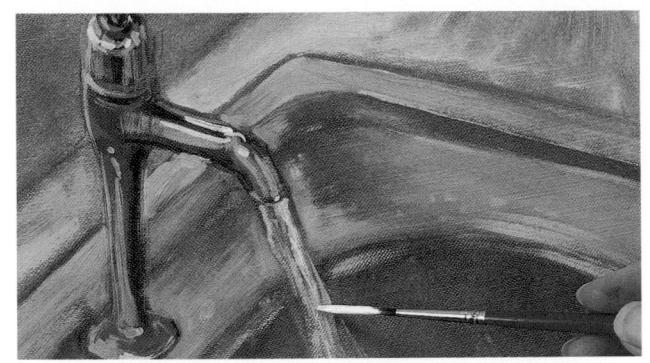

With a rigger brush, paint the reflections using a mix of titanium white and light red. Reflections often need warming or cooling with another pigment, as they take their color from the color of the light source.

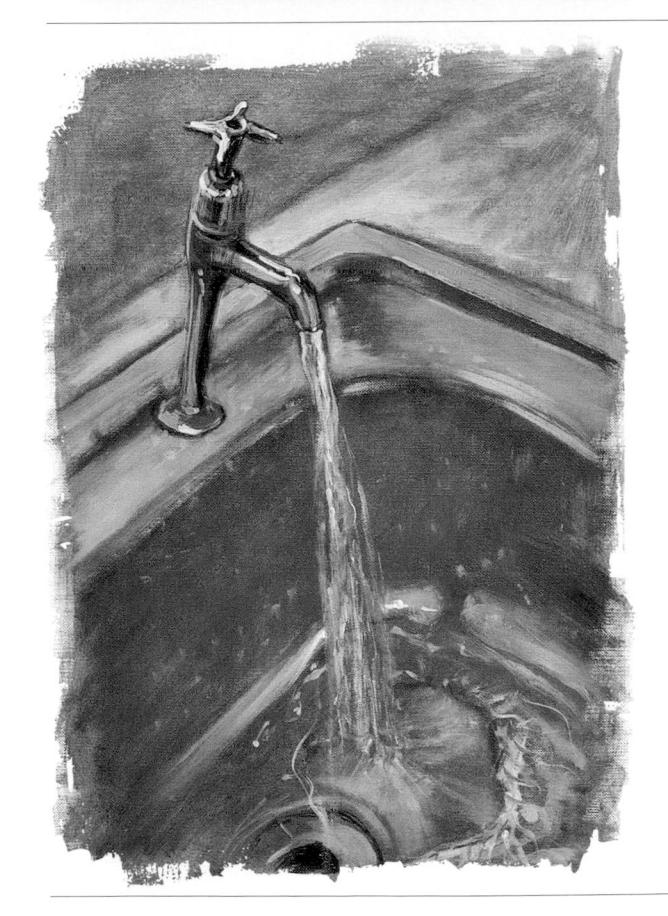

Finally, add some touches of titanium white to the faucet to complete the painting.

Painting waves

Waves are essentially architectural forms; but they are structures that are constantly changing as they crash down and become reconstructed. Observe the principal forms carefully; these include the outer contours of rolling banks of froth and spray, which are part of this architecture.

There can be a surprising number of deep colors in waves that contrast with the white of the spume. But

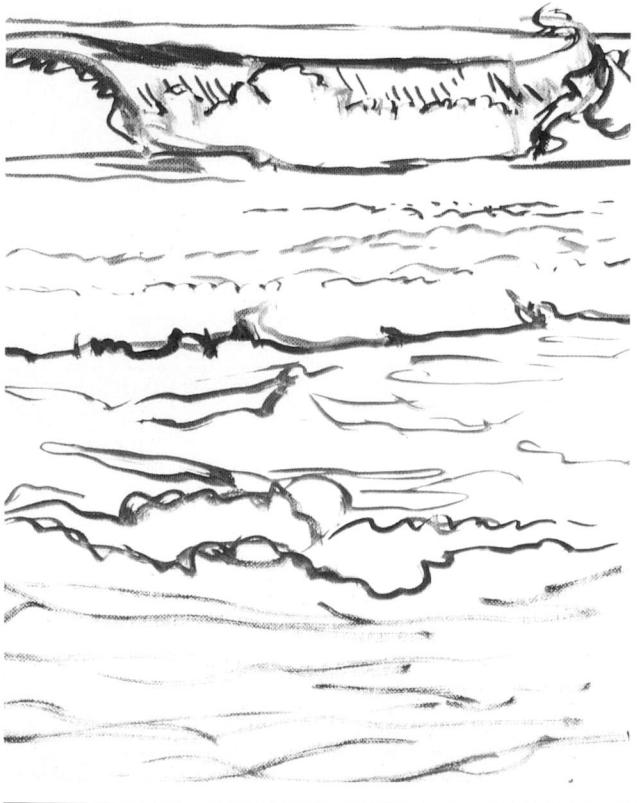

On a white surface, paint the outlines of the patterns created by the foam with phthalocyanine blue. Make sure the lines are not all parallel to the bottom edge of the picture; only the horizon is absolutely horizontal. The diagonals of the wave and the ripples give the painting dynamism.

lightness does tend to dominate, and finding a range of pale tints to break up the blandness of white can be quite difficult. Paint the general outline of your waves first, including the crests of the waves and the patterns of the foam. Then, as you paint, closely observe the color and movement of the waves.

Paint the main body of the sea with phthalocyanine blue and green, lightened with varying amounts of titanium white. Leave the foam from the breakers and the choppy water white, with various tints of blue and green in the depressions.

The shallower sea in the immediate foreground is fragmented by areas of foam. Apply a transparent mix of red-violet and ultramarine so the white support glows through.

The foreground area is in shadow. Paint the depressions in the water and gently blend in slight shadow detail to the foam in the foreground with a mix of red-violet, ultramarine, and titanium white.

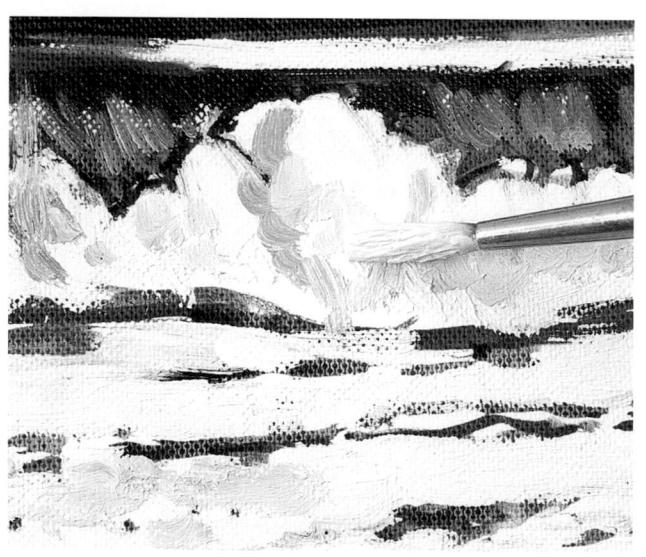

Paint the body of the wave behind the big breaker with a mix of ultramarine and a little red-violet. Lighten the color as it nears the foam, but keep it dark at the top. Lightly blend in some faint lilac lines where the wave curves to give it volume and a sense of power. Create a very pale lilac using the same colors as the foreground but with more titanium white. Use this mix to paint swirled patterns with your brush to give the foam texture.

artist's note

To paint water successfully, it is necessary to simplify what you see, but you cannot hope to distill the essence of a subject until you are familiar with its complexities. Be prepared to spend time watching water; then, when you begin to paint, never attempt to paint every tiny detail of a ripple or wave. This will result in a fussy and weak painting. Trust your own observations and try to achieve strength through simplicity.

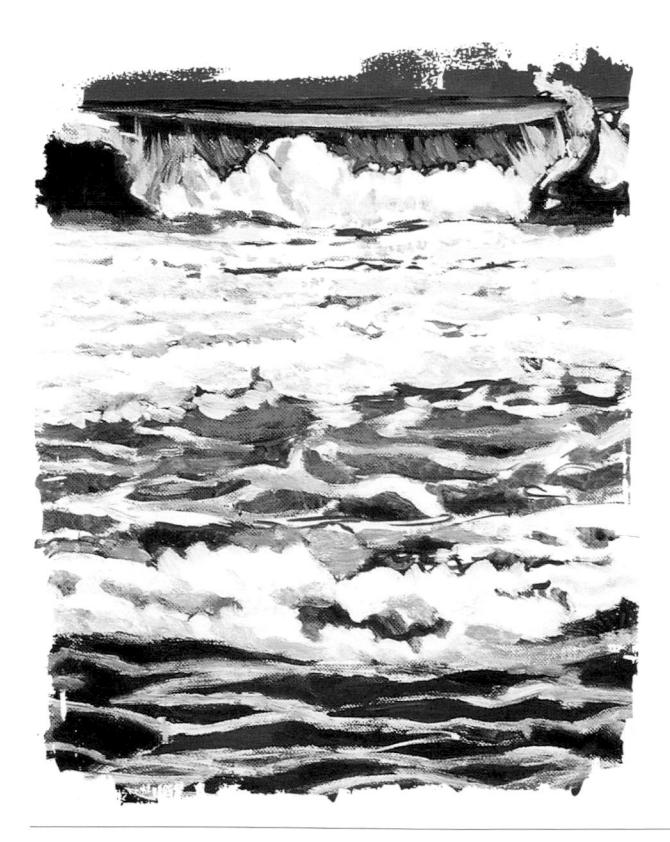

Paint the sky with a mix of ultramarine and titanium white. Apply the color evenly so that it acts as a powerful contrast to the cold brightness of the frothy sea. The vertical format of the picture gives the composition a monumental feel, making the viewer look up at the wave crashing in.

Demonstration: Lighthouse in heavy seas

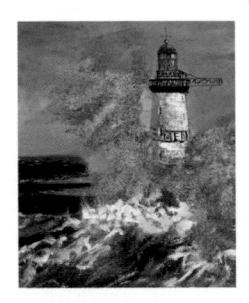

The sea is not easy to paint from life because it is constantly changing. Every passing cloud affects the light; the tide comes in or goes out; wind ruffles the ocean, changing its texture; and mist creeps up to mask a horizon that was clear and sharp only moments before.

In this painting, there is scope for experimenting with techniques such as spattering, dry brushing, scumbling, sgraffito, and glazing to capture the various moods and textures of the sea.

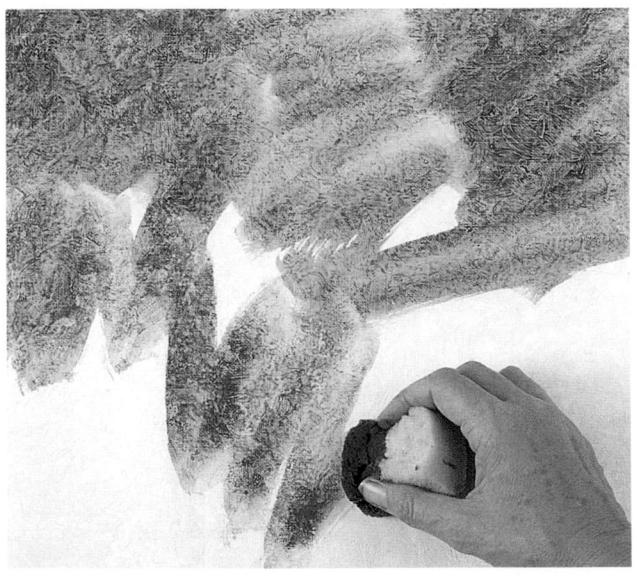

Use choppy brush strokes to apply a layer of titanium white mixed with *impasto* medium to the whole surface of the canvas. The textured brush strokes will show through when color is dragged over them later. Let this layer dry, and freely apply a layer of ultramarine thinned with turpentine and painting medium with a piece of sponge.

DEMONSTRATION: LIGHTHOUSE IN HEAVY SEAS

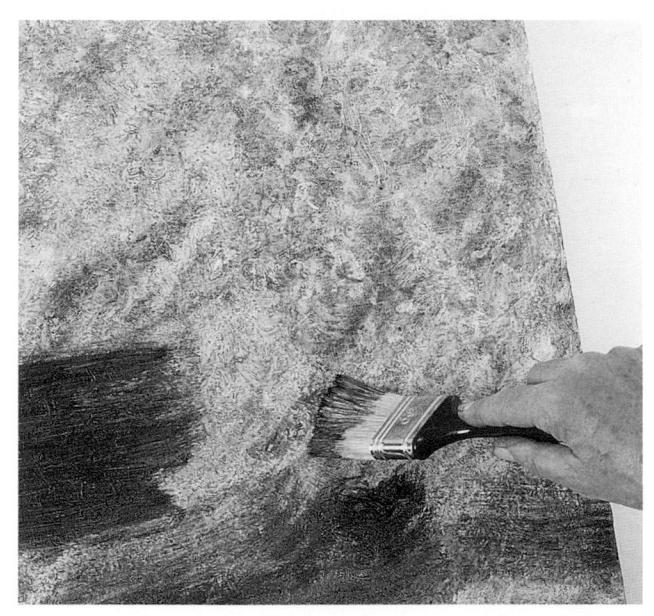

With a 1-inch (25-mm) decorator's brush, apply a mix of ultramarine, ivory black, and lemon yellow with painting medium, to depict the sea and suggest nearby waves. Place the horizon just below the middle of the picture.

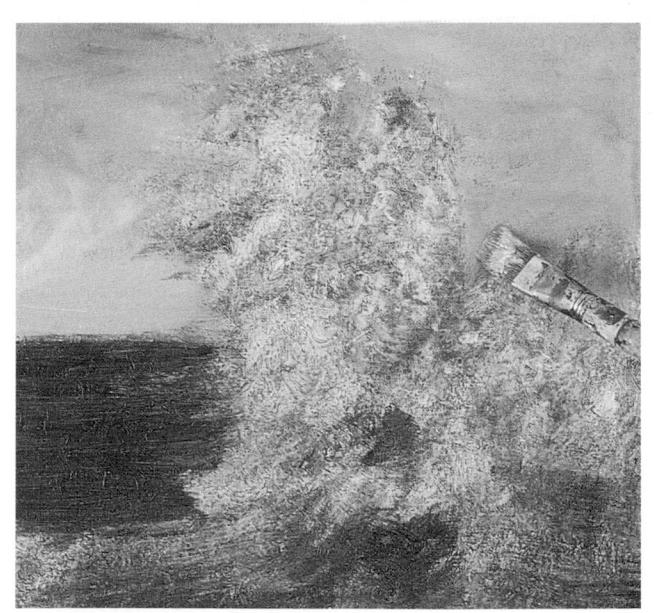

Block in the sky with parallel, horizontal brush strokes, using a mix of cobalt blue, titanium white, and painting medium.

Leave the underpainting showing through where you will later fill in the wave and lighthouse.

Use a large flat hog brush to lighten the sea in places with an ultramarine and titanium white mix. The texture of the white underpainting should show through the brush strokes.

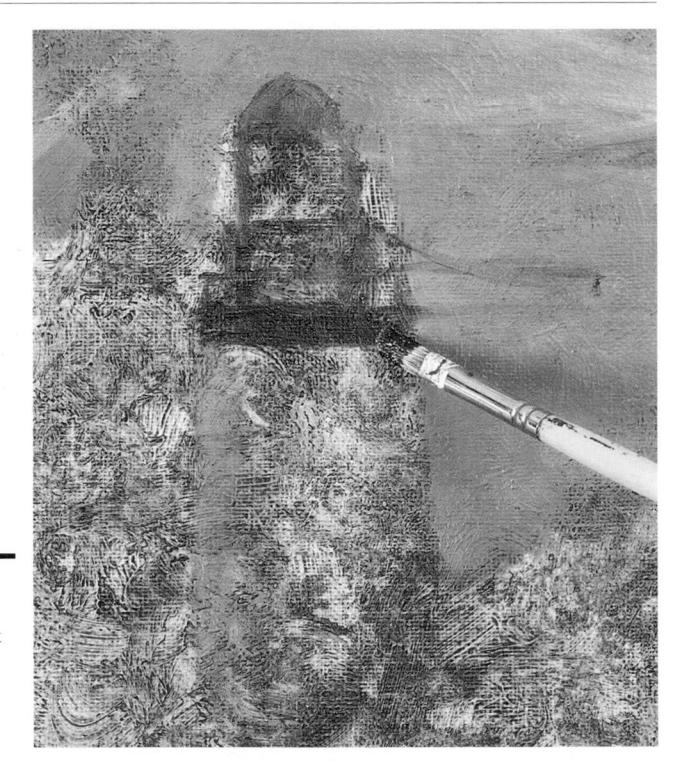

Do not paint the outline of the lighthouse, but start by painting its top using a small flat sable and a mix of painting medium and ivory black.

DEMONSTRATION: LIGHTHOUSE IN HEAVY SEAS

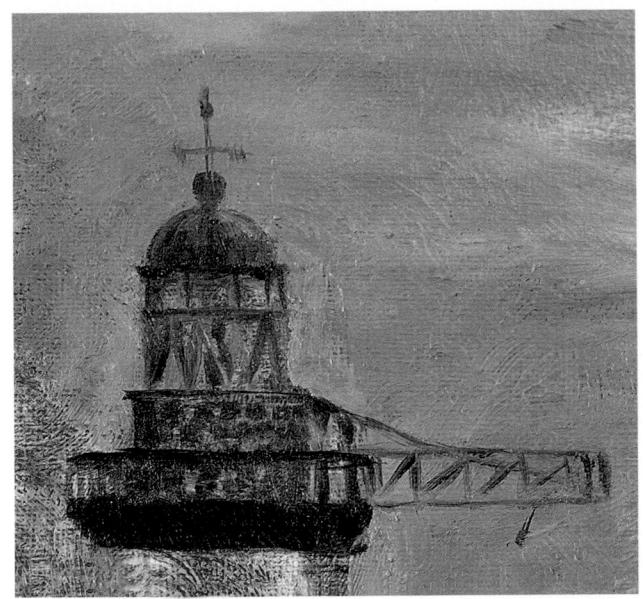

For the finest details use a very small round sable brush with a good point. The ivory black mixes with the sky color as you paint, giving some delicate light and shade.

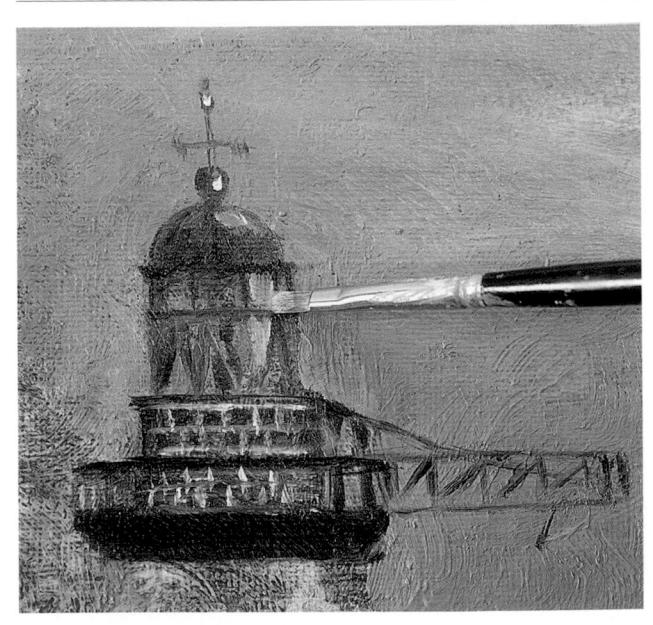

Now use a flat sable again and titanium white to add more light touches to the metal frame and windows.

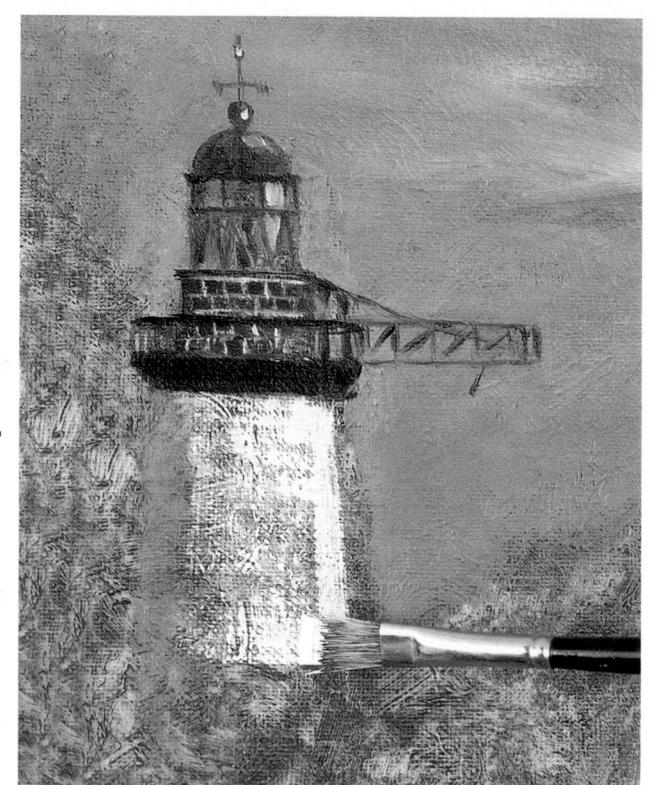

Add a little emerald green on the windows and some cadmium red deep on the top of the lighthouse. With a larger, long flat hog, drag some titanium white across the lighthouse base. Apply lighter pressure to the side where the wave crashes against it so that less of it is visible. This will make the lighthouse look rounded.

Dab on ivory black with the tip of a flat hog to paint the lighthouse name.

DEMONSTRATION: LIGHTHOUSE IN HEAVY SEAS

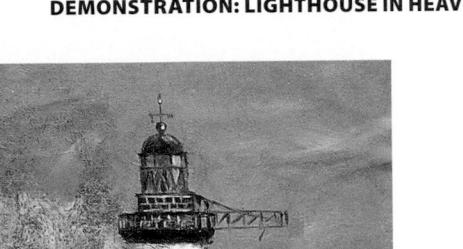

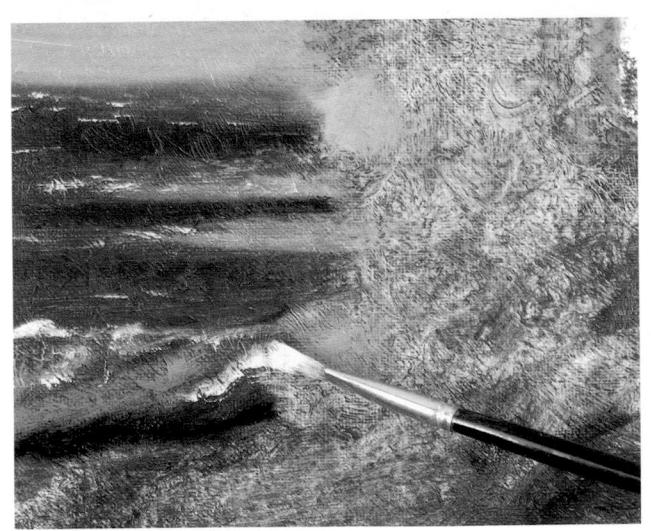

Use titanium white and the edge of a long, flat hog brush to touch in the distant white tops of the waves. Increase the size of the strokes in the foreground. The very small marks in the distance will contribute to a sense of distance.

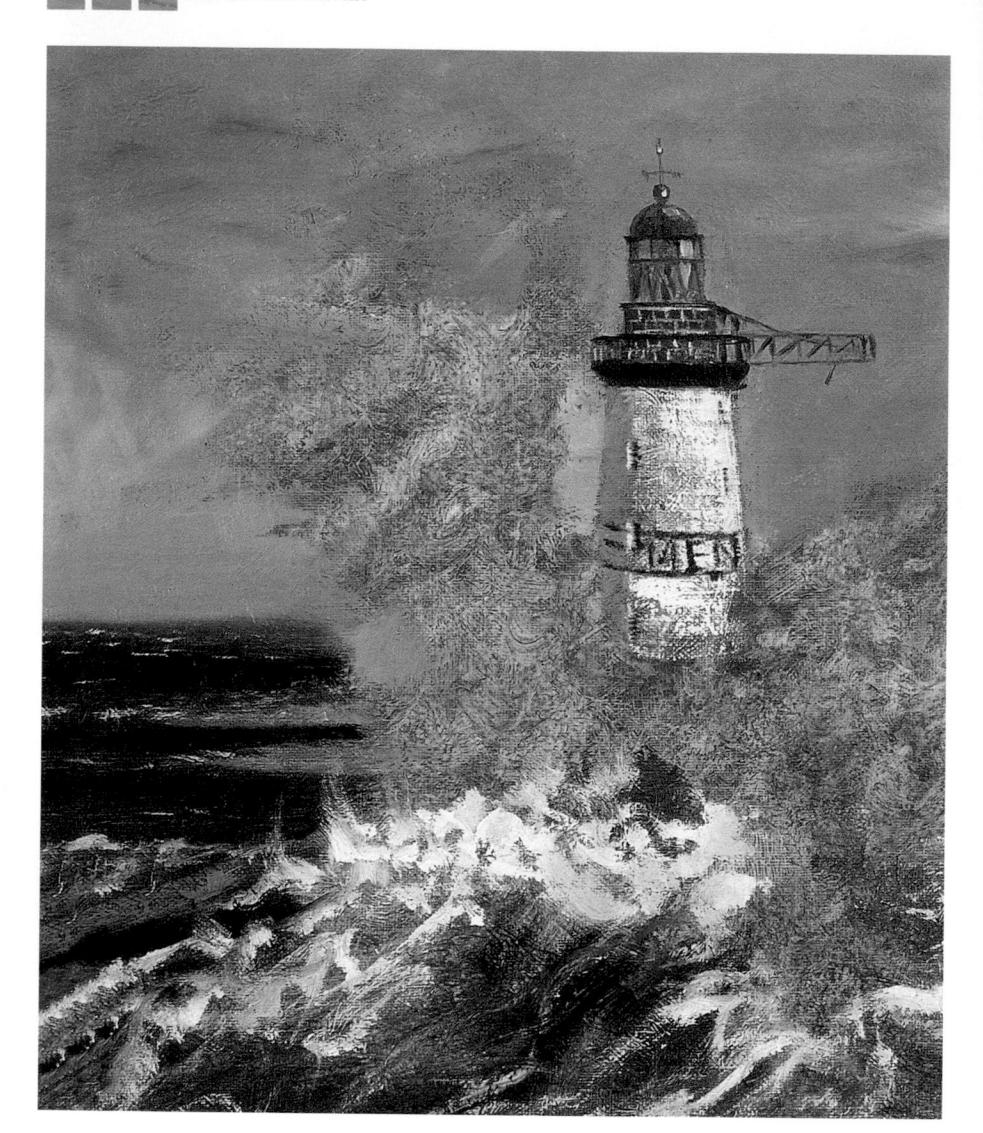

Apply more titanium white to the waves in the foreground, using free and spontaneous brush strokes to give a sense of movement and power.

DEMONSTRATION: LIGHTHOUSE IN HEAVY SEAS

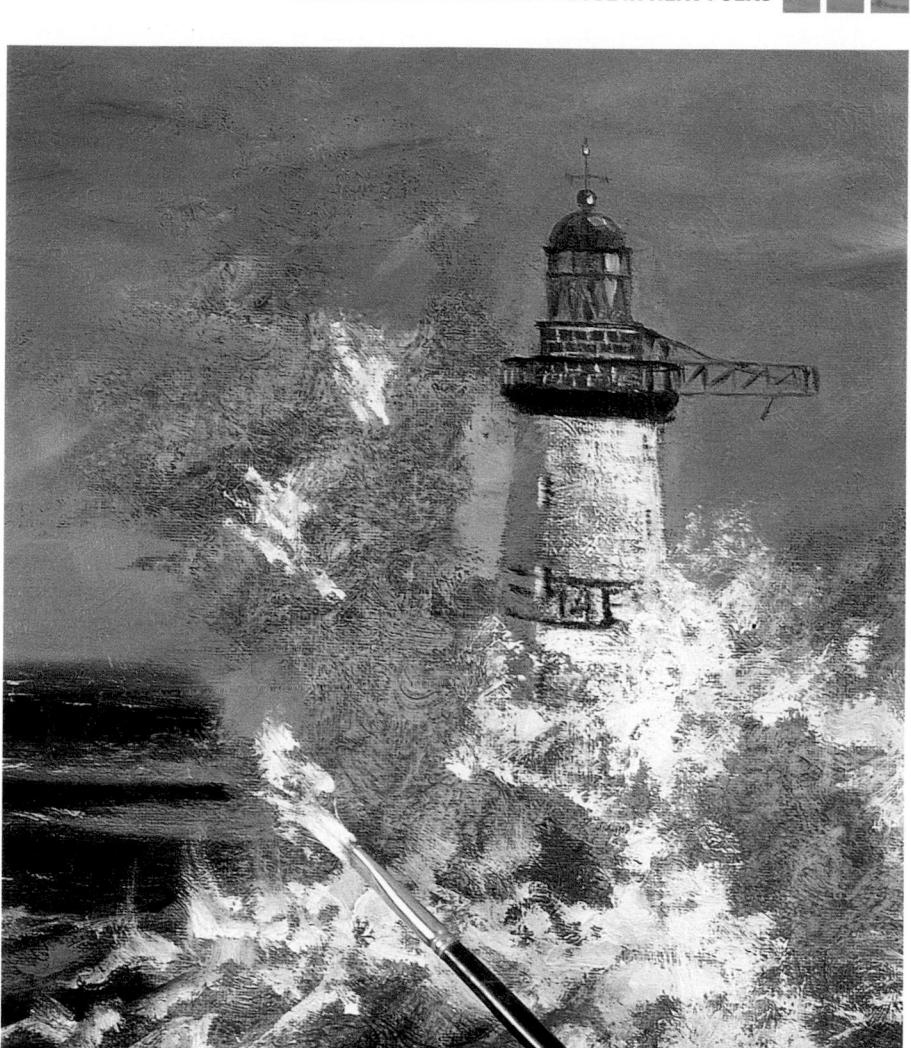

Add a touch of lemon yellow to the white to convey an impression of late afternoon sunlight. Dab and drag the color to suggest plumes of spray.

1 4 Use a flat hog brush to spatter a mist of tiny droplets for the fine clouds of spray sent up by the breaking wave.

15 When spattering, the paint must be quite thin, so add extra turpentine and medium to the mix. Hold the brush close to the canvas to avoid spraying too far across the picture.

DEMONSTRATION: LIGHTHOUSE IN HEAVY SEAS

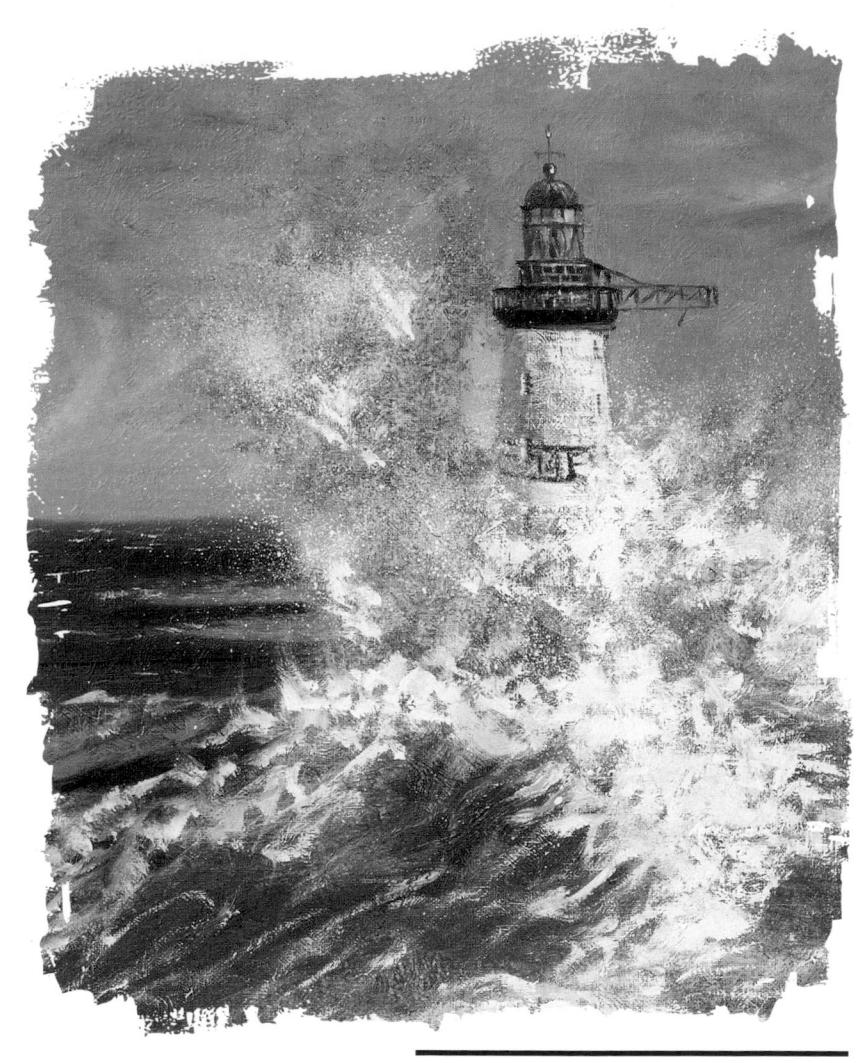

The cold blues and greens contrast with the warm evening light catching the spray. Light, fast, and sensitive brush strokes help convey the sea's fluidity. The free handling of the waves contrasted with the delicate treatment of the lighthouse make it look almost fragile.

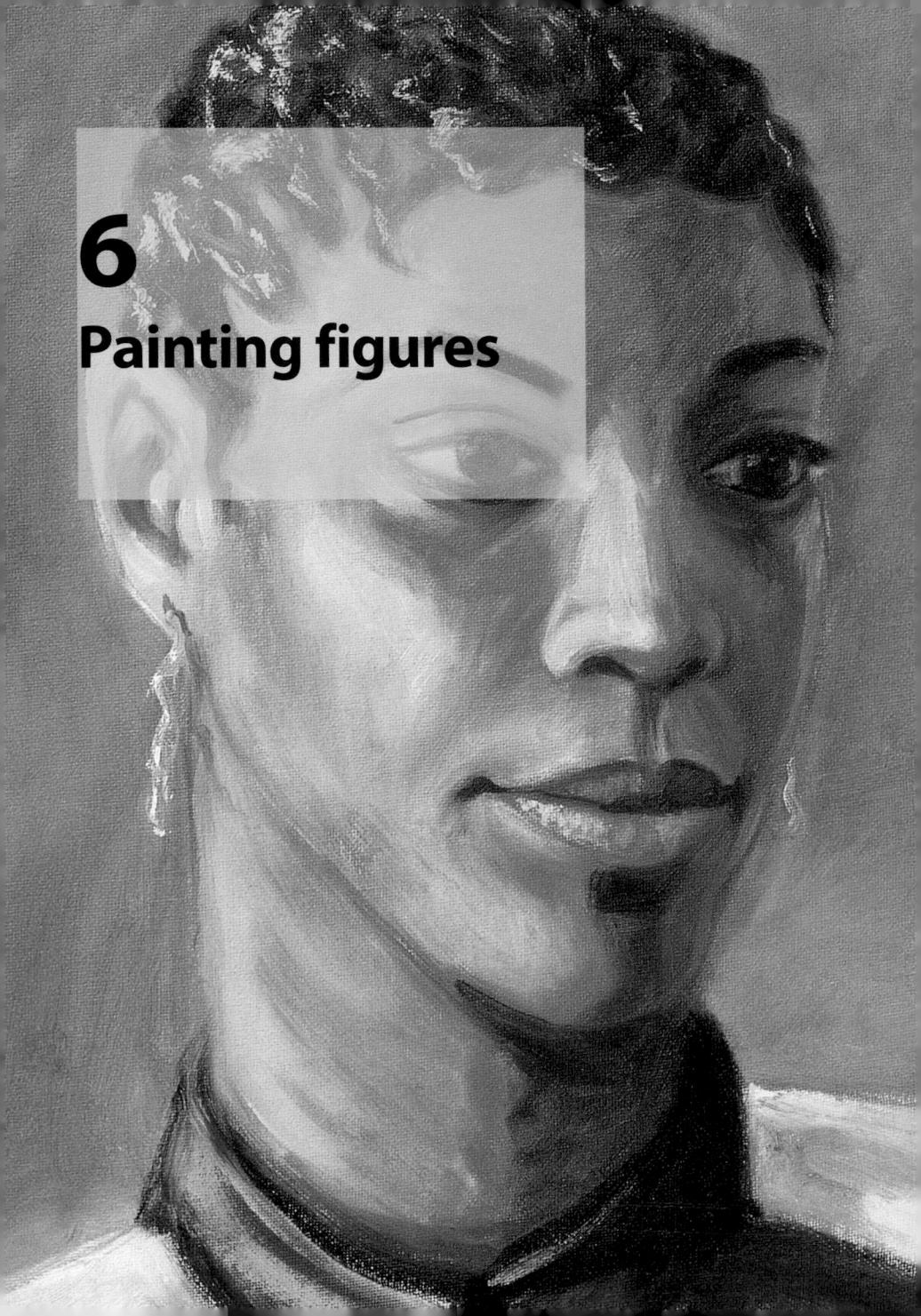

O bservation is the key to success with portraiture—with technique coming a close second.

When you have persuaded someone to sit for you and are about to begin painting, remember that however you might be feeling, it is up to you to put your sitter at ease. Choose a pose that is easy for the model to hold, and make sure that their chair is comfortable.

A solitary figure will always be the main focus of a painting, even if indistinct and in the middle distance. If you paint a full-length figure, the face will be the focus; if you paint the head and face only, the eyes will be the focus, just as when we meet people in real life. Therefore, the direction of the gaze in portraiture is vital.

Figures can appear in pictures for many reasons. They may be included in the distance to give scale to a landscape or street scene; they may be in the middle distance, grouped to lead the eye into the picture, or to give interest to a setting; or they may be the main subjects. Their function in the painting will dictate the way you paint them.

Take a sketchbook to a crowded railroad station, airport lounge, or bar, and fill it with studies. Then try some paintings from the best studies. Don't let your brushwork become fussy; stick to essentials. It may help to use a larger brush than you think you need; that way you will be forced to simplify. Working from photographs is good practice too, and it allows you to make a more finished painting. But don't become discouraged; painting portraits doesn't always come easily, and it takes even the best artists years of practice. The pleasure is in following the process; then painting portraits can be an endless source of enjoyment.

Integrating facial features with the rest of the face

The important thing to remember when painting features is their shape and their relationship to the head as a whole. Eyes are often painted with too much prominence and simplified into flat oval shapes with a circle in the middle for the iris. Instead, the eye should be drawn in relation to the rest of the face, taking into consideration the eyelids, eye sockets, and brows. Noses are often caricatured, giving little sense of shape or form. To avoid this, define the bottom of the nose carefully, and measure its distance from the ears and mouth. Similarly, mouths are often painted as flat forms when in fact a mouth is a soft, full shape with depth and detail.

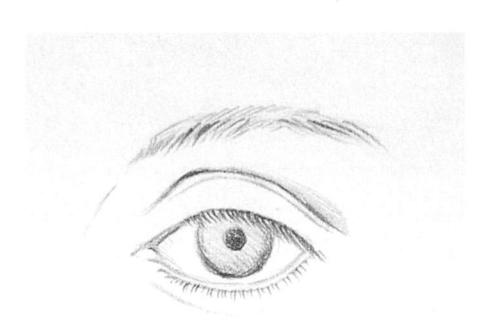

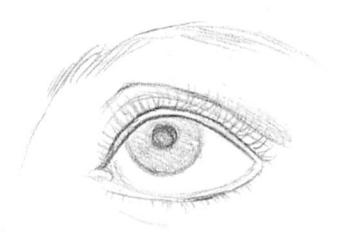

In this straight-ahead view, the top lid partially covers the iris, but a little white is visible above the bottom lid. As the eye turns upward, much more of the white becomes visible, and the size of the top lid decreases.

INTEGRATING FACIAL FEATURES WITH THE REST OF THE FACE

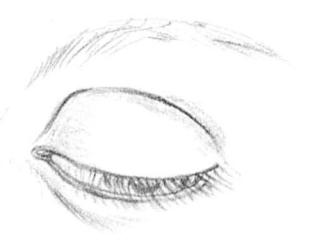

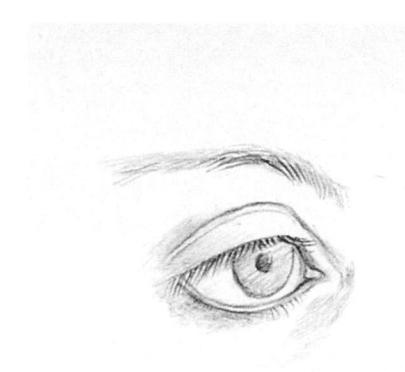

With the eye almost closed, the top lid follows the curve of the eyeball.

In this three-quarter view, the eye is seen in perspective and thus changes shape. Notice that much more white is visible.

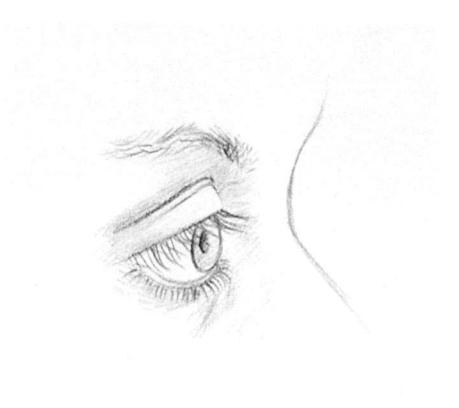

In a side view, the curvature of the eyeball is very apparent.

With the head turned away, more of the lid and eyelashes are visible.

PAINTING FIGURES

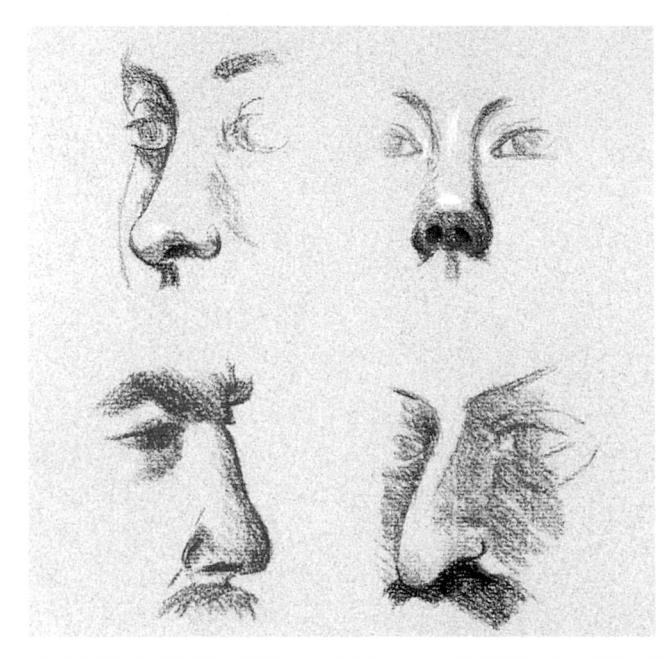

The nose, in the center of the face, forms a link with all other features and so is of crucial importance. The top of the nose makes a bridge between the eyes, the sides of the nose slope down into the cheeks, and the nostrils link with the upper lip and mouth. A nose is roughly triangular in shape—narrow at the top and then widening out to a rounder shape at the tip, with the wings of both nostrils curving at each side. Practice by drawing your own nose from different angles.

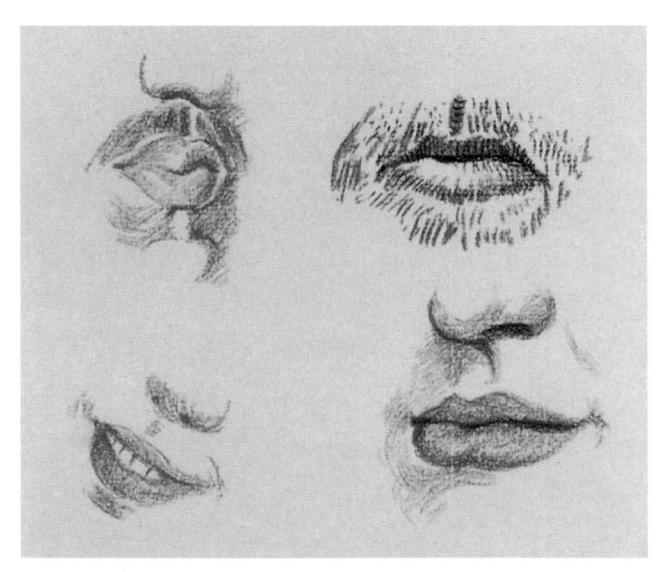

Mouths are a particularly important feature in portraiture because they are responsible for a great deal of the expression of the face. Lips follow the shape of the jaws and of the teeth behind them. The sides of the mouth are two planes, which have their high point at the "Cupid's bow" in the center of the mouth and then curve gently into the cheek. This curve is the reason for the steep recession at the far side of the mouth seen in a three-quarter view.

INTEGRATING FACIAL FEATURES WITH THE REST OF THE FACE

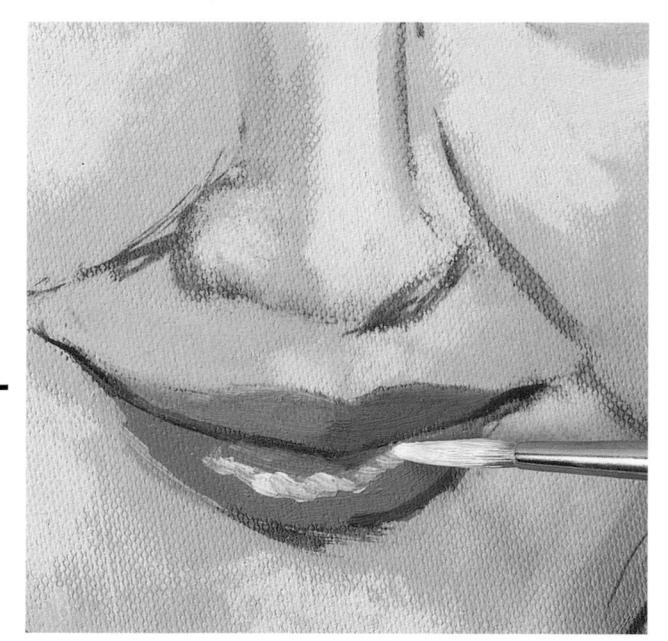

When painting a smile, the corners of the mouth, the mouth opening, and the contour of the lower lip should all be delicately painted. Do not overemphasize any element or you could turn the smile into a grimace.

Facial expressions are controlled by muscles, many of which are interconnected, so when we laugh, we do so with our whole face. It is a good idea to practice drawing facial expressions in your sketchbook before attempting to paint a whole portrait.

Painting facial features when the subject's head is turned

The angle that gives the most difficulty is the three-quarter view, when your sitter's head is not looking straight at you but is turned by 45 degrees. The features are then distorted, or foreshortened. It seems we all have an unconscious mechanism that tries to turn a head back to look the viewer straight in the eyes, perhaps because, being symmetrical, a head is much easier to draw that way. However, when we view a head in perspective, the two viewpoints—one observable, the other imagined—become muddled, and this is why the head does not look convincing.

An important point to remember is that no single plane of the head is flat, especially the curving surface of the face. Before you start to paint, draw a light sketch and place guidelines around the head so that you can position the features on the curving surfaces. Draw an imaginary line down the middle of the face to help you line up the features. Then, following the guidelines, gradually add the modeling and details of the features.

PAINTING FACIAL FEATURES WHEN THE SUBJECT'S HEAD IS TURNED

When drawing, bear in mind some facts about the general proportions of the head and the alignment of features. In this diagram, you can see that the eyes should be approximately halfway down the head. The ears should line up with the eyes and nose, and the pupils of the eyes should align with the corners of the mouth. The inside edges of the eyebrows line up with the corners of the eyes, and the space between the bottom of the nose and the chin is greater than that between the bottom of the nose and eyes.

The next thing to observe is what happens to the head when it is at an angle. Note that here, as the head moves, the proportions change because it is seen in perspective. When a person is looking to one side, you see more of the back of the head and less of the features. Looking up reduces the apparent size of the top of the head. Looking down compresses the features, and more of the top of the head is visible.

PAINTING FIGURES

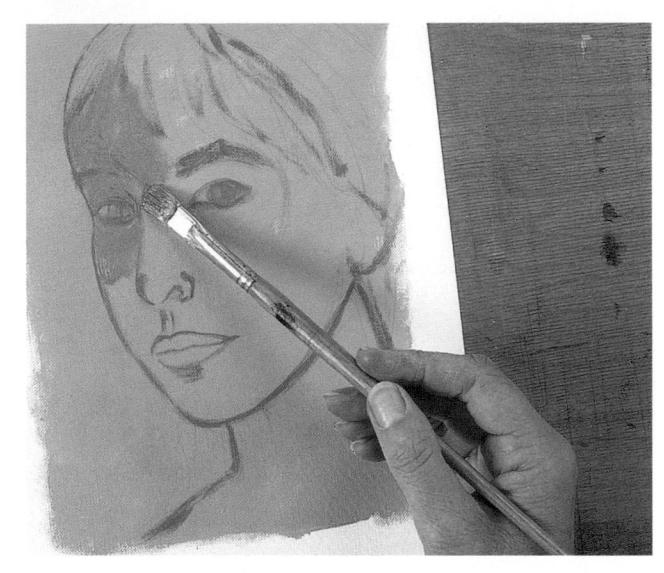

Draw this woman's head using a mixture of yellow ocher, cadmium red, and a little titanium white. A good drawing as a starting point makes painting much easier. It is a good idea to practice drawing heads before painting them.

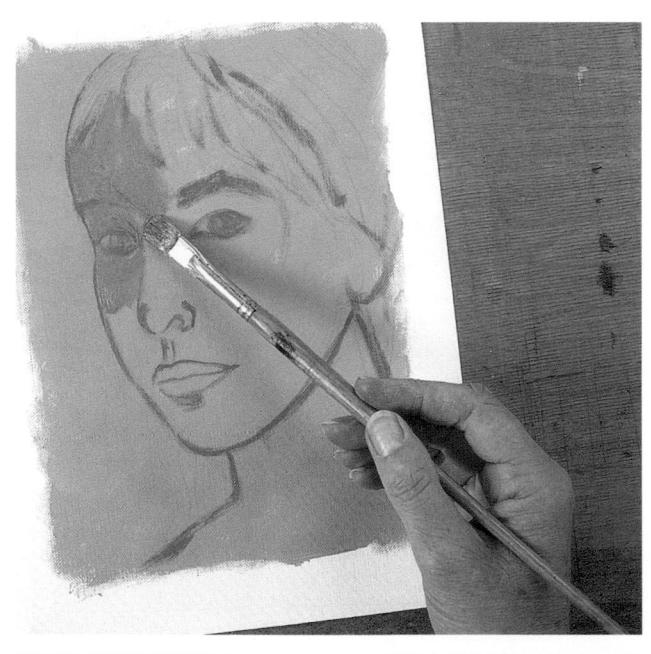

The right eye is in steep perspective, as is the far side of the mouth, so place the nose well over to the left. Notice how narrow the gap is between the tip of her nose and the contour of her right cheek and how wide the space is between her left nostril and ear. Also, the two eyes are not the same size or shape.

Achieving realistic skin tones

The color of skin varies enormously, even within specific racial groups. The tints and shades you see will of course also depend on lighting conditions. Skin is reflective, so any colors nearby will influence the colors you see. Think of your choice for flesh tints in two ways; first, as relatively lighter or darker than one another (tonal); and second, as relatively warmer or cooler (chromatic). Develop your ability to see chromatically as well as tonally.

The trick to painting skin tones is to begin by establishing the overall color of the person's face. You can then build upon this base with other colors as you add shading and highlights. The mix used in this example is yellow ocher, cadmium red, and titanium white.

PAINTING FIGURES

For this portrait, the initial flesh tint is a mix of cadmium orange, cobalt green, Indian red, and white. The lighter highlights on the cheek bone and nose are cobalt green and white, with the addition of cerulean blue.

In this portrait, the skin is painted with a mix of raw umber, cadmium orange, and Venetian red. This tone is cooled in places with cerulean blue.

artist's note

Even within the same racial group, face colors vary enormously; "white" skins can be pinkish, olive, creamy, or quite dark brown or red if the person has spent a lot of time outdoors. You can improve your color assessment by squinting your eyes. This blurs the features and any other details and gives you a broad impression of both the color and the tone of the skin.

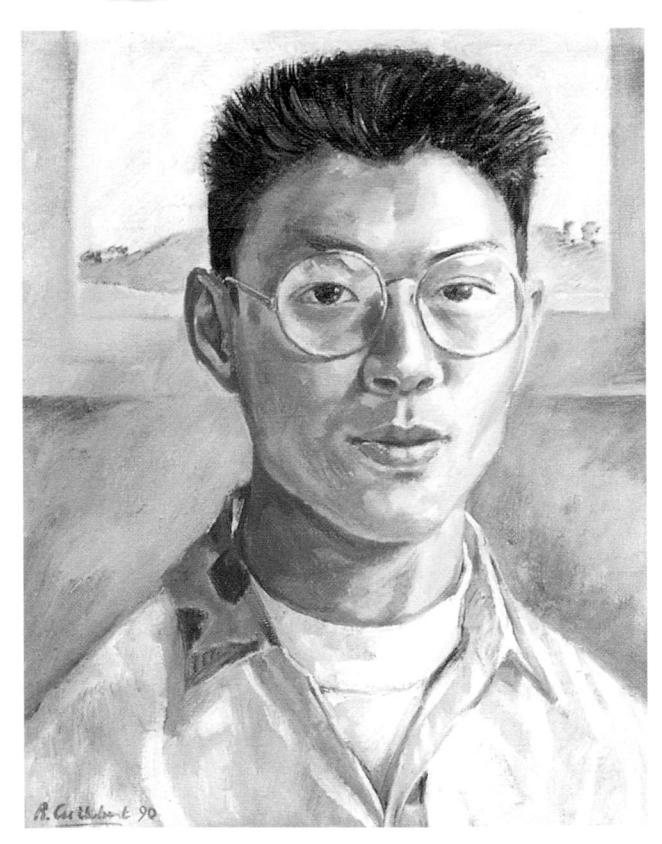

The base color for this portrait is yellow ocher and raw sienna, with some titanium white and a little lemon yellow. The shadow area is a mix of cobalt blue and cadmium red.

Painting hands

Hands are difficult to draw because they can assume so many different positions and often present surprising shapes. To improve your paintings of hands, first observe the shape and proportions of a hand. A hand is broader and flatter than a wrist, and a palm is basically square. The thumb has a low connection toward the wrist, and the fingers are jointed by three rows of knuckles—the first along the top of the palm. The distance between knuckles gets progressively shorter toward the fingertips and fingers taper toward their tips.

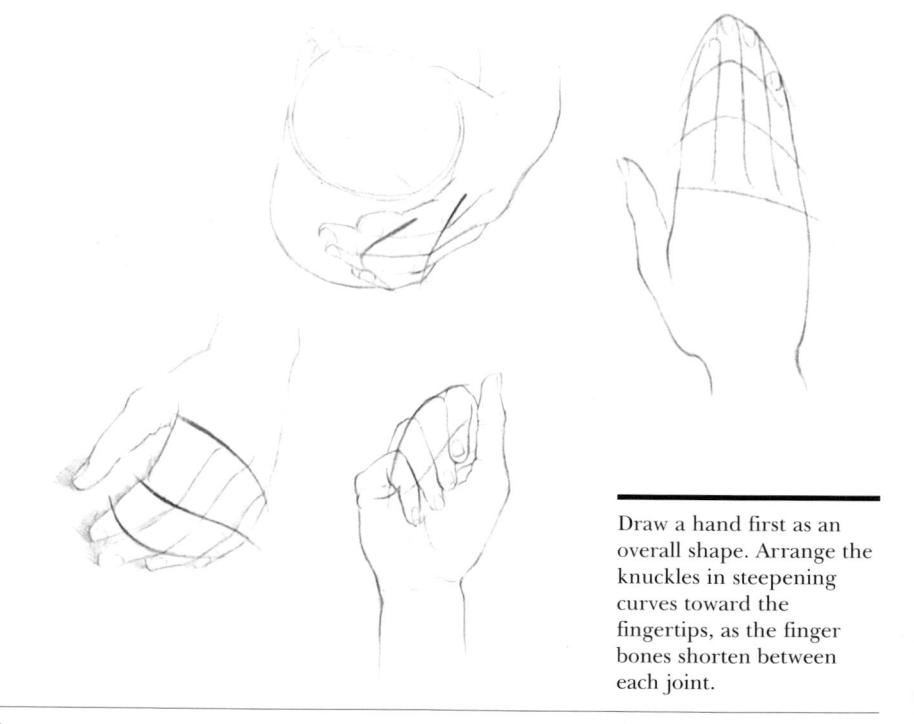

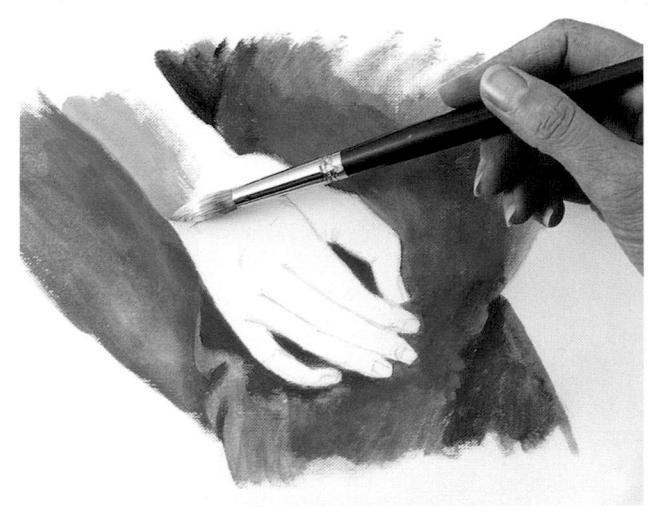

Observing the shape and proportions of the hand, sketch in pencil. Then paint the surrounding blue of the jeans with varying mixes of blue and titanium white. Next, apply a green underpainting to the hand with a mix of titanium white and Hooker's green. This will disappear as the painting progresses, but it will continue to have an effect on the colors as it shows through the layers.

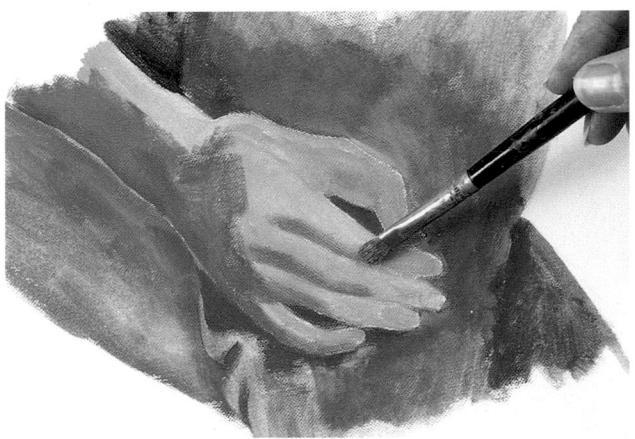

Add a half-tone with a mix of the green underpainting and yellow ocher, cadmium red, titanium white, and blue.

Next create a pale flesh tint, using all the colors from the previous mix, but without the blue and with a touch more titanium white. Use a medium filbert sable to paint the back of the hand and the wrist, blending the color into the preceding layers. Leave darker areas unpainted where you want to create shadows between the fingers and the shaded side of the hand.

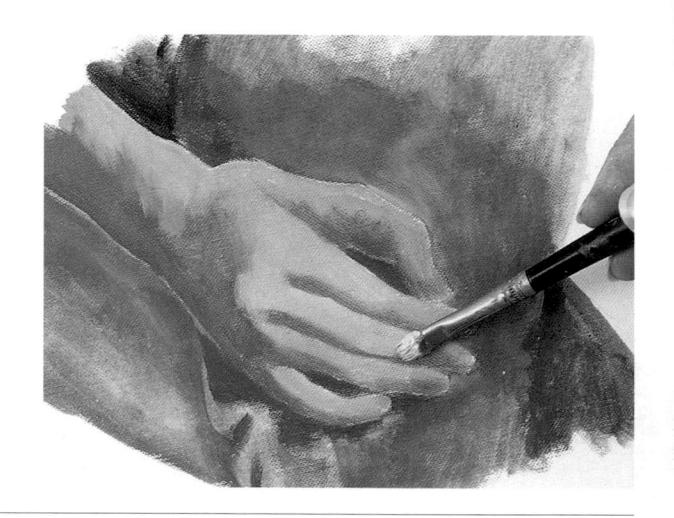

Add some red ocher to the mix to create a warmer, deeper color for extra shading. This will counteract with the green underpainting, which is still too dominant. Use the edge of your brush to define the details around the fingernails.

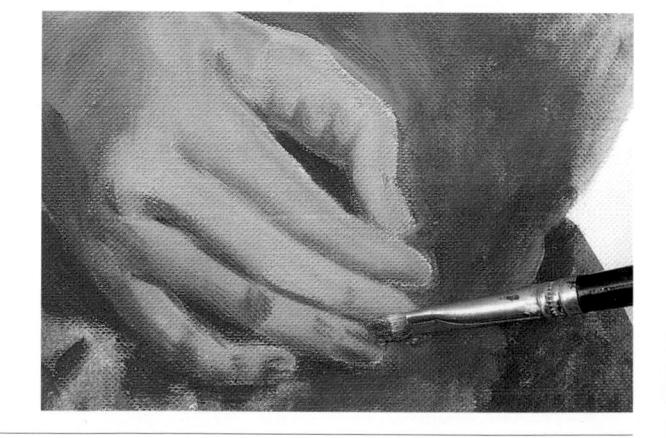

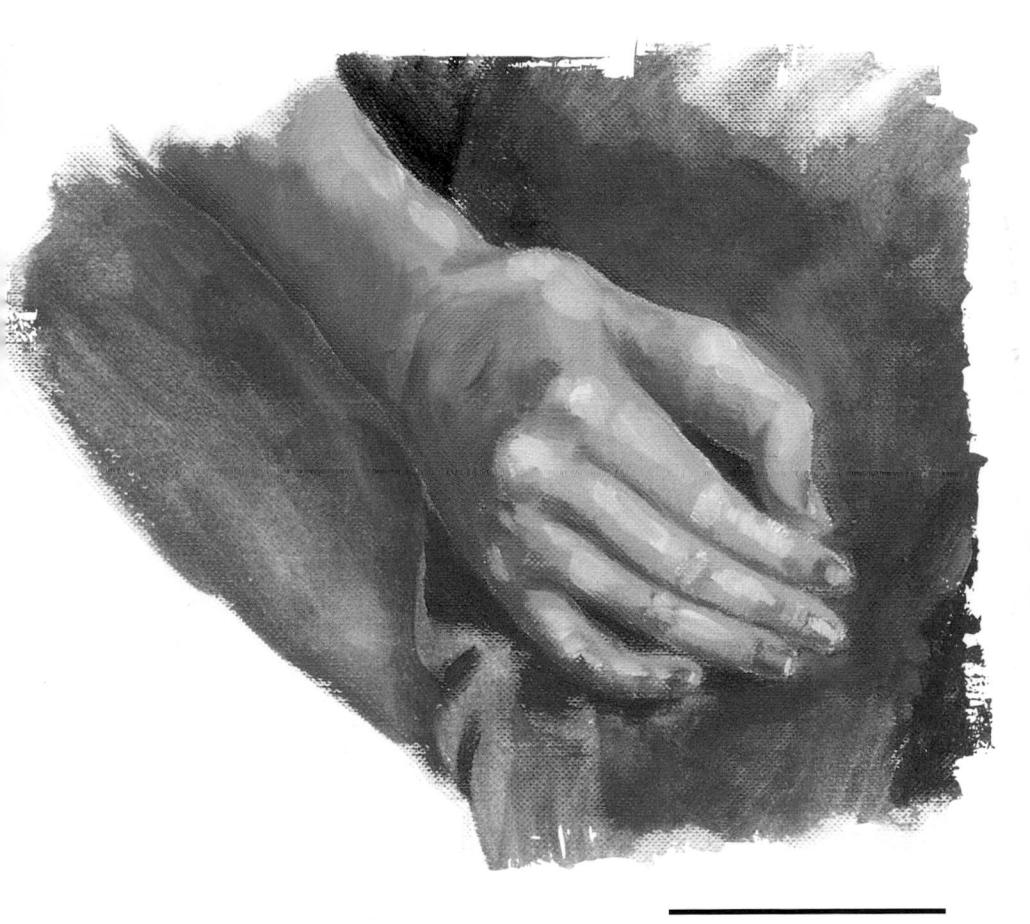

Finally, add some highlights with a mix of titanium white and small amounts of yellow ocher and blue.

Painting movement convincingly

Contours and detail convey solidity and stillness. But plenty of paint and swift brushwork will impart a sense of movement. The degree of the form that should be developed depends on the extent of movement; the faster the movement, the less the contour is needed. When the contours are interrupted with fast strokes of the brush, the painting dissolves into movement. Blurring and merging the colors of the subject with your brush adds to the effect

First, sketch the general form of the dancer with alizarin crimson. Then mix the crimson with viridian to create a rich, dark shade for the background.

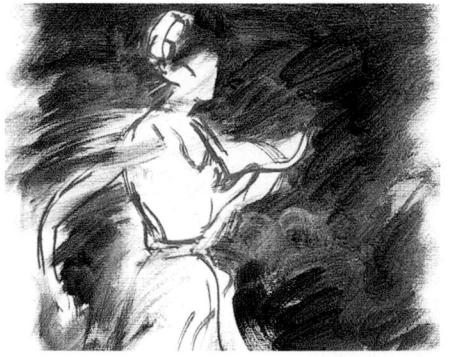

Paint the background freely, brushing across the contours of the dancer in places. Establish a sense of movement from the start.

PAINTING MOVEMENT CONVINCINGLY

Next, apply an underpainting of cadmium orange, titanium white, and alizarin crimson to the dancer and her swirling costume.

In places, blend the red into the surrounding darks, using broad, sweeping brush strokes to imitate the dancer's gyrations.

PAINTING FIGURES

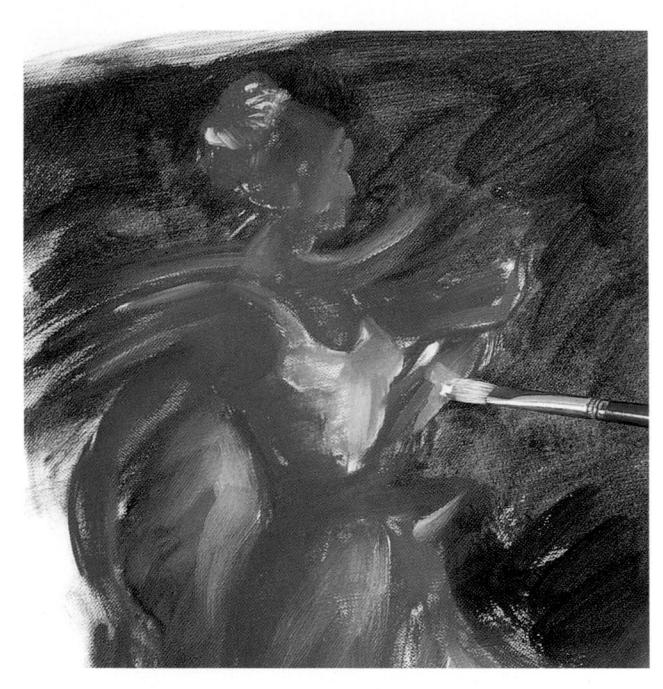

Apply cadmium yellow to brighten areas of the dancer's dress. Apply this roughly to the back of her dress and around her neck area to enhance the twisting movement of her hips.

With a mix of cadmium yellow and titanium white, suggest a warm flesh tint on the dancer's face and arm. Darken the background further by adding ivory black to the viridian and alizarin crimson. This brings the dancer forward from the rest of the painting and strengthens the movement of her body and dress.

PAINTING MOVEMENT CONVINCINGLY

Do not add too much detail to the painting. Everything should be left undefined to capture the sense of movement.

Demonstration: Picnic by a river

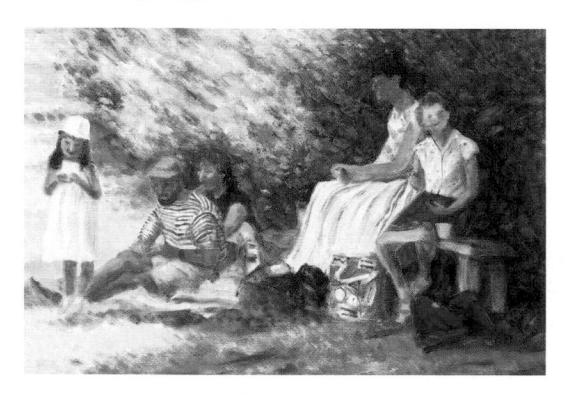

Groups of figures are wonderful subjects for a painting, and they have provided artists with inspiration for centuries. Figures can tell stories about their relationships, their histories, and

their predicaments, so artists have often grouped figures together to tell epic tales, depict religious stories, deliver a moral message, and record political events.

A group figure painting is quite a challenge to organize and paint convincingly. A photograph is often useful as a starting point, but the composition may need to be altered to make a good painting. The painting below is taken from a photograph of a group of people having a picnic in a field. The composition is an ideal balance of the positions and relationships of the different figures.

DEMONSTRATION: PICNIC BY A RIVER

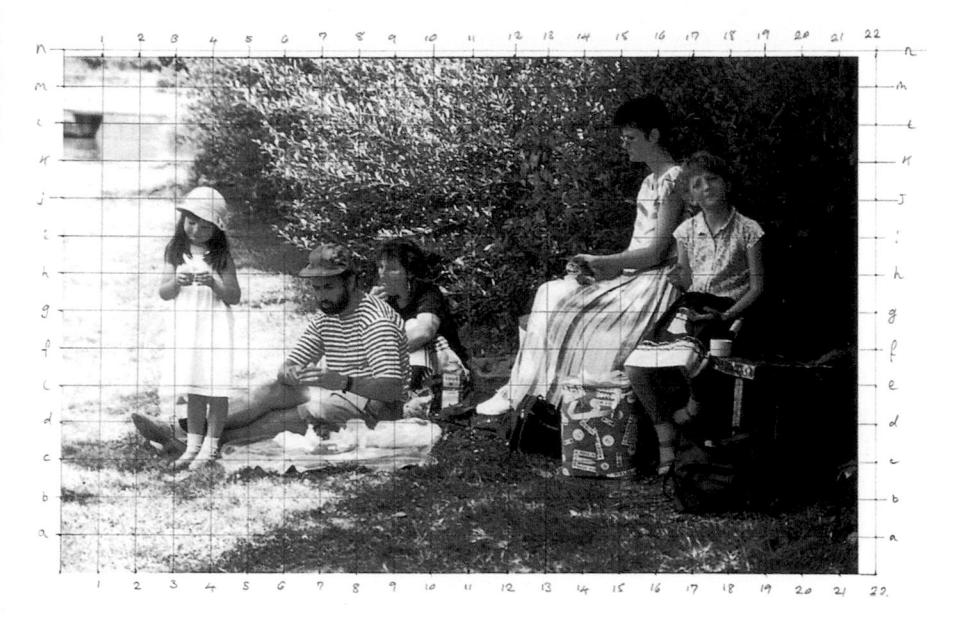

The mother and child on the right appear light against a dark background, and on the left, the figures melt into the light. Divide the photograph into a grid of squares before you start to draw.

Transfer the grid onto the support, and copy the photograph so that the size and positions of the people are accurate. This is a good way to work if you do not feel confident about your drawing.

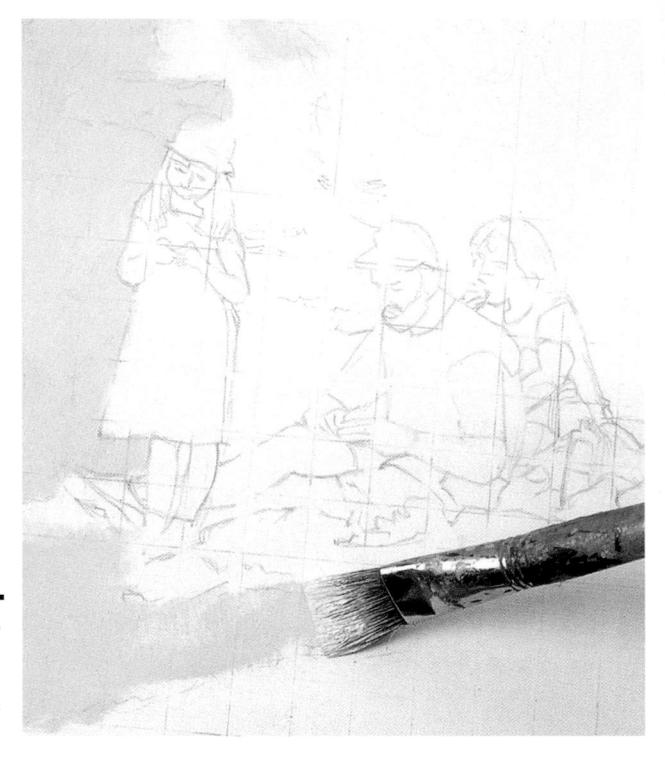

Apply the base colors first. Paint the grass with a mix of lemon yellow, titanium white, and painting medium.

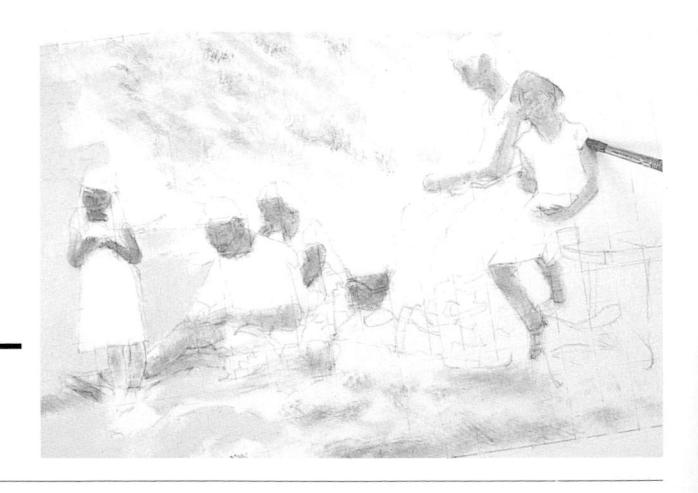

Use a rigger brush to underpaint the five figures using yellow ocher.

DEMONSTRATION: PICNIC BY A RIVER

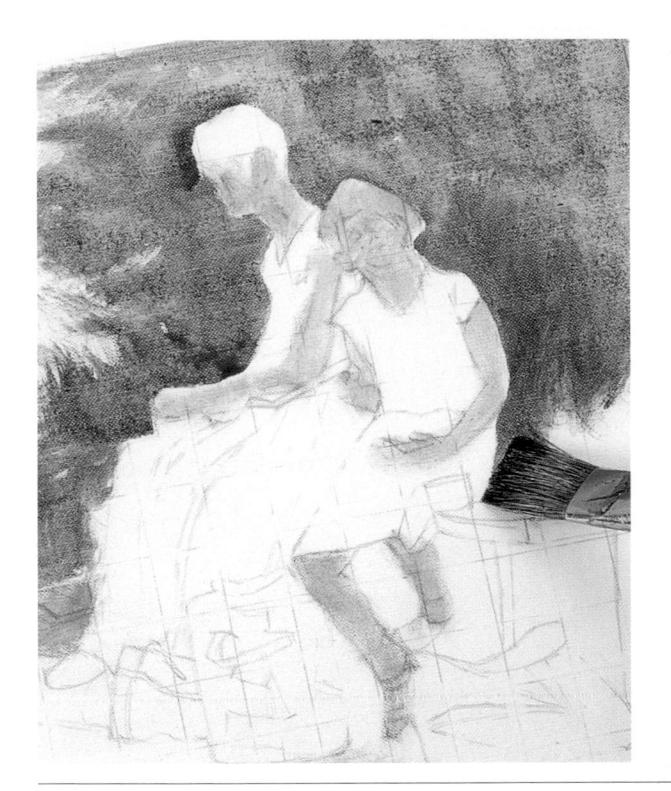

For the bushes in shadow, apply an underpainting of permanent mauve. Work carefully round the figures so that you don't obscure the drawing. Using a pair of complementary colors for the underpainting gives the piece interest.

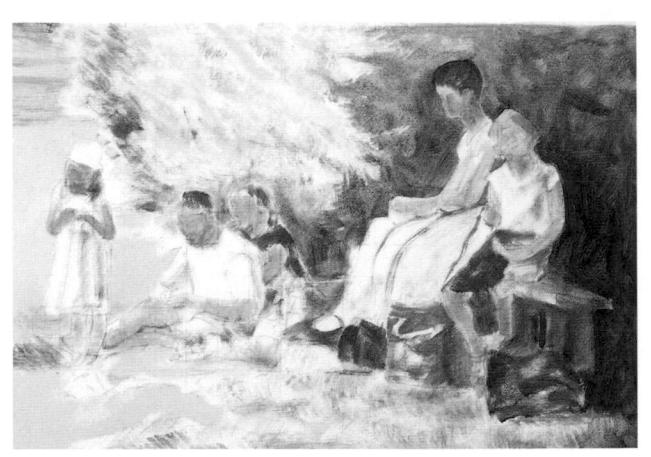

Apply an ultramarine underpainting for the bushes and the clothing, then scumble it over the bushes to deepen the shadows.

PAINTING FIGURES

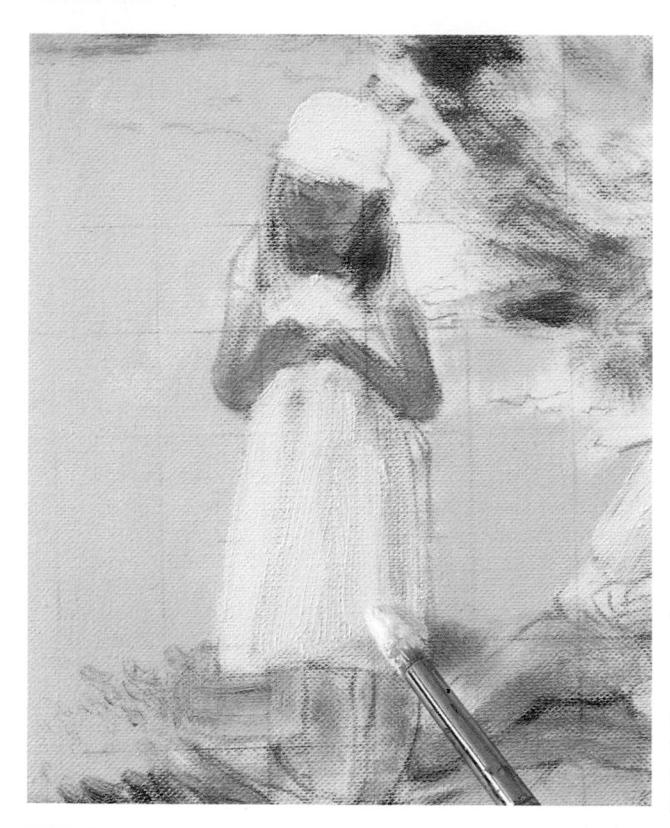

For white surfaces like the girl's dress, apply a coat of titanium white. Don't leave the primer showing in such areas, as this will make the painting seem patchy.

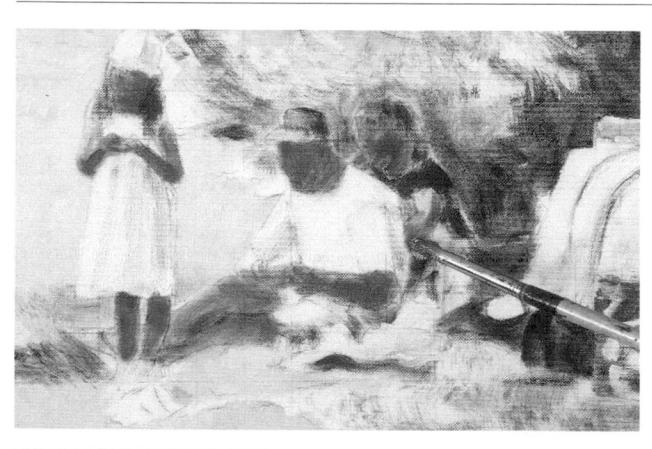

Next, darken the figures with a mix of cadmium scarlet and yellow ocher. Develop the figures together to ensure that they are integrated into the picture.

DEMONSTRATION: PICNIC BY A RIVER

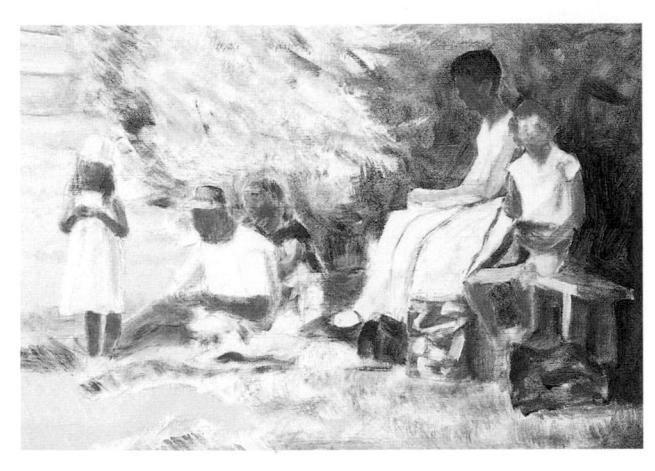

At this stage, the composition is roughly mapped out, but the paint is very thin. A thicker coat is needed to mask the grid of the initial drawing.

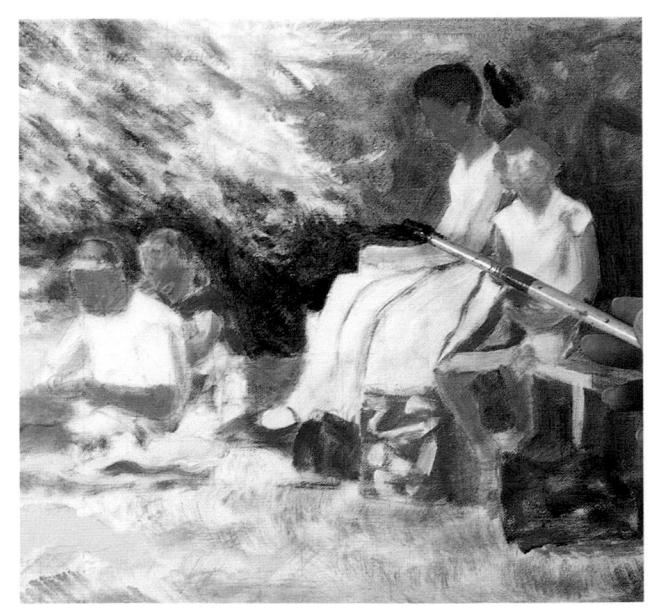

1 O Use short, broken brush strokes to paint the hedge with viridian, a transparent green. Here, the underpainting shows through, altering the hue.

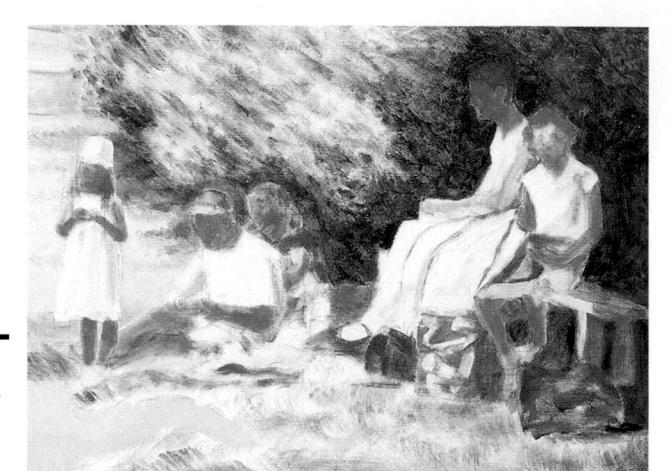

Now you can see that the dark green creates a dramatic contrast between the light and the shade.

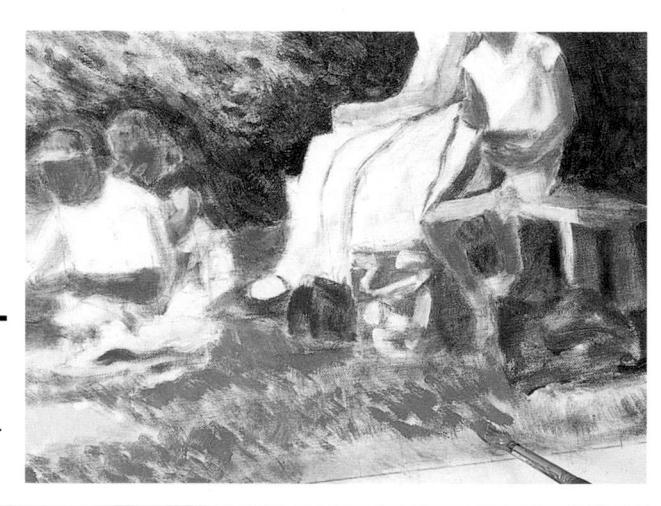

1 Pror the grass in shadow, mix cadmium lemon and emerald green. Use this color for the bushes as well.

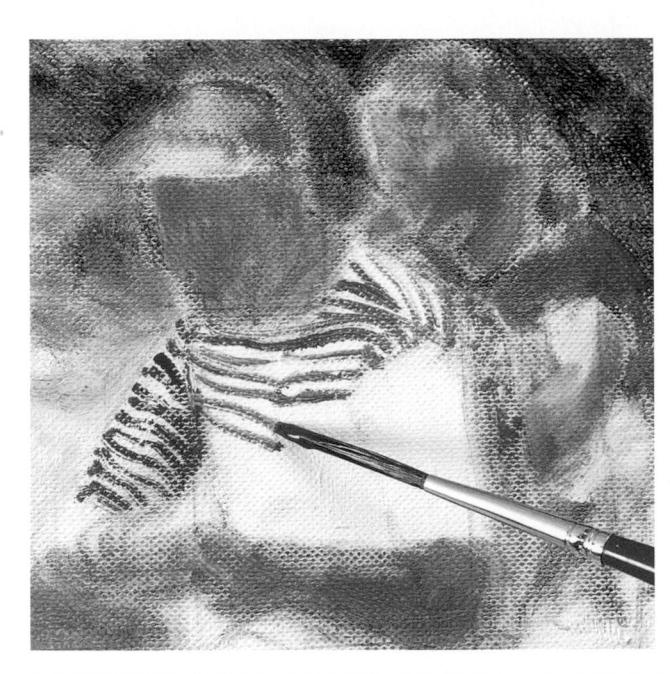

Begin to add details with a rigger brush, painting the red stripes of the man's T-shirt with cadmium red.

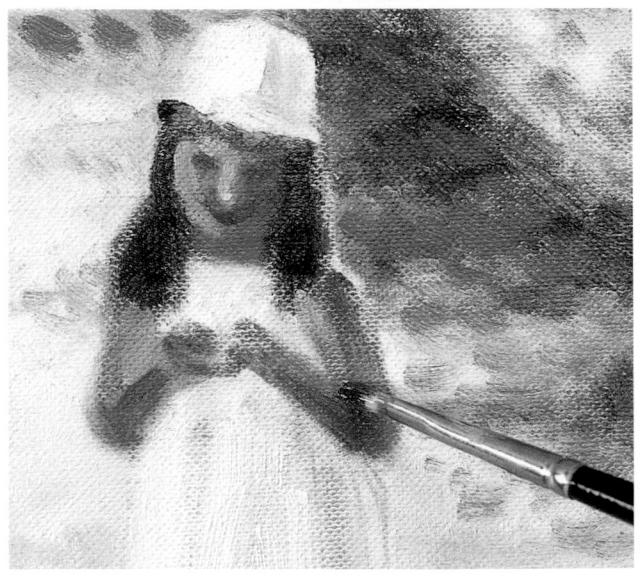

Paint the standing girl's hair and some shading on her arm with permanent mauve. Use the same color for shading all the features of the other people in the painting.

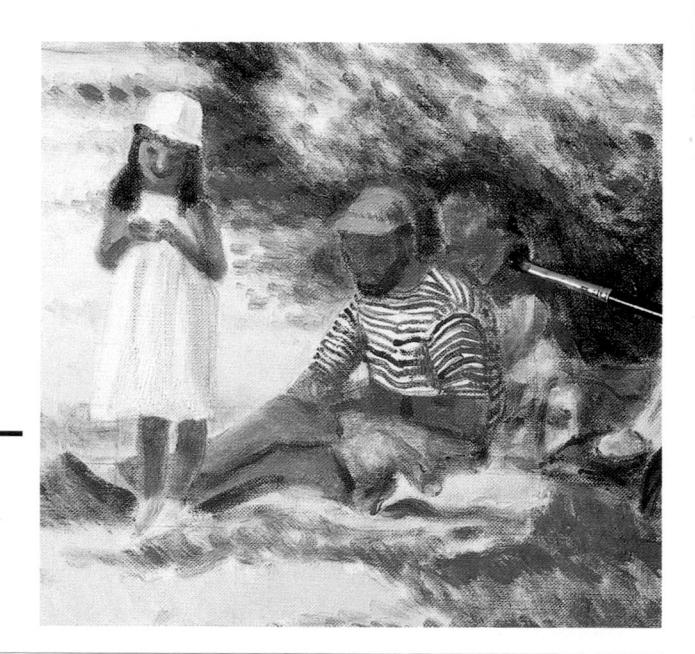

15 Use a fine flat sable brush to paint the woman's hair and blouse with a mixture of ultramarine and permanent mauve.

Apply small dabs of paint and don't make the painting too detailed. This helps keep the picture unified even though the composition is fairly complicated.

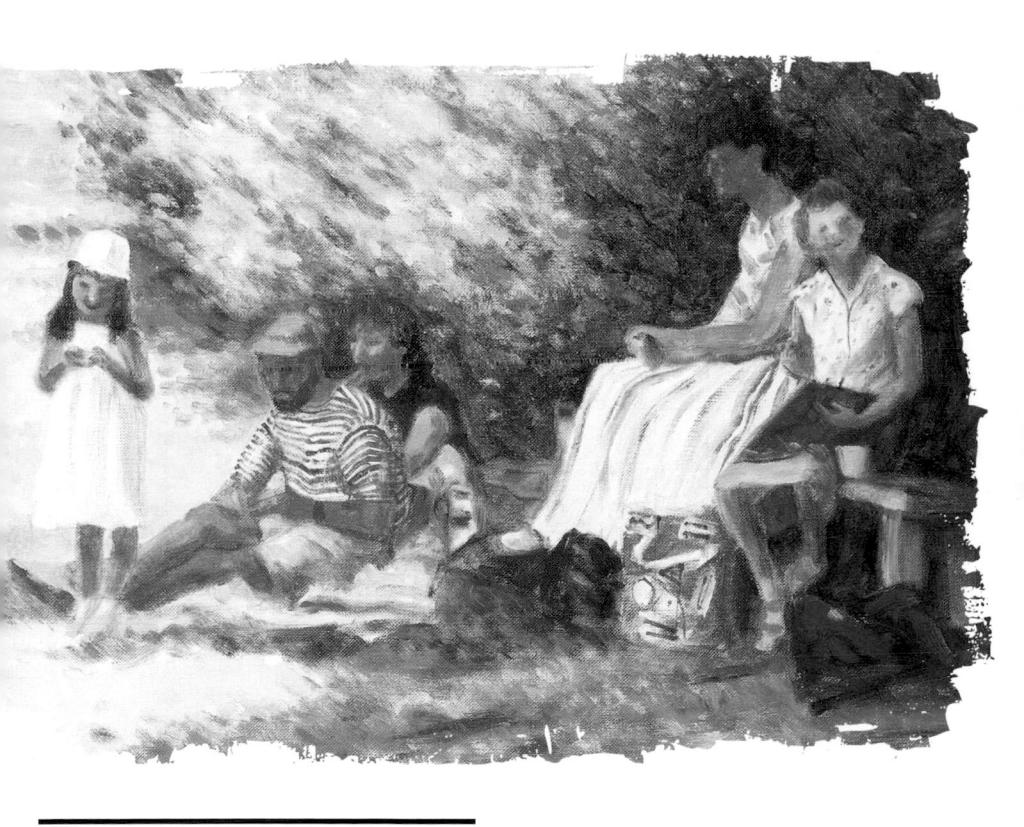

The finished painting is a colorful but balanced compostion that successfully captures the warm atmosphere of a lazy afternoon picnic.

Index F equipment 8-9, 140-1 expressions, facial 197 eyes 194-5 alla prima 27-9 Auerbach, Frank 7 F В fabric see cloth background 122-5 facial features 194-200 brickwork 17, 152, 155 figure, human 192-221 brushes 16-19 see also portraiture buildings 152 groups 212-21 movement of 208-11 Cfingers, using 26 fixative 10 canvas, stretching 20-1 charcoal 13, 27, 31, 32, 55 flowers 87-91 cloth 98-102 fog 136-9 clouds 129-31 foliage 132-5 color(s) foreground 122-5 background 52-4 formats, selecting 80-1 blending 50 Freud, Lucian 6 blocking in 16 G complementary 48-9 mixing 44, 45 glass 103-5 primary 44 glazes, using 55-63 secondary 44 grass 71-3, 149 tertiary 45-7 grounds wheel 44 Н composition 80-1, 86, 92-3, 121, 140 - 2hands 204-7 contrast(s) highlights 10, 98-9, 100, 103-5, chromatic 52-3, 201 201 - 2hills 10, 126-8 tonal 52-3, 126, 136, 201 crockery 96-7 hue 10, 43 D detail 16, 18, 30, 87-91, 92, 122, 132, impasto 10, 32-3, 64-5 208 L dilutents linseed oil 9, 23, 25, 55, 61 landscapes 120-55 turpentine 22-3, 55, 61 leaves 90, 137 diluting 22-3, 31, 55, 61 see also foliage distance, sense of 132-5 light(ing) 82-5, 98, 103-5, 106, 126, drawing 13, 30-1, 100, 106, 140-2, 139, 151, 155, 162, 174-5 linseed oil see dilutents 196-200 see also sketching

M mahl stick 11, 167 metal 106-9 middle ground 122-5 mist 50, 138-9, 150 mistakes, correcting 36-9 Monet, Claude 6, 27 movement, painting 208-11	sketching 12, 14, 30-1 see also drawing skin tones 201-3 sky 25, 62, 129-31, 166 spattering 12, 24-5, 182, 190 sponge, sponging 24-6 still life 78-119 stippling 12, 129 sun, sunlight 136, 161, 162
N	sunset 50
negative space(s) 10, 86	Т
O outdoors, painting 140-51 P painting medium 23, 42 palette, starter 43 pencil 13, 30-1 perspective 40-1, 198-9 aerial/atmospheric 10, 126-8 linear 11, 13, 40-1 one-point 11, 40 three-point 41 two-point 41 Picasso, Pablo 6 pigments, transparent 22 Pissarro, Camille 27 portraiture 194-207 see also figure, human facial features 194-200 head, perspective 198-200 skin tones 201-3	texture 13, 17, 25, 33, 60–1 Thiebaud, Wayne 6 three-dimensionality 82–5 tint 13, 179, 201–2 Titian 6 tone 13, 43, 201–3 Tonking 13, 34–5 townscapes 122–5, 152–5 trees 132–5 turpentine see dilutents V Van Eyck, Jan 6 Van Gogh, Vincent 27 vanishing point 13, 40–1 varnish 55, 61 viewfinder 13 W warping 13 water 156–91
D	painting reflections on 162-5
R reflection(s) 162–5	running 174–7 still 158–61
resists 12	waves see sea
S scumbling 12, 139, 151, 182, 215 sea 178-91 waves 178-81	wet-into-wet 13, 27 windows 152-5 wood 17, 154
sgraffito 12, 24, 182	

shading, shadows 43, 50, 58, 82-5, 92, 93, 98-9, 130

Oil painting suppliers

The stores listed below are all happy to supply via mail order—and some have retail stores, too.

United States

MisterArt 913 Willard Street Houston, TX 77006 800-721-3015 www.misterart.com

Jerry's Artarama PO Box 58638J Raleigh, NC 27658 800-827-8478 www.jerrysartarama.com

McCallister's Art Supplies 300 Salem Avenue Dayton, OH 45406 888-419-6615 www.mccallisters.com

Pearl 1033 East Oakland Park Boulevard Fort Lauderdale, FL33334 954-567-9678 www.pearlpaint.com

United Kingdom

T.N. Lawrence and Son 208 Portland Road Hove BN3 5QT 0845 644 3232 www.lawrence.co.uk

Ken Bromley Art Supplies Curzon House Curzon Road Bolton BL1 4RW 01204 381900 www.artsupplies.co.uk

Art Discount
Graphics House
Charnley Road
Blackpool
Lancashire FY1 4PE
0845 230 5510
www.artdiscount.co.uk